American Illustration 7

American Illustration 7

The seventh annual of American editorial,
book, advertising, poster, promotion, and computer art
and unpublished work

Edited by Edward Booth-Clibborn

A B B E V I L L E P R E S S · P U B L I S H E R S · N E W Y O R K

Editor: **Edward Booth-Clibborn**
Project Director: **Stephanie Van Dine**
Designer: **Hans Teensma/Impress**
Creative Consultant: **Harold Kaplan**
Associate Editor: **Amy Handy**
Project Assistants: **Susan Willmarth, Amy Guip**
Mechanical Artist: **Joan Lockhart**
Typesetting: **Digger O'Dell/Impress**
Endpaper artwork, cloth cover stamp, and
illustrations of judges: **Anthony Russo**
Studio photographs: **John Goodman**

Special thanks to the School of Visual Arts for providing the space and
equipment for the annual American Illustration judging.

The artwork and the caption information in this book have been
supplied by the entrants. While every effort has been made to ensure
accuracy, American Illustration, Inc., does not under any circumstances
accept any responsibility for errors or omissions.

If you are a practicing illustrator, artist, or student and would like to
submit work to the next annual competition, write to:

AMERICAN ILLUSTRATION, INC.,
67 Irving Place
New York, NY 10003 (212) 460-5558

American Illustration, Inc., Call for Entries
Copyright 1987 American Illustration, Inc.

Distributed in the United States of America and Canada by
ABBEVILLE PRESS
488 Madison Avenue
New York, NY 10022
ISBN 0-89659-946-9
ISSN 0737-6642

Book trade in the United Kingdom by
Internos Books, Colville Road, London W3 8BL England

Book trade for the rest of the world:
Hearst Books International, 105 Madison Avenue, New York, NY 10016

Direct mail, world:
Internos Books, Colville Road, London W3 8BL England

Direct mail USA, Canada:
Print Books, 6400 Goldsboro Road, Bethesda, MD 20817

Printed and bound in Japan

CONTENTS

INTRODUCTION

W HEN WE FIRST started American Illustration six years ago, we had one ambition: to
break down the walls of illustration's Hall of Fame so new talent could roam free
through its hallowed estate.

This year, I believe, we are seeing our American dream come true. And, I feel sure, the
country's founders would have been proud of us. For our objective has always been to
bring together the very best of American illustration each year, irrespective of the
individual artist's membership in the right societies, his or her acceptance in the right social
circles, or drawing power in Manhattan cocktail bars. All we are interested in is their
drawing power on paper or canvas or whatever their chosen medium may be.

And we are interested in quality.

This year our jury spent two days at the School of Visual Arts in New York, poring
over countless items of artwork, newspaper and magazine pulls, slides, and pieces of
packaging. They looked at miles of film and video tape. And, in the end, they selected the
work you see in this book.

They were not primarily interested in who had done the work, but in whether or not
the work had been done well. This will explain why you will not see many items by the
great names in American illustration, but rather more great images from a talented group
of young illustrators who may well, in time, become the great names of the future.

If you would like to join them next year, you'll find a Submission Form enclosed with
this volume. In the meantime, I hope you will enjoy this, the seventh edition of *American
Illustration* — our contribution to the fight for a fair hearing in every walk of American life.

EDWARD BOOTH-CLIBBORN

THE JURY

Derek Ungless

Derek Ungless is the creative director of ANGLE°, a design office based in New York. His projects include the redesign of the *Financial Times* of Canada, and *Creeds,* a fashion quarterly. He recently designed *House & Garden* and he has previously served as the art director of *Rolling Stone,* and as art director of *Saturday Night* magazine (Toronto), and design consultant at *Esquire* magazine. His work has been honored by the American Institute of Graphic Arts, the New York Art Directors Club, the National Magazine Awards Foundation of Canada, and the British Design and Art Direction Awards.

Rip Georges

Rip Georges is the art director of *Esquire* magazine. He studied at the University of California at Santa Barbara, and he holds a postgraduate degree from the Brighton College of Design in England. He has been art director for *Regardie's, LA Style, Arts & Architecture,* and *Revue* magazines, as well as for projects for the 1984 Olympics and the Playboy Jazz Festival. Rip's work has received numerous awards from, among others, the American Institute of Graphic Arts, the Art Directors Club of Los Angeles, the Society of Publication Designers, and the Typographic Institute of America.

Robin Jefferies

Robin Jefferies has worked for the Kansas City Star since 1979, as staff artist, assistant art director, and art director, and now serves as art director for the feature sections of the paper. She holds a B.F.A. from the Kansas City Art Institute and has received honors from the New York Art Directors Club, the Society of Newspaper Design, and *Print* magazine.

Gina Davis

Gina Davis is the art director of *Savvy* magazine. She has served as art director at *Esquire* and *Manhattan, Inc.* magazines and has also worked for Random House/Pantheon Books. She has received honors from the Society of Publication Designers.

Steven Hoffman

Steven Hoffman became design director at *Sports Illustrated* in 1987. He has designed for *New West, New York, Newsweek, Business Week, Metropolitan Home, Harper's Bazaar,* and *Savvy,* and has been a design consultant for Bergdorf Goodman, New York University, and Time, Inc. His work has been recognized by the American Institute of Graphic Arts, the Society of Publication Designers, the New York Art Directors Club, and the Society of Illustrators.

Lucy Bartholomay

Lucy Bartholomay, the art director of the *Boston Globe Magazine,* has also served as design director of the *Boston Monthly* and *The Real Paper.* She has received medals from the New York Art Directors Club, the Society of Publication Designers, the Boston Art Directors Club, and the Society of Newspaper Design. Her work has been recognized by the Type Directors Club, *Graphis, Print,* and *Communication Arts.*

Robert Best

Robert Best is the design director of both *New York* and *Premiere* magazines. Under his direction, *New York* has received numerous awards and honors from a variety of organizations, including the American Society of Magazine Editors, the Magazine Publishers Association, the Society of Publication Designers, the American Institute of Graphic Arts, and the International Editorial Design Competition. Robert Best is a graduate of the School of Visual Arts at Syracuse University, and teaches editorial design at the School of Visual Arts, New York.

I

EDITORIAL

*Illustrations for newspapers
and their supplements, and consumer,
trade, and technical magazines
and periodicals*

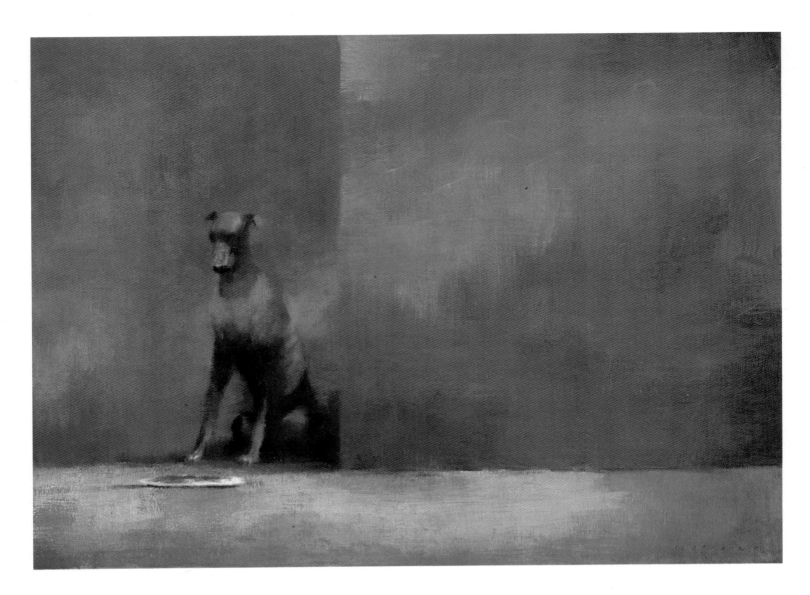

12

ART DIRECTOR
Hans-Georg Pospischil
DESIGNER
Hans-Georg Pospischil
PUBLICATION
Frankfurter Allgemeine Magazin
October 16, 1987
PUBLISHING COMPANY
Frankfurter Allgemeine Zeitung
WRITER
Michael Freitag

Brad Holland

A feature on greyhounds included this picture.
Medium: Acrylic.

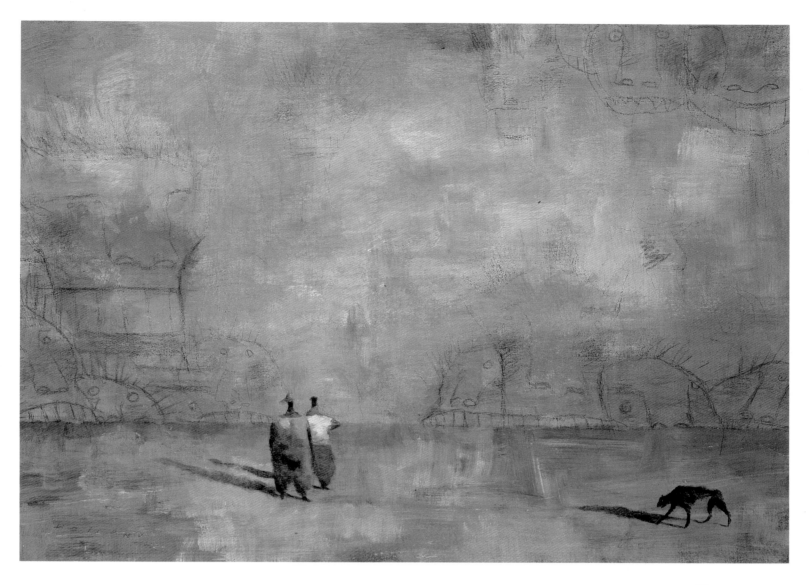

13

ART DIRECTOR
Hans–Georg Pospischil
DESIGNER
Hans–Georg Pospischil
PUBLICATION
Frankfurter Allgemeine Magazin
November 27, 1987
PUBLISHING COMPANY
Frankfurter Allgemeine Zeitung
WRITER
Peter Stephan Jurgk

Brad Holland

"In Der Vorholle Des Lebens" featured this image.
Medium: Acrylic.

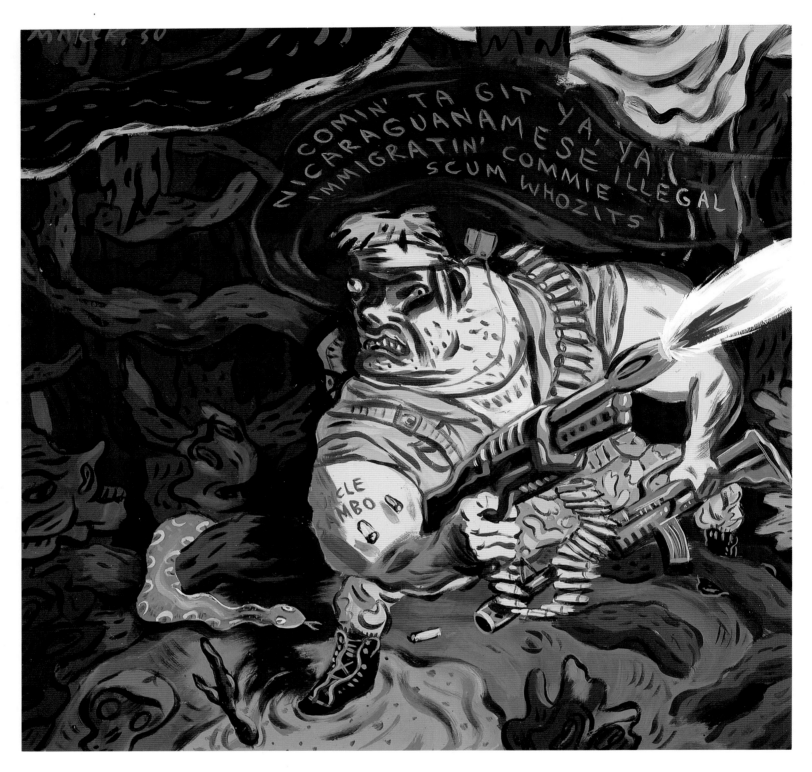

14

ART DIRECTORS
Fred Woodward and Jolene Cuyler
PUBLICATION
Regardie's Magazine
July 1987
PUBLISHING COMPANY
Regardie's Magazine, Inc.
WRITER
Richard Halloran

Mark Marek

Mark Marek's picture of aggression accompanied
the article "The War Business: Operation
Honduras." Medium: Acrylic.

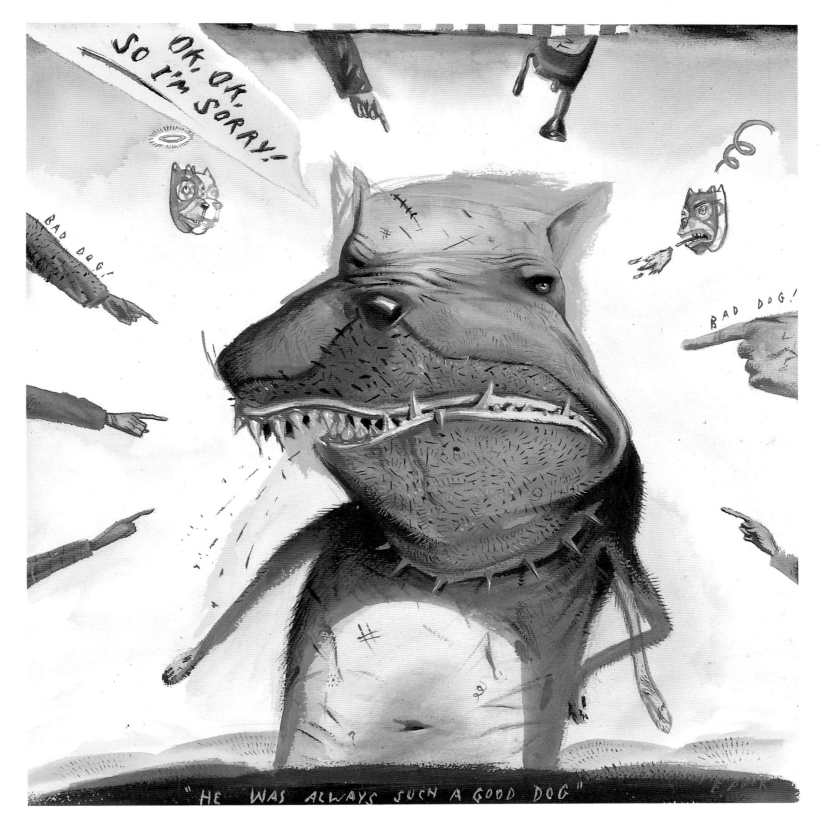

ART DIRECTOR
Fred Woodward
PUBLICATION
Rolling Stone
January 17, 1987
PUBLISHING COMPANY
Straight Arrow Publishers, Inc.

Everett Peck

"Irrational Affairs" looked at ten controversial issues
of the past year; here, the problem of the pit bull.
Medium: Mixed media.

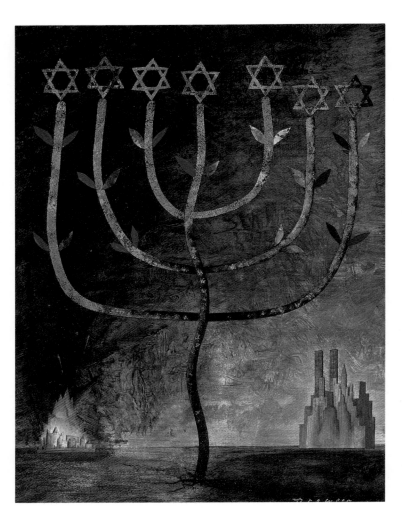

16

ART DIRECTOR
Teresa Fernandes
DESIGNER
Teresa Fernandes
PUBLICATION
Toronto Life Magazine
November 1987
PUBLISHING COMPANY
Toronto Life Publishing Co.
WRITER
Elaine Dewar

Blair Drawson

"The Mysterious Reichmanns" examined a Jewish
family's historical past and its effect on their lives
today. Medium: Acrylic on paper, mounted on
panel.

 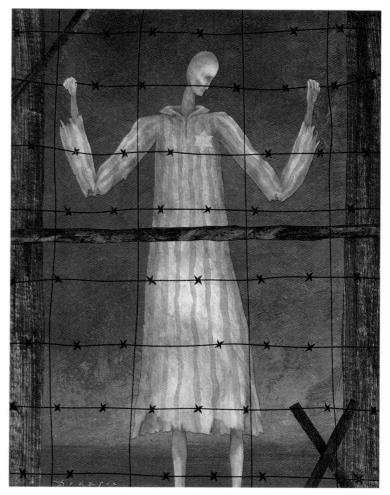

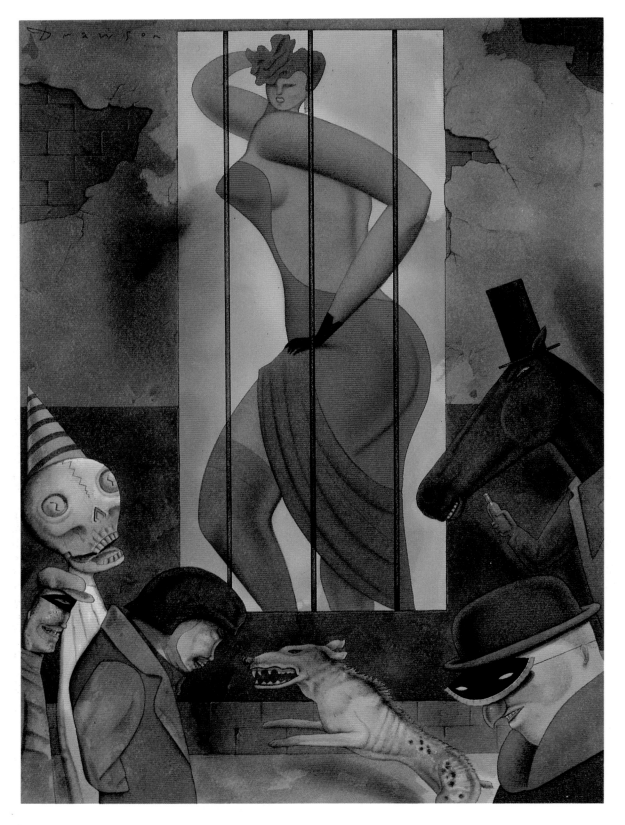

ART DIRECTOR
Rip Georges
PUBLICATION
**Regardie's Magazine
May 1987**
PUBLISHING COMPANY
Regardie's Magazine, Inc.
WRITER
Kevin Murphy

Blair Drawson

A journalist described his stint at a tabloid in "My
Life as a Sleazemonger." Medium: Acrylic on paper.

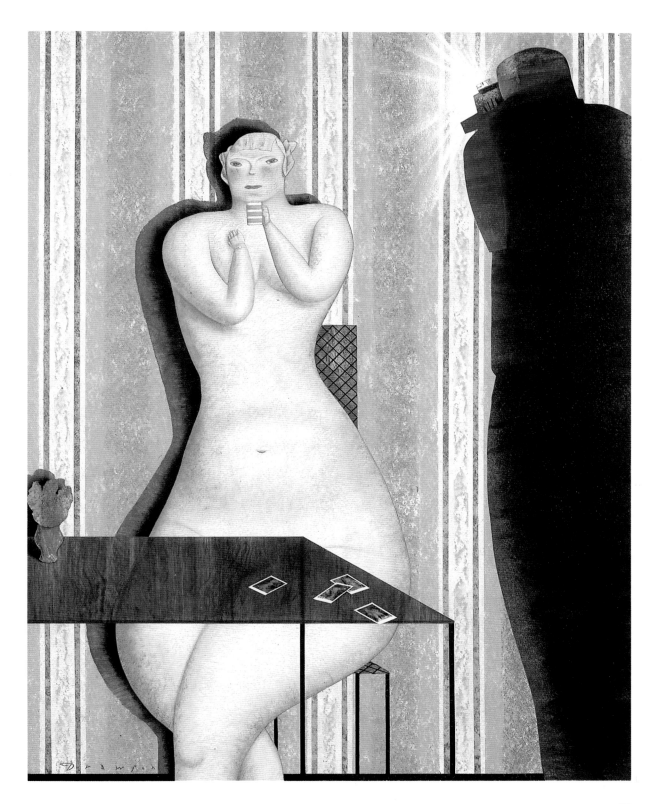

Art Director
Steven Hoffman
Editor
Eileen Garred
Publication
**New York University Magazine
Winter 1987**
Publishing Company
New York University
Writer
Agnes Rossi

Blair Drawson

Blair Drawson's illustration appeared with a work of
fiction entitled "Athletes and Artists." Medium:
Acrylic on paper, mounted on panel.

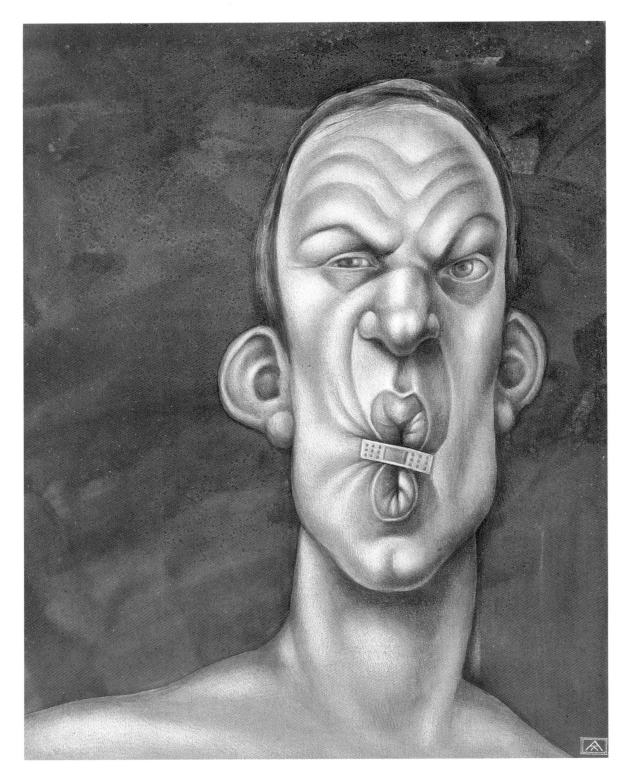

ART DIRECTOR
Michael Walsh
DESIGNER
Michael Walsh
PUBLICATION
Washington Post Magazine
January 1988
PUBLISHING COMPANY
Washington Post
WRITER
Walt Harrington

Anita Kunz

Seen here are two of the three images Anita Kunz
created for an article about lying. Medium:
Watercolor and gouache.

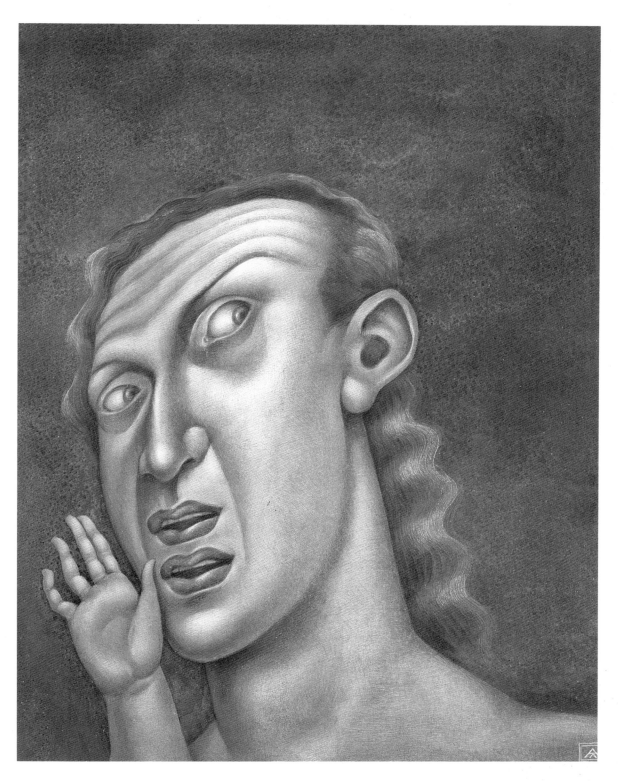

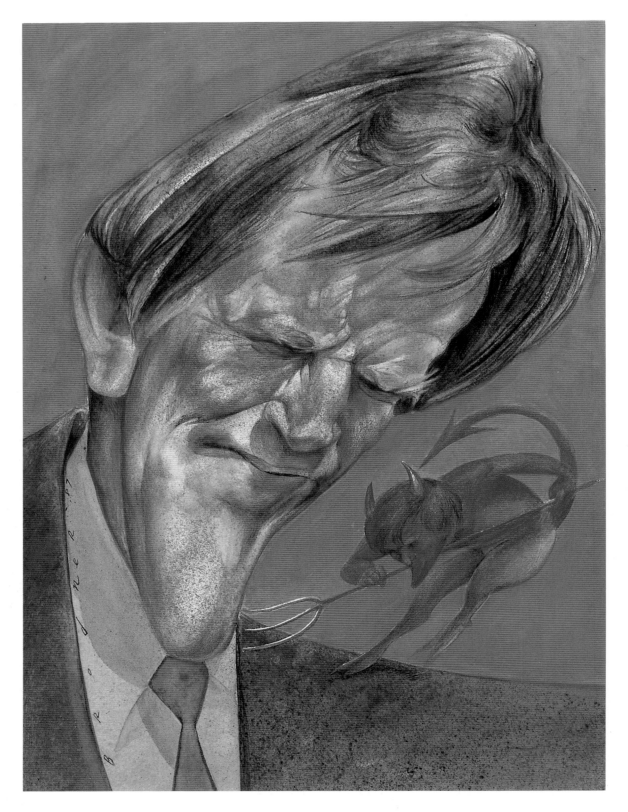

ART DIRECTOR
Michael Walsh
DESIGNER
Michael Walsh
PUBLICATION
Washington Post Magazine
July 12, 1987
PUBLISHING COMPANY
Washington Post

Steve Brodner

The temptations of Gary Hart were the cover
subject of "Hell Week: Inside a Political Disaster."
Medium: Watercolor.

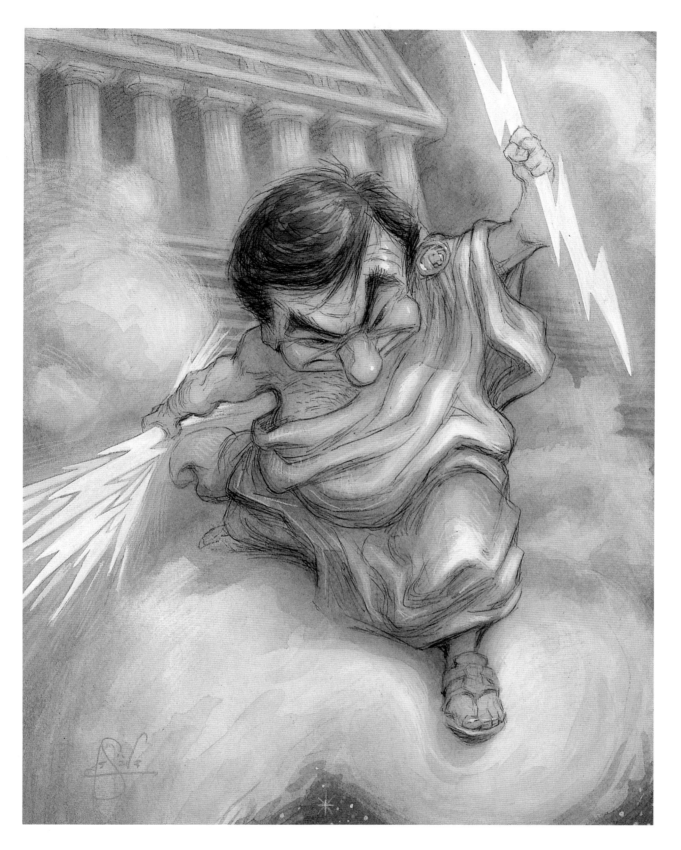

ART DIRECTOR
Rip Georges
PUBLICATION
**Regardie's Magazine
December 1987**
PUBLISHING COMPANY
Regardie's Magazine, Inc.

Peter de Seve

The Greek theme is played up in a picture of
Michael Dukakis for "Presidential Sweepstakes."
Medium: Watercolor.

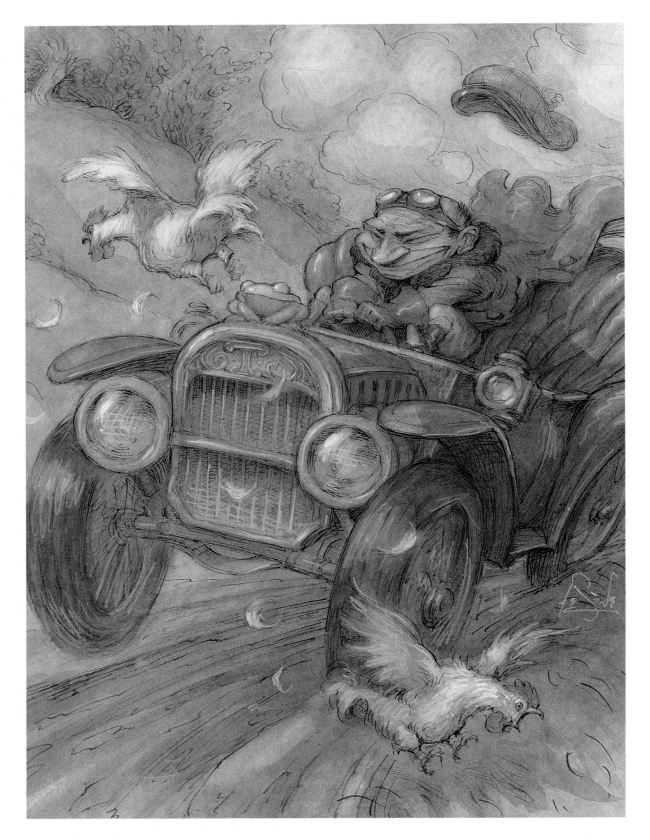

ART DIRECTOR
Rip Georges
PUBLICATION
**Regardie's Magazine
September 1987**
PUBLISHING COMPANY
Regardie's Magazine, Inc.

Peter de Seve

The series "Altered Egos" included this look at
Senator Jack Herrity as Mr. Toad from *The Wind in
the Willows*. Medium: Watercolor.

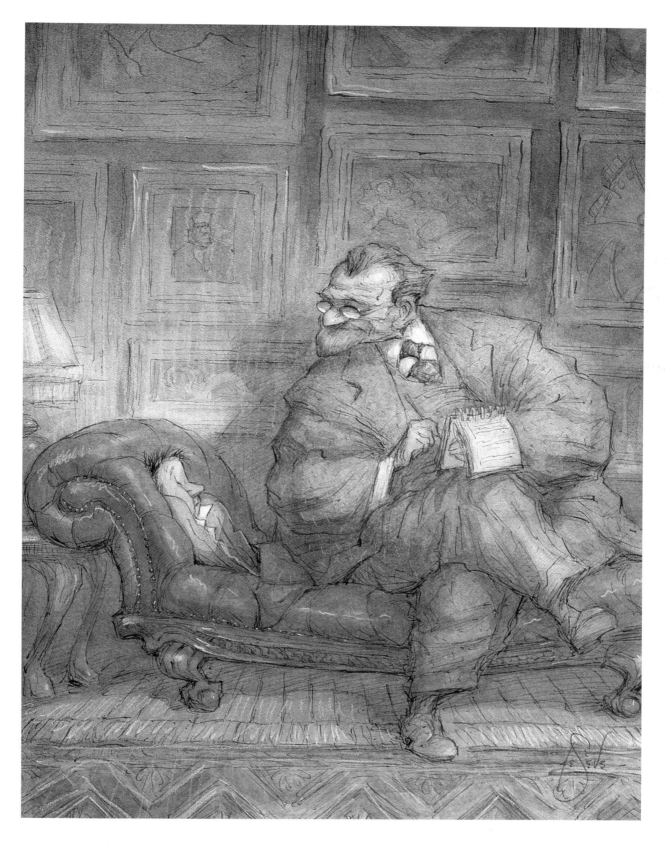

ART DIRECTOR
Robert Best
PUBLICATION
New York Magazine
August 31, 1987
PUBLISHING COMPANY
New York Magazine

Peter de Seve

The difficulty of terminating a doctor–patient
relationship was the subject of "Prisoners of
Psychotherapy." Medium: Watercolor.

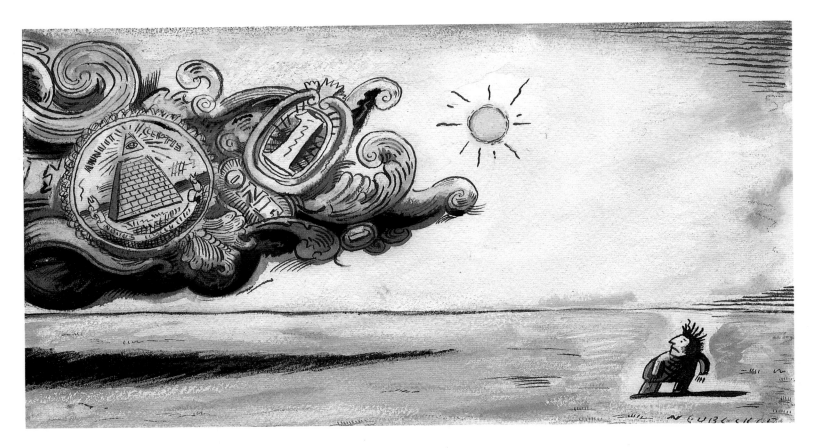

ART DIRECTOR
Laura Baer
DESIGNER
Malcolm Frouman
PUBLICATION
**Business Week
April 20, 1987**
PUBLISHING COMPANY
McGraw-Hill
WRITERS
**Howard Gleckman,
Douglas Harbrecht,
and Jeff Laderman**

Robert Neubecker

The disastrous implications of the return of inflation
hover like the proverbial dark cloud in an
illustration for the article "Spooked Again: A Whiff
of Inflation Sparks a Panicky Reaction." Medium:
Watercolor, ink, and colored pencil.

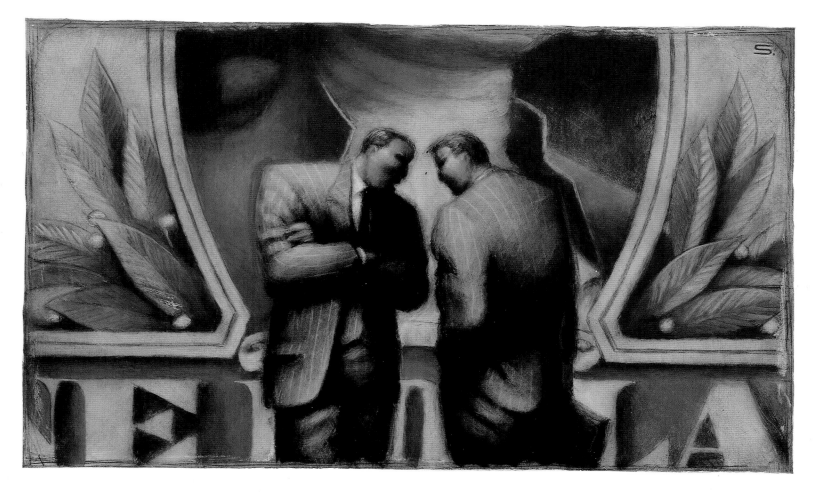

ART DIRECTOR
Gina Davis
DESIGNER
Sue Ng
PUBLICATION
Savvy Magazine
June 1987
PUBLISHING COMPANY
Family Media, Inc.
WRITER
Susan Antilla

David Shannon

An article on insider trading included this image of
two shady businessmen posed against the almighty
dollar. Medium: Acrylic.

Art Director
Fred Woodward
Publication
Texas Monthly
January 1987
Publishing Company
Texas Monthly, Inc.
Writer
Anne Dingus

José Cruz

"Adios, Bandito" bade farewell to the stereotyped
character of the well-known corn chip seller.
Medium: Acrylic.

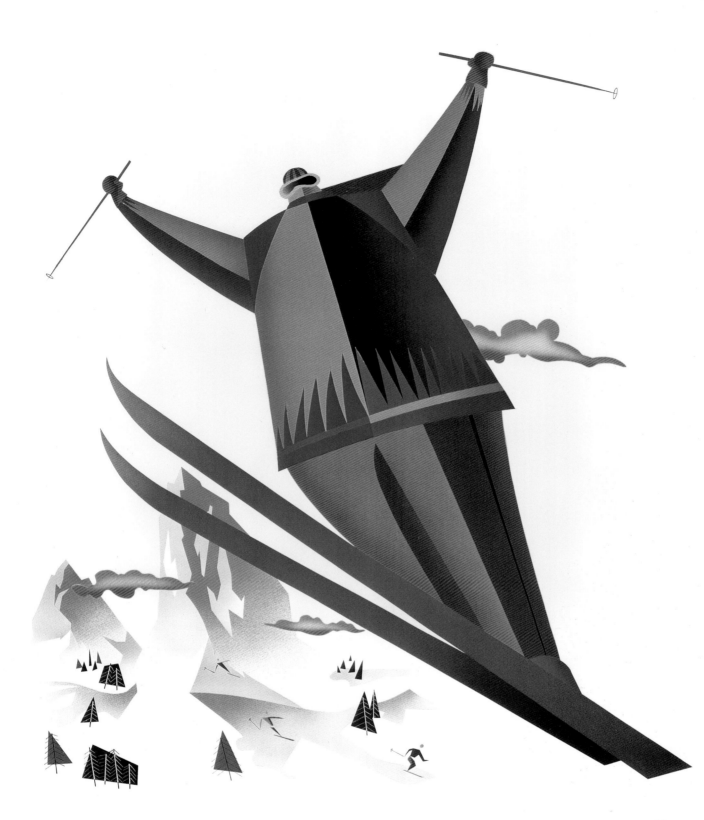

ART DIRECTOR
Lucy Bartholomay
DESIGNER
Catherine Aldrich
PUBLICATION
Boston Globe Magazine
January 31, 1988
PUBLISHING COMPANY
Boston Globe
WRITER
Bob MacDonald

Terry Allen

The triumphant pose of a soaring, single skier
echoes the mood of "A Turn for the Better," the
story of a writer's return to skiing after a serious
accident the year before. Medium: Gouache.

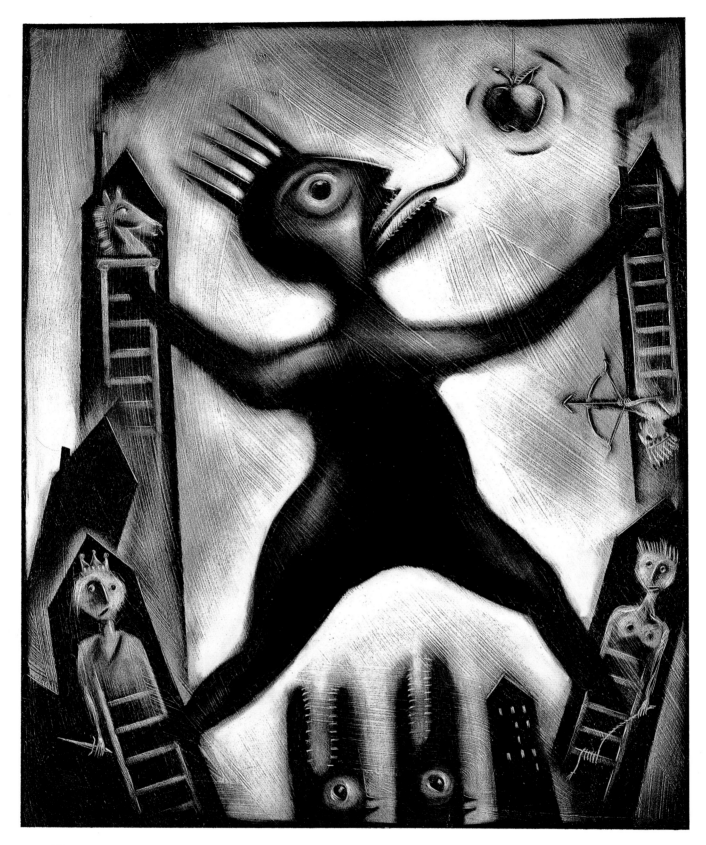

Art Director
Gianni Caccia
Publication
**Vice Versa Magazine
December 1987**
Publishing Company
Vice Versa Publications

Richard Parent

For a double-page spread, Richard Parent
interpreted the theme "The Americas." Medium:
Acrylic and oil pastel.

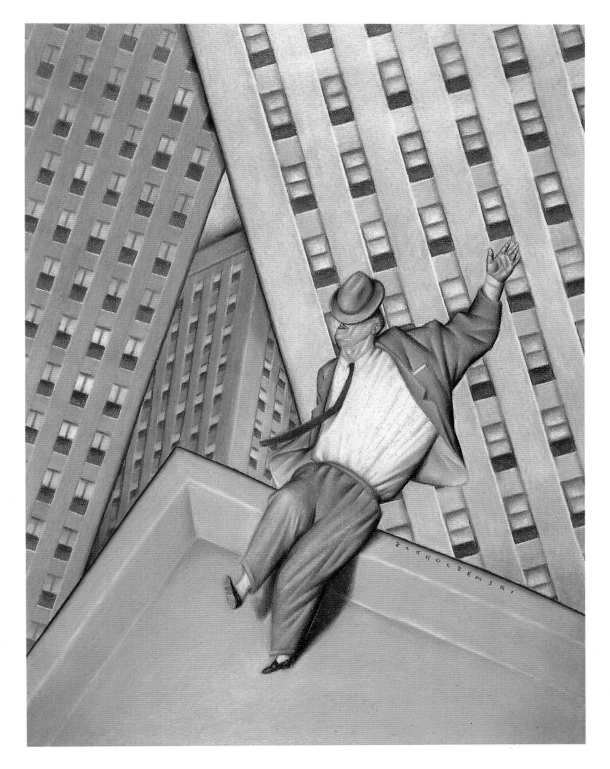

ART DIRECTOR
John Cloutier
DESIGNER
John Cloutier
PUBLICATION
Source
Winter 1987–88
PUBLISHING COMPANY
**University Publications,
State University of New York
at Buffalo**
WRITER
David C. Webb

Daniel Zakroczemski

This view of an earthquake experience accompanied
an article on earthquake studies. Medium:
Prismacolor.

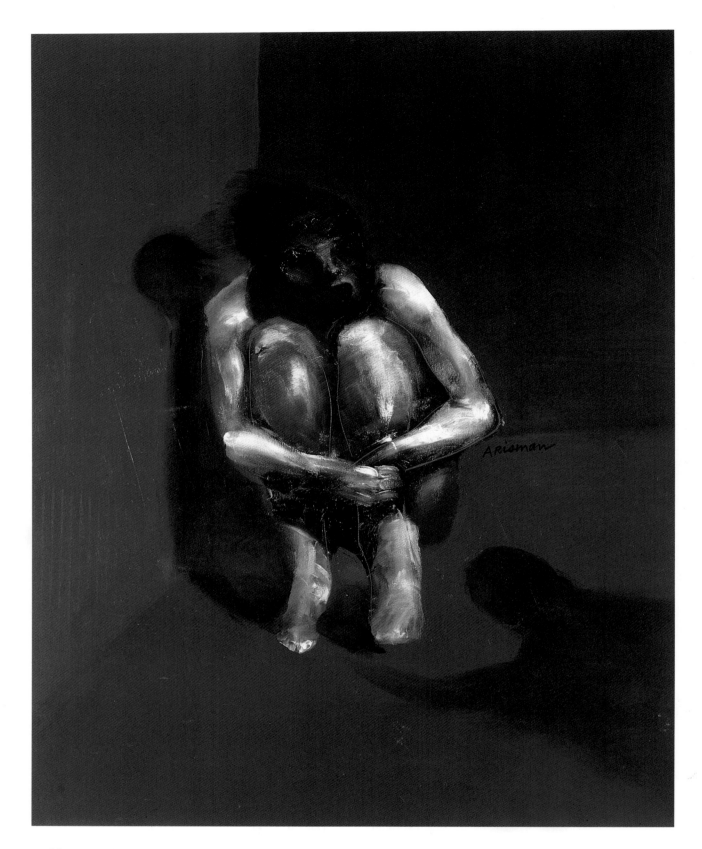

ART DIRECTOR
Louise Kollenbaum

PUBLICATION
Mother Jones
November 1987

PUBLISHING COMPANY
Foundation for National Progress

Marshall Arisman

Marshall Arisman's image evokes the anguish of a
victim of wife beating for an article on the subject.
Medium: Oil on ragboard.

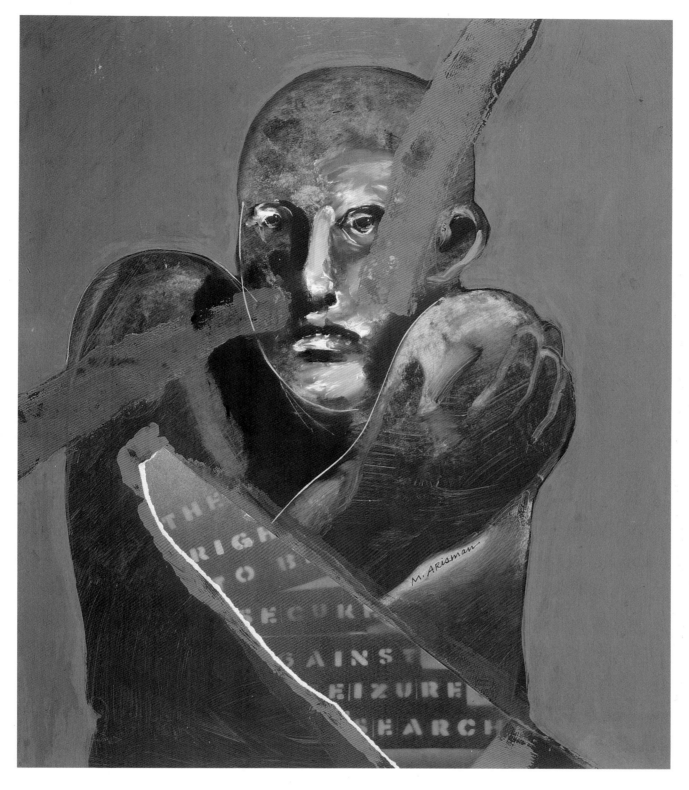

ART DIRECTOR
Diana LaGuardia
PUBLICATION
New York Times Magazine
September 13, 1987
PUBLISHING COMPANY
New York Times
WRITER
Yale Kamisar

Marshall Arisman

For an article about the fourth amendment,
concerning the right to be secure against search and
seizure, Marshall Arisman depicted a figure being
invaded by outside forces.
Medium: Oil on ragboard.

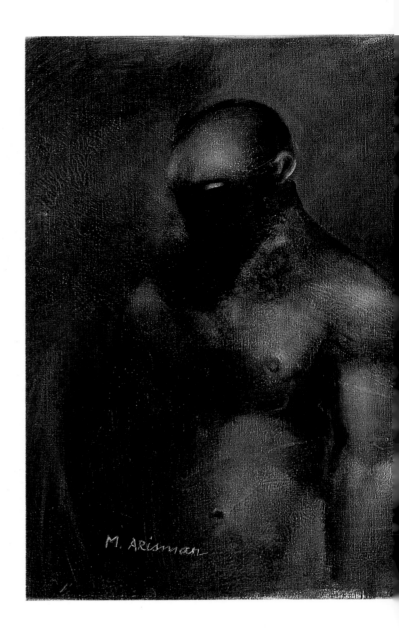

34

ART DIRECTOR
Rip Georges
PUBLICATION
Regardie's Magazine
PUBLISHING COMPANY
Regardie's Magazine, Inc.

Marshall Arisman

These dramatic images accompanied "In the Belly of
the Beast," a series of quotes on the subject of
power. Medium: Oil on canvas.

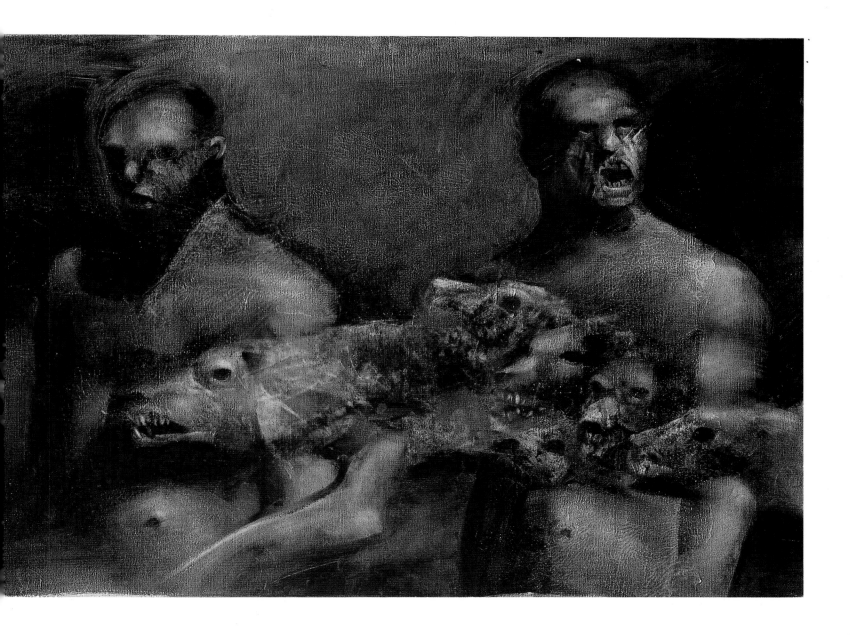

ART DIRECTOR
Teresa Fernandes
DESIGNER
Teresa Fernandes
PUBLICATION
**Toronto Life Magazine
February 1988**
PUBLISHING COMPANY
Toronto Life Publishing Co.
WRITER
Gary Michael Dault

Henrik Drescher

The significance of homes in our lives and our architecture is the subject of speculative articles in the feature "Reinventing the Home." Medium: Watercolor, ink, and dyes.

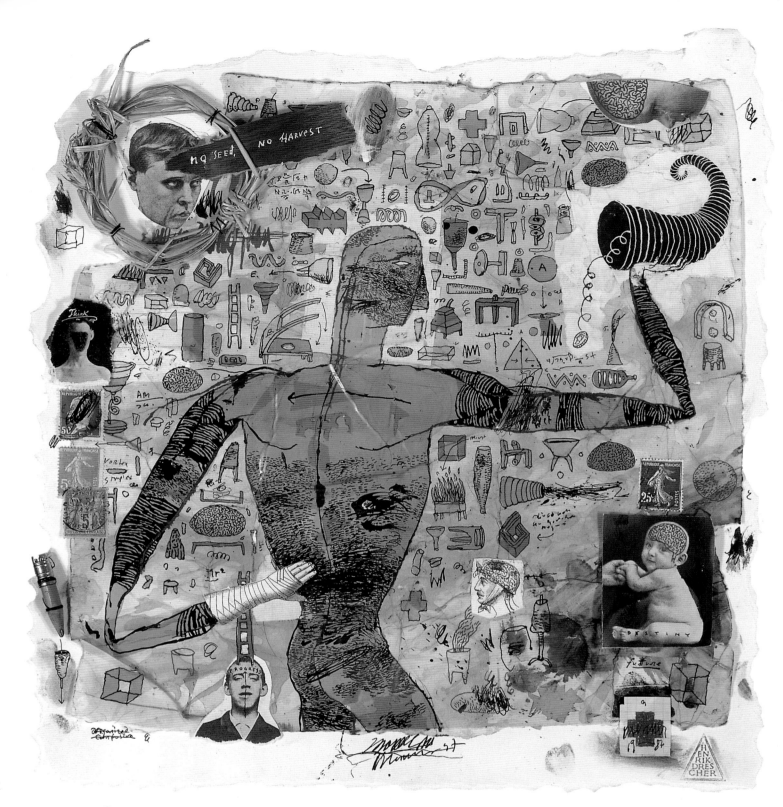

38

ART DIRECTOR
Teresa Fernandes
DESIGNER
Teresa Fernandes
PUBLICATION
Toronto Life Magazine
January 1988
PUBLISHING COMPANY
Toronto Life Publishing Co.
WRITER
Brian Shein

Henrik Drescher

Three pieces by Henrik Drescher were featured in "School of Hard Knocks," an article about the years of underfunding suffered by the University of Toronto. Medium: Watercolor, ink, pomegranate juice, and found objects.

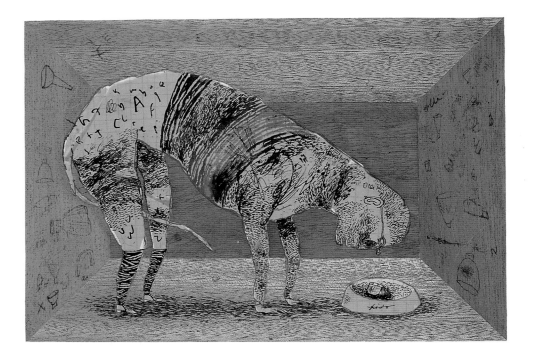

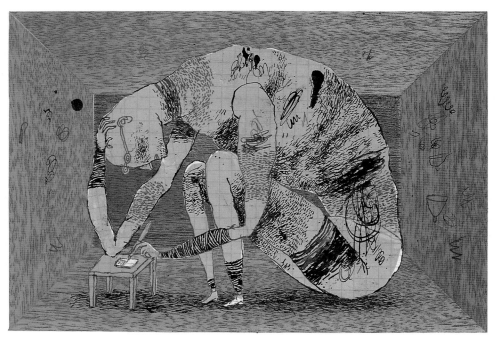

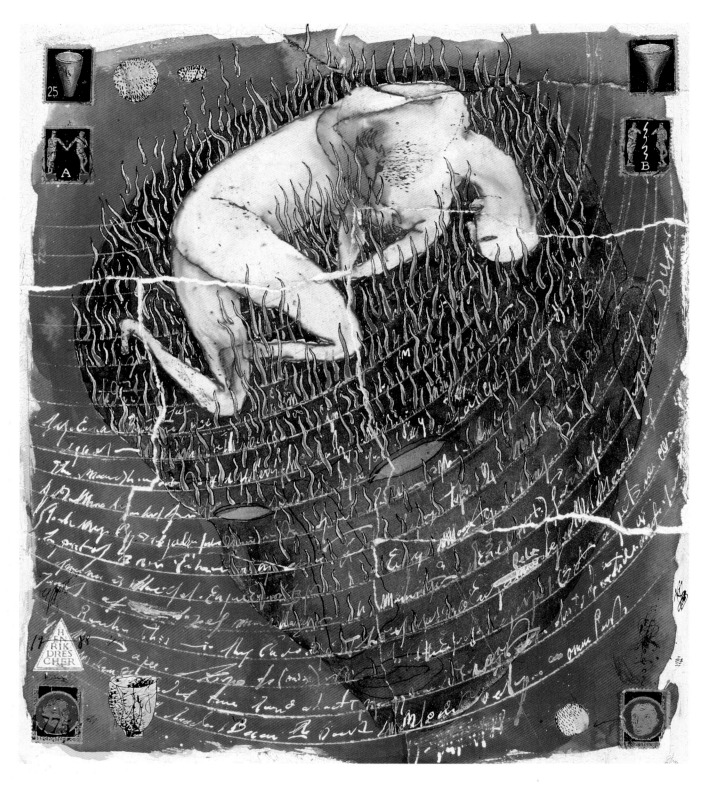

ART DIRECTOR
Lucy Bartholomay
DESIGNER
Lucy Bartholomay
PUBLICATION
Boston Globe Magazine
February 28, 1987
PUBLISHING COMPANY
Boston Globe
WRITER
Lee Grove

Henrik Drescher

This illustration, carefully avoiding the expected
imagery of the topic, accompanied the article "The
Metaphor of Aids." Medium: Watercolor,
ink, and varnish.

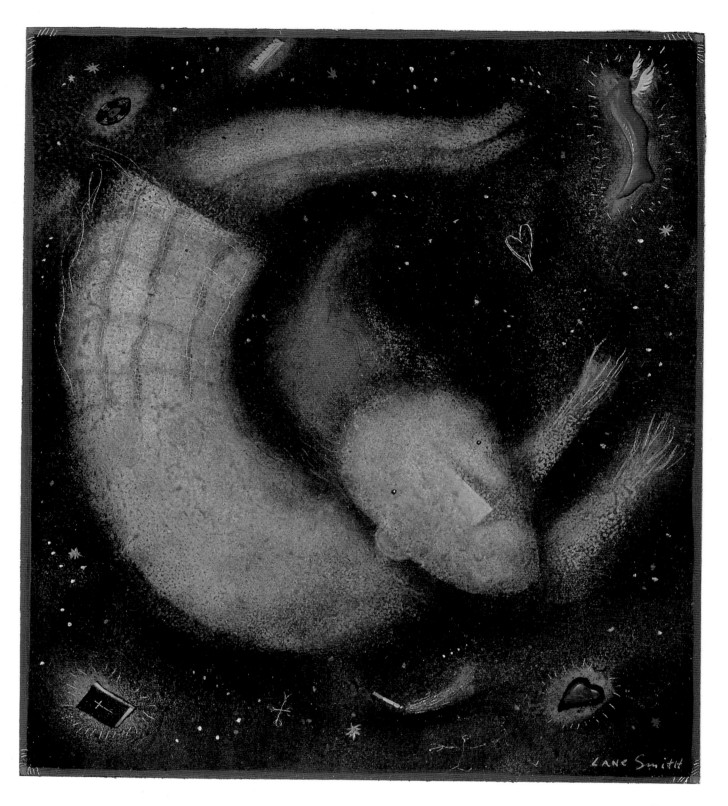

ART DIRECTOR
Roxanne Stachelek
DESIGNER
Roxanne Stachelek
PUBLICATION
Northeast Magazine
August 16, 1987
PUBLISHING COMPANY
The Hartford Courant
WRITER
Wally Lamb

Lane Smith

Symbols from the story surround the central
character of "The Flying Leg," a story about the
traumas of adolescence. Medium: Oil.

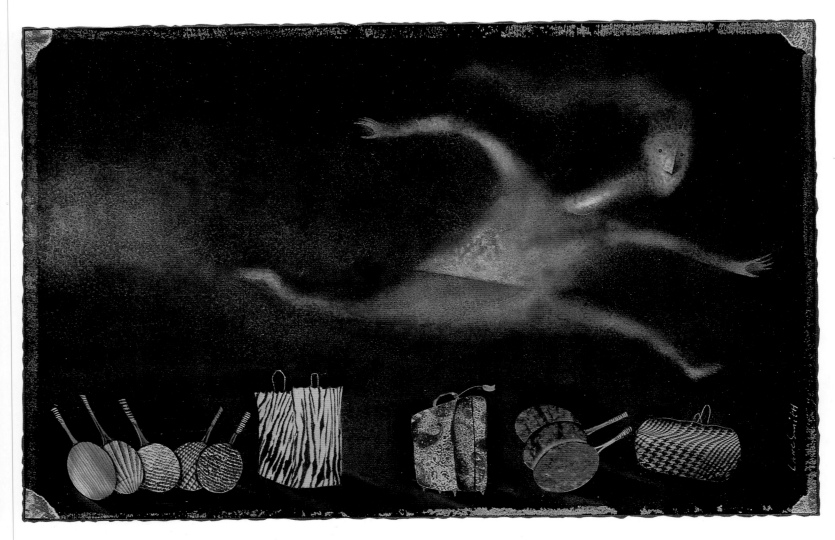

42

ART DIRECTOR
Wendy Reingold
DESIGNER
Wendy Reingold
PUBLICATION
World Tennis
September 1987
PUBLISHING COMPANY
Family Media, Inc.
WRITER
Chris Evert

Lane Smith

"Travelers Advisory" discussed ways to keep in
shape while on the road. Medium: Oil and collage.

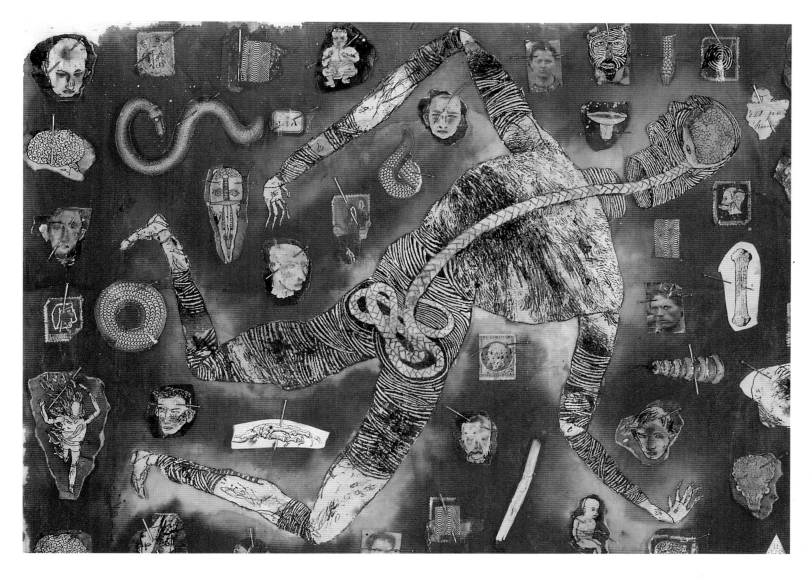

ART DIRECTOR
Fred Woodward
PUBLICATION
Rolling Stone
March 24, 1988
PUBLISHING COMPANY
Straight Arrow Publishers, Inc.
WRITER
Tom McNichol

Henrik Drescher

Henrik Drescher's imagery evokes the terrors of
drug addiction for the article "PCP: A Cheap Thrill
with a High Price." Medium: Watercolor, dyes, ink
and collage.

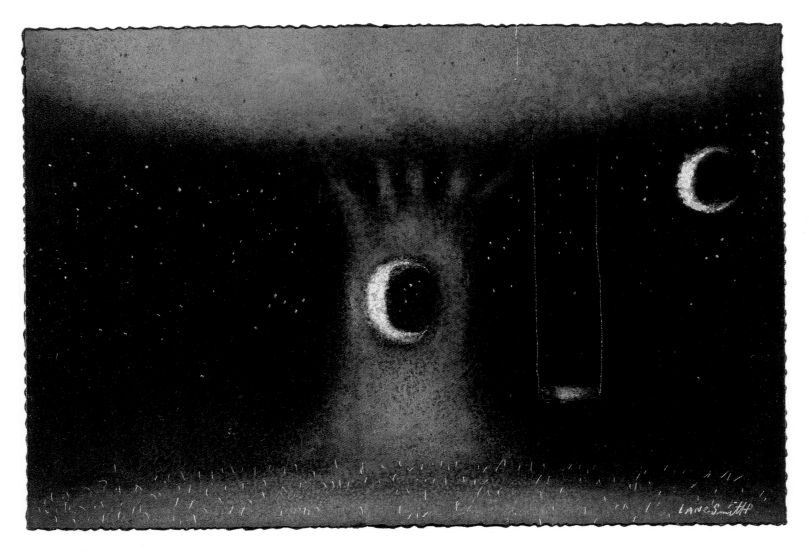

44

ART DIRECTOR
Tina Adamek
PUBLICATION
Postgraduate Medicine
March 1988
PUBLISHING COMPANY
McGraw-Hill, Inc.

Lane Smith

For the clinical article "Peptic Ulcer Disease in Infants and Children," art director and illustrator agreed that the delicate subject matter called for a nonliteral approach. The swing symbolizes childhood, while the hole in the tree represents the ulcer. Medium: Oil.

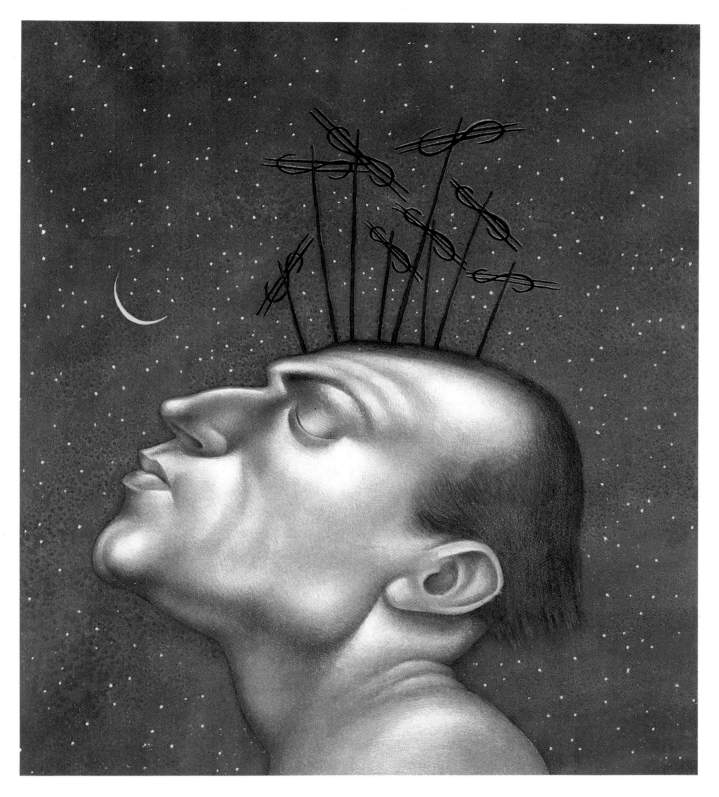

45

ART DIRECTOR
Lucy Bartholomay
DESIGNER
Lucy Bartholomay
PUBLICATION
Boston Globe Magazine
January 24, 1988
PUBLISHING COMPANY
Boston Globe
WRITER
Ed Seigel

Anita Kunz

Anita Kunz created this illustration to parallel the
mood of "The Slumbering Giant: Why T.V. Is So
Timid." Medium: Watercolor and gouache.

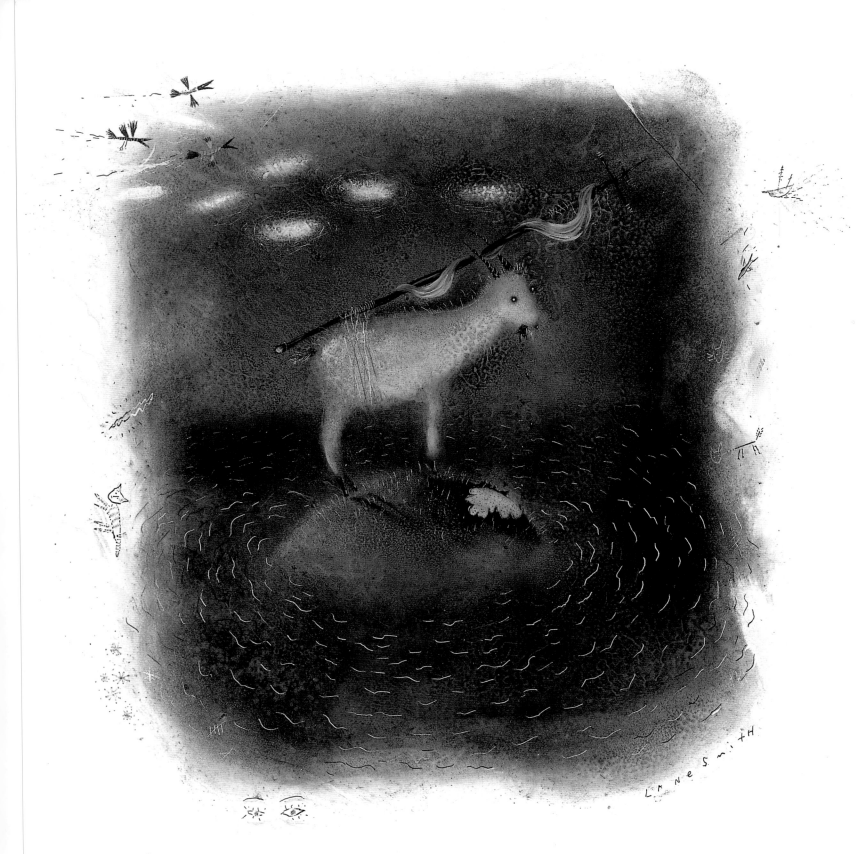

ART DIRECTOR
Lucy Bartholomay
DESIGNER
Gail Anderson
PUBLICATION
Boston Globe Magazine
PUBLISHING COMPANY
Boston Globe
WRITER
Nadine Gordimer

Lane Smith

This illustration accompanied the short story
"Terraloyna." Medium: Oil.

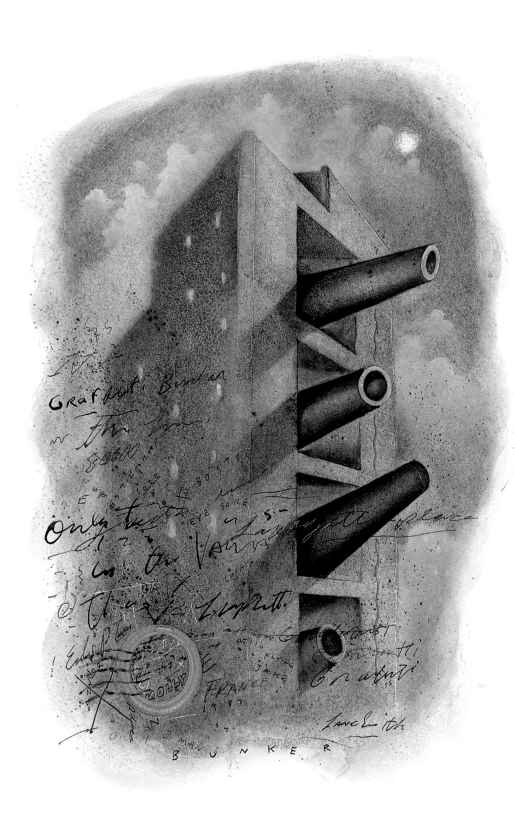

ART DIRECTOR
Lucy Bartholomay
DESIGNER
Lucy Bartholomay
PUBLICATION
Boston Globe Magazine
September 6, 1987
PUBLISHING COMPANY
Boston Globe
WRITER
Renee Loth

Lane Smith

"From Backwater to Backlash" looked at the
buildings Bostonians love to hate. Lane Smith
depicted the "bunker mentality" of Lafayette Place.
Medium: Oil and ink.

ART DIRECTOR
Peter Deutsch
DESIGNER
Peter Deutsch
PUBLICATION
**Quality Review
June 1987**
PUBLISHING COMPANY
**American Society for
Quality Control, Inc.**
WRITER
John Pierson

Lane Smith

The bitter confrontation of a cockfight provided the
perfect symbolism of competition for the article "Is
the Sky Falling on American Competitiveness?"
Medium: Oil.

ART DIRECTOR
Judy Garlan
DESIGNER
Judy Garlan
PUBLICATION
Atlantic Monthly
February 1988
PUBLISHING COMPANY
Atlantic Monthly
WRITER
Seweryn Bailer

Anita Kunz

The difficulty of dealing with bureaucrats was the
subject of "Inside Glasnost." Medium: Watercolor
and gouache.

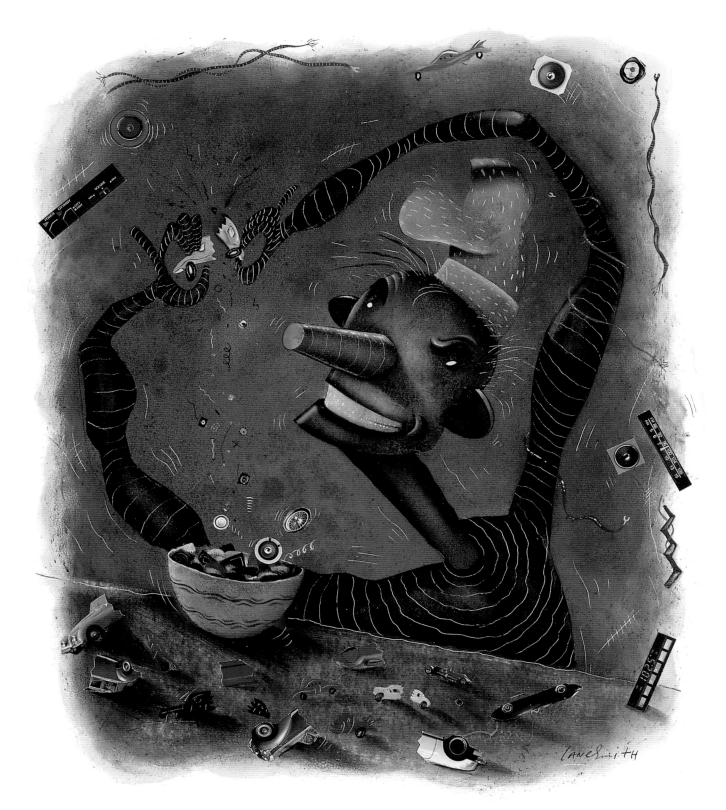

ART DIRECTOR
Margaret Bruen
DESIGNER
Margaret Bruen
PUBLICATION
Car Stereo Review
December 1987
PUBLISHING COMPANY
Diamandis Communications, Inc.
WRITER
Robert Bentley

Lane Smith

Lane Smith's crazed chef breaks cars open like eggs
for "Maximum Security," an article about protecting
cars from thieves. Medium: Oil and collage.

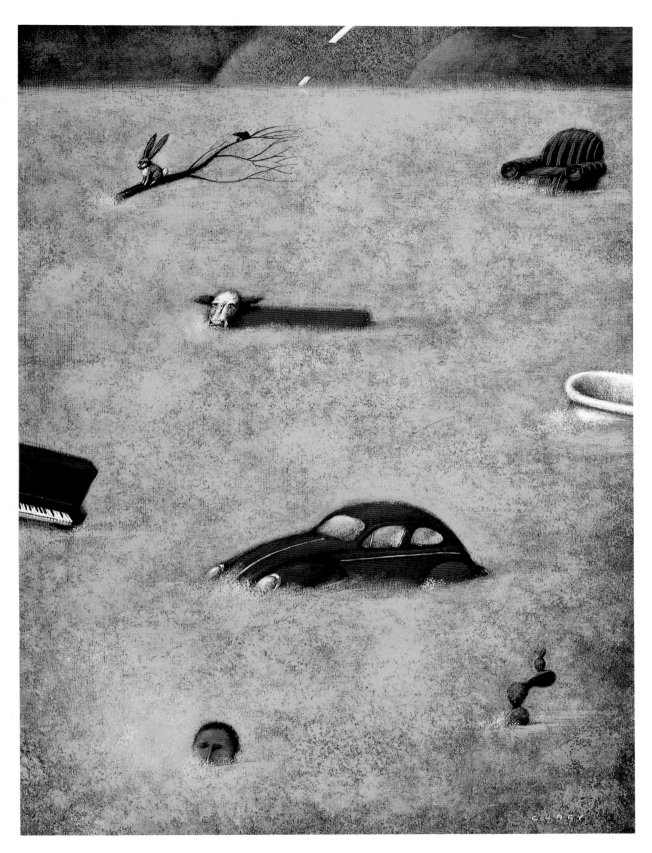

Art Director
D.J. Stout
Publication
Texas Monthly
April 1987
Publishing Company
Texas Monthly, Inc.

Tom Curry

A regular feature called "Texas Primer" used this
image for its piece on flash floods. Medium: Acrylic.

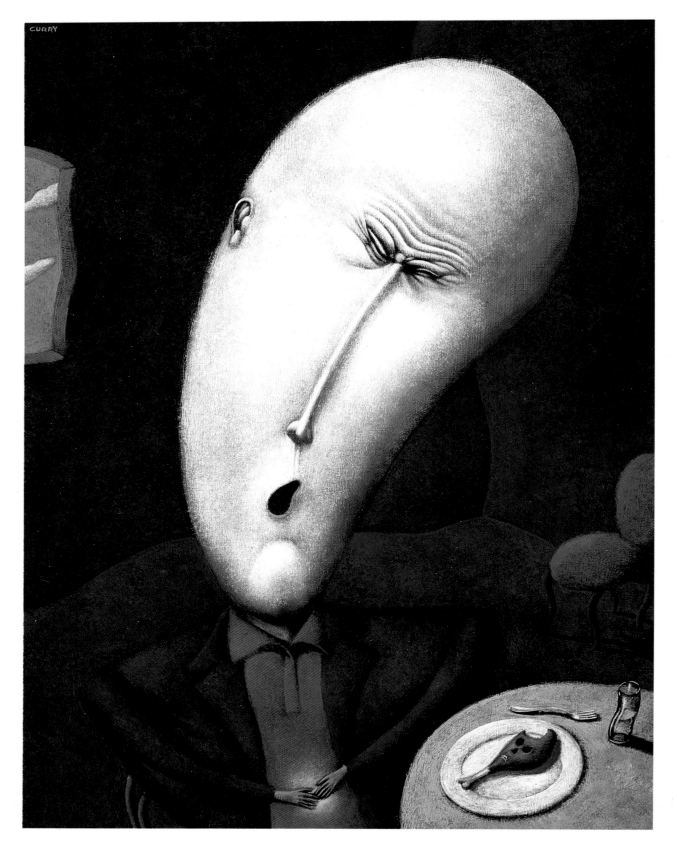

ART DIRECTOR
Jane Palacek
PUBLICATION
**Hippocrates Magazine
November 1987**
PUBLISHING COMPANY
Hippocrates, Inc.

Tom Curry

Tom Curry depicts the agony of food poisoning for
an article on salmonella. Medium: Acrylic.

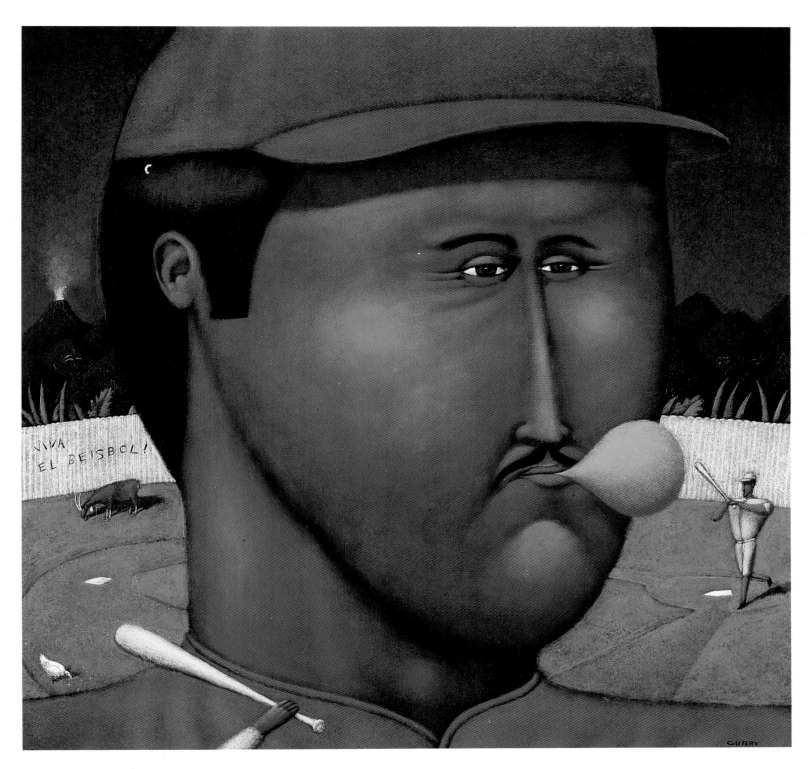

ART DIRECTOR
Louise Kollenbaum
PUBLICATION
Mother Jones
March 1987
PUBLISHING COMPANY
Foundation for National Progress

53

Tom Curry

Professional baseball conquers new territory in "So
Try on Baseball in Central America."
Medium: Acrylic.

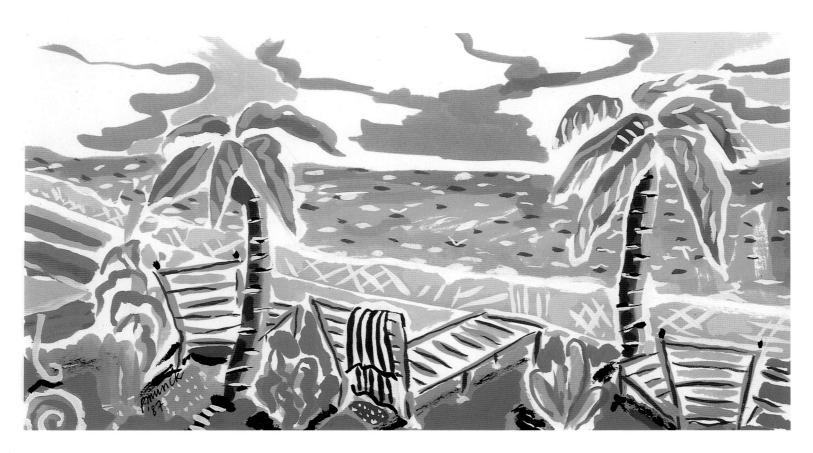

54

ART DIRECTOR
Lucy Bartholomay
DESIGNER
Lucy Bartholomay
PUBLICATION
Boston Globe Magazine
March 15, 1987
PUBLISHING COMPANY
Boston Globe

Paula Munck

The cover of "Adventures in Travel," a special
section on travel in the topics, featured this image.
Medium: Gouache.

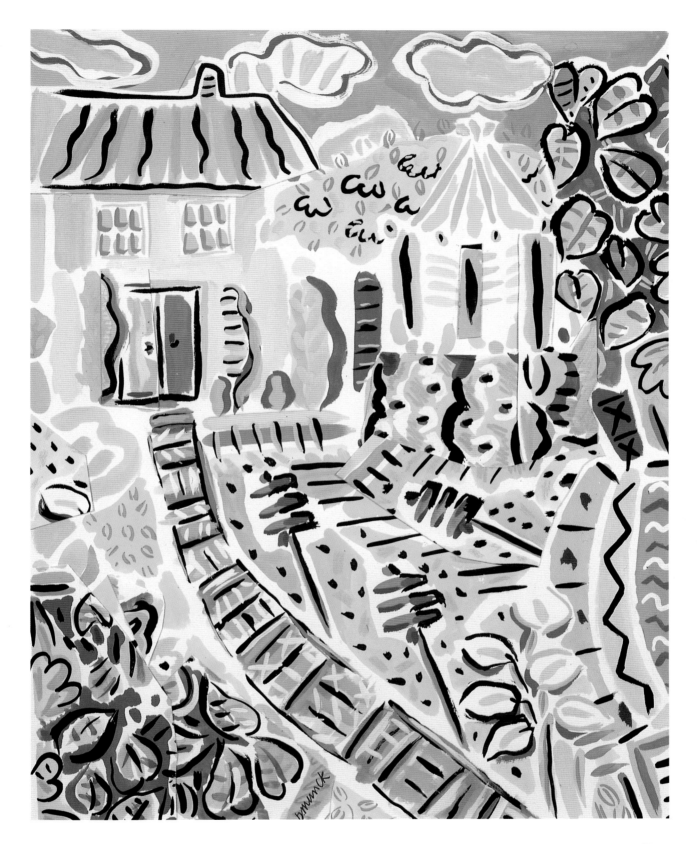

ART DIRECTOR
Aldona Charlton
PUBLICATION
Boston Globe Magazine
May 1987
PUBLISHING COMPANY
Boston Globe
WRITER
Diane Nottle

Paula Munck

"A Little Help in the Yard" offered suggestions for
unmanageable gardens. Medium: Gouache.

56

ART DIRECTOR
Tom Waters
PUBLICATION
Twilight Zone Magazine
February 1988
PUBLISHING COMPANY
Twilight Zone Publications, division of Montcalm
Publishing Corp.
WRITER
Kim Antieau

Scott W. Hunt

"Listening for the General" tells the story of a Latin
general whose ear is cut off and kept by the
resistance so they may hear his thoughts. Scott W.
Hunt's image evokes the macabre quality of the tale
without resorting to literal depiction. Medium:
Black pastel.

ART DIRECTOR
Cynthia Hoffman
PUBLICATION
Chicago Magazine
May 1987
PUBLISHING COMPANY
Metropolitan Communications, Inc.

Anthony Russo
An article in *Chicago* revealed "What Cops Know."
Medium: Acrylic.

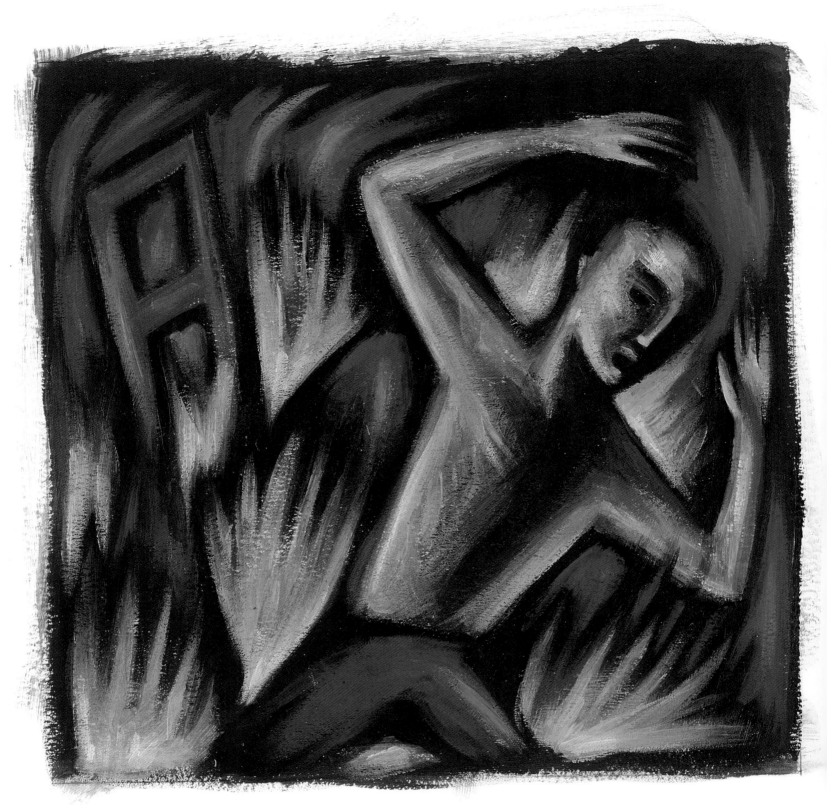

ART DIRECTOR
Fred Woodward

PUBLICATION
Rolling Stone
September 24, 1987

PUBLISHING COMPANY
Straight Arrow Publishers, Inc.

WRITER
Trustman Senger

Anthony Russo

"Trial by Fire" examined the difficulties of a law
student. Medium: Acrylic.

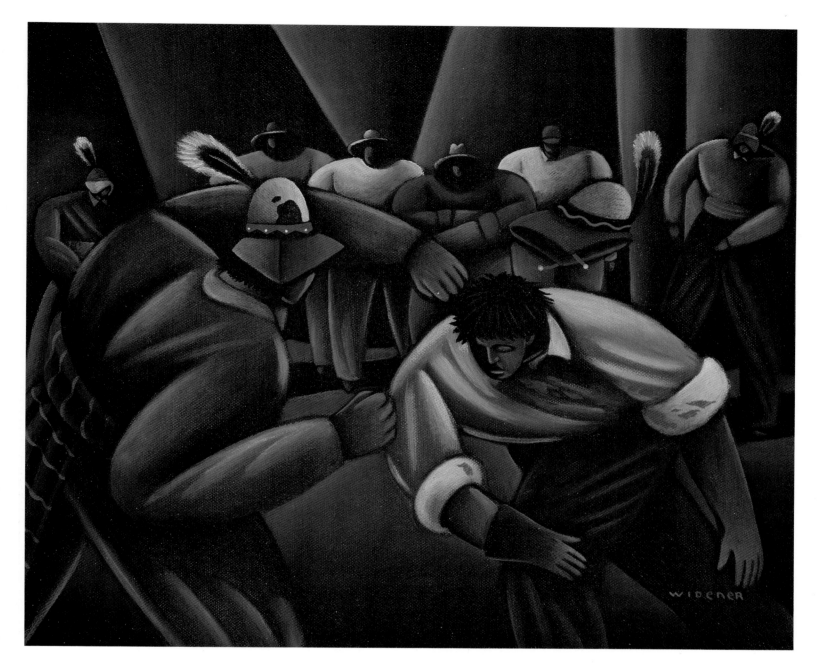

Design Director
Steven Hoffman
Designer
Steven Hoffman
Publication
Sports Illustrated
October 5, 1987
Publishing Company
Time, Inc.
Writer
Gary Smith

Terry Widener

Two images for "The Fiesta in the Town of the
Ghosts" profiled two Indian tribes in the Bolivian
Andes that meet each year for a ritual fist fight.
Medium: Acrylic.

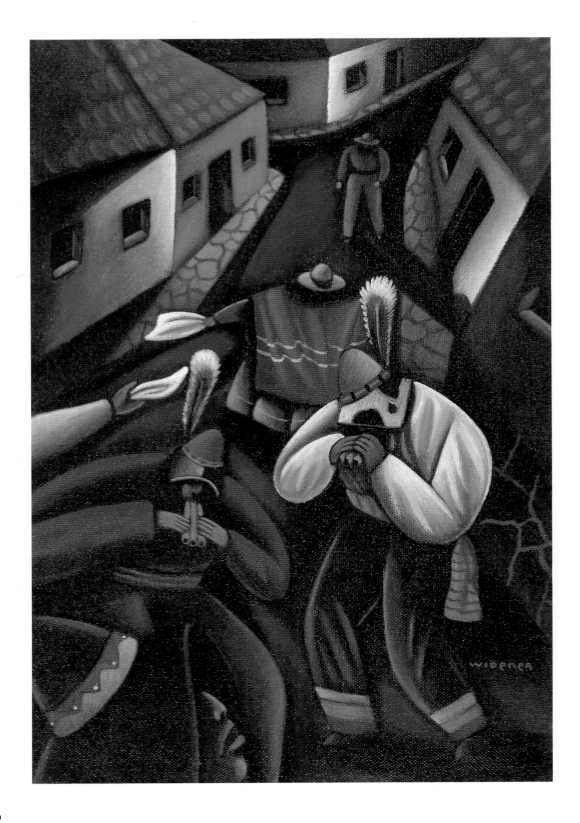

60

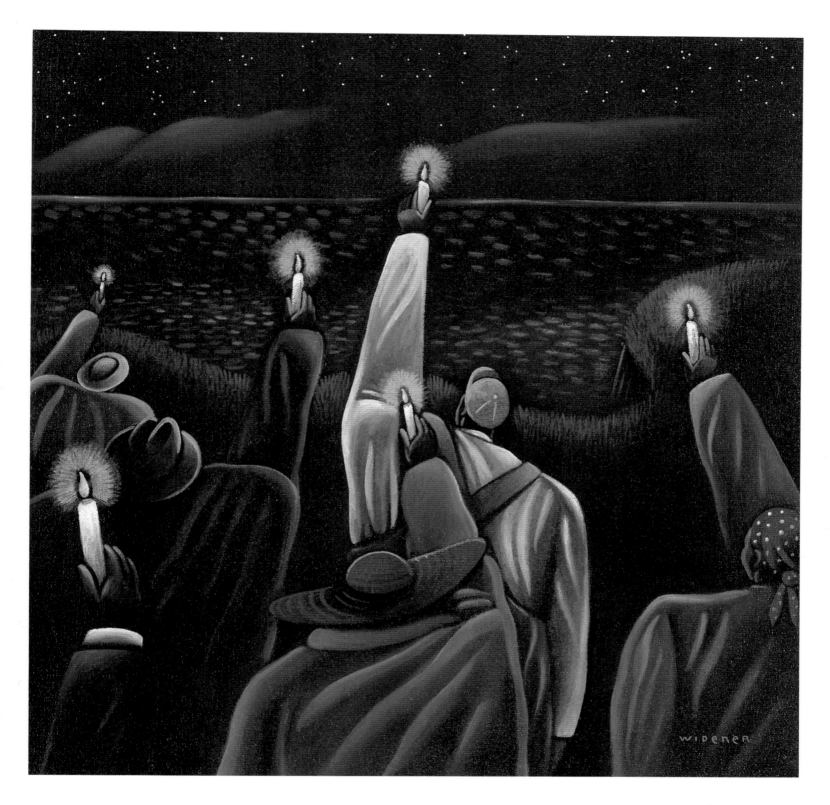

ART DIRECTOR
Steven Hoffman
EDITOR
Eileen Garred
PUBLICATION
**New York University Magazine
Winter 1987**
PUBLISHING COMPANY
New York University
WRITER
Gloria Naylor

Terry Widener

A rural southern Christmas tradition of light and
magic supplied the theme for *Mama Day,* a novel
excerpted in the magazine. Medium: Acrylic.

ART DIRECTOR
Dean Motter
DESIGNER
Dean Motter
PUBLICATION
Vortex
Fall 1987
PUBLISHING COMPANY
Vortex Comics

Maurice Vellekoop

Characters from the Vortex series appear in Maurice
Vellekoop's cover. Medium: Mixed media.

ART DIRECTOR
Dean Motter
DESIGNER
Dean Motter
PUBLICATION
Mister X
PUBLISHING COMPANY
Vortex Comics

Maurice Vellekoop

Characters from the Mister X series appear in
Maurice Vellekoop's cover. Medium: Mixed media.

64

ART DIRECTOR
Tom Russell
DESIGNER
Bett McLean
PUBLICATION
Best of Business Quarterly
PUBLISHING COMPANY
Whittle Communications
WRITER
Yamazaki Masakazu

Melissa Grimes

For "A Strategy for Japan's Survival," Japan is
depicted symbolically accepting goods from other
countries. Medium: Collage, colored paper,
and photocopy.

ART DIRECTOR
Doug Renfro
DESIGNER
Bill McKenney
PUBLICATION
The Big Picture
February – March 1988
PUBLISHING COMPANY
Whittle Communications
WRITER
Jackie Kaufman

John Craig

For "Stacks Alive!" John Craig peopled a library
with famous fictional characters that children were
encouraged to identify. Medium: Collage.

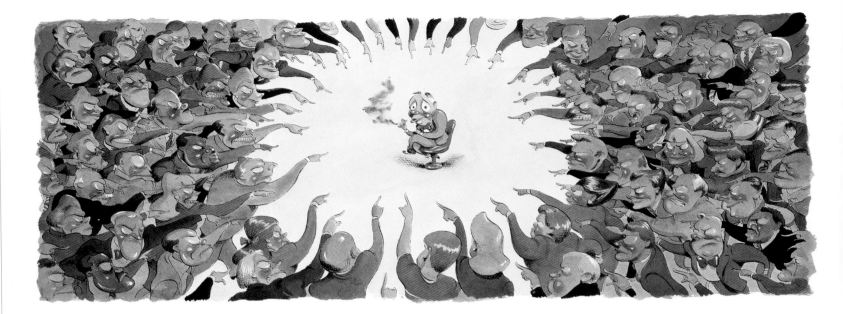

ART DIRECTOR
Rudy Hoglund
DESIGNER
Arthur Hochstein
PUBLICATION
Time Magazine
February 23, 1987
PUBLISHING COMPANY
Time, Inc.
WRITER
Otto Friedrich

Michael Witte

A humorous look at the serious crusade against smoking in public appeared in "Where There's Smoke." Medium: Watercolor and pen and ink.

ART DIRECTOR
Gina Davis
DESIGNER
Gina Davis
PUBLICATION
Savvy Magazine
June 1987
PUBLISHING COMPANY
Family Media, Inc.
WRITER
Emily Prager

Tim Gabor

Tim Gabor's illustration for a book review of *About
Men: Reflections on the Male Experience* (compiled from
the "About Men" column of the *New York Times*
magazine) highlighted the conflict between
boyhood and manhood. Medium: Colored pencil.

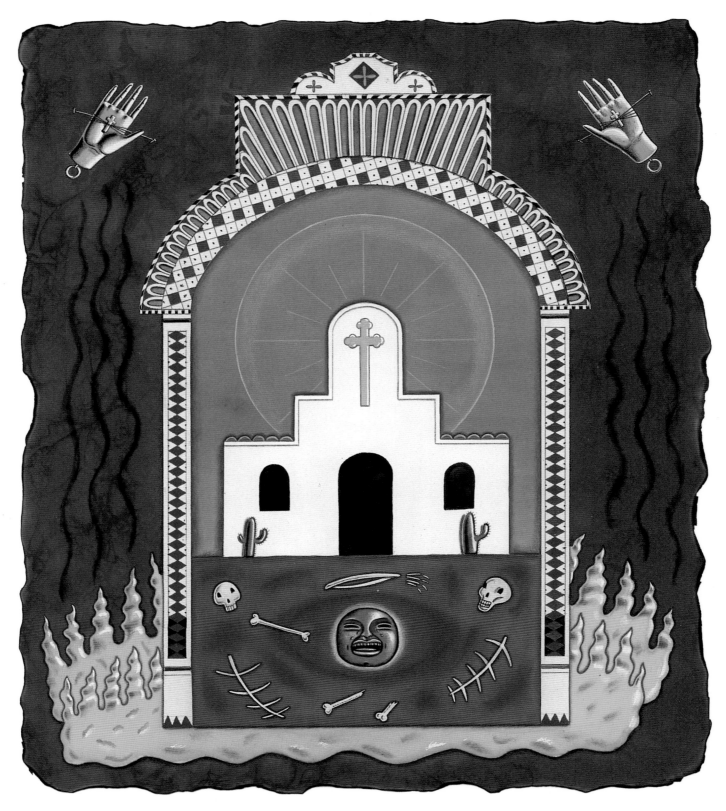

Designer
Gail Anderson
Publication
Boston Globe Magazine
September 1987
Publishing Company
Boston Globe
Writer
Norman Boucher

Jamie Bennett

"The Politics of Sainthood" looked at Junipero
Serra, an eighteenth-century Franciscan padre who
is under consideration for sainthood. Medium: Dyes
and found objects.

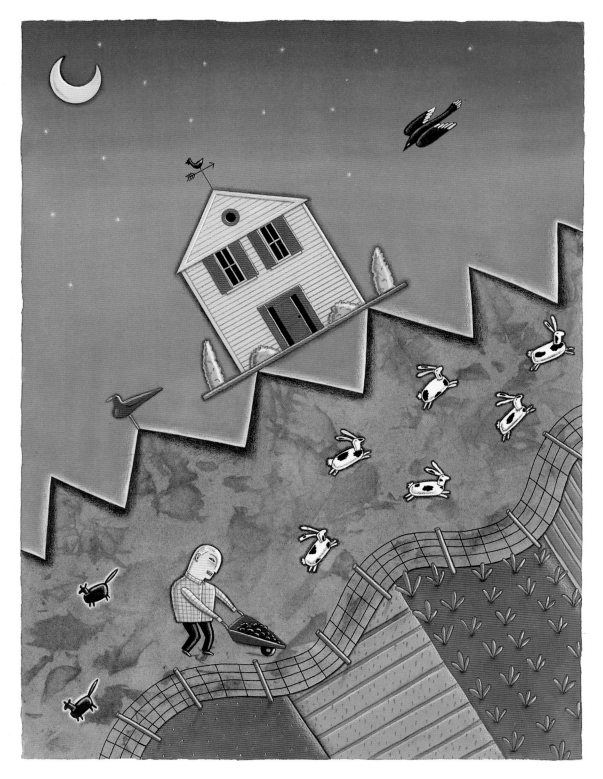

ART DIRECTOR
Deb Hardison
DESIGNER
Bett McLean
PUBLICATION
Connecticut's Finest
March 1987
PUBLISHING COMPANY
Whittle Communications
WRITER
Howard Fast

Jamie Bennett

To emphasize the tension in forcing a house and
garden into an unsuitable environment, Jamie
Bennett utilized sharp angles and texture in an
image for "Almost Eden." Medium: Watercolor.

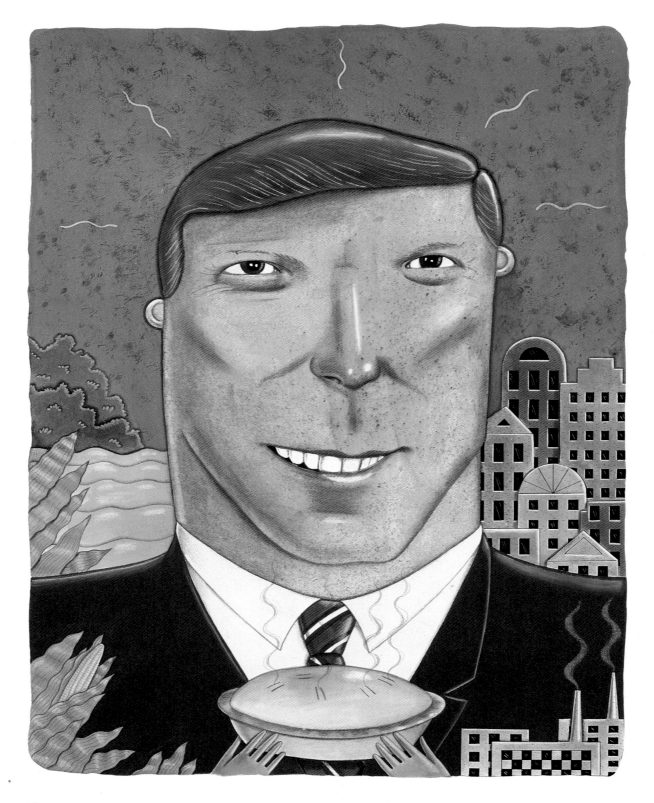

ART DIRECTOR
Rip Georges
DESIGNER
Rip Georges
PUBLICATION
Regardie's Magazine
December 1987
PUBLISHING COMPANY
Regardie's Magazine, Inc.
WRITER
Ron Dorfman

Jamie Bennett

Jamie Bennett's portrait of candidate Richard
Gephardt appeared in "Presidential Sweepstakes."
Medium: Dyes.

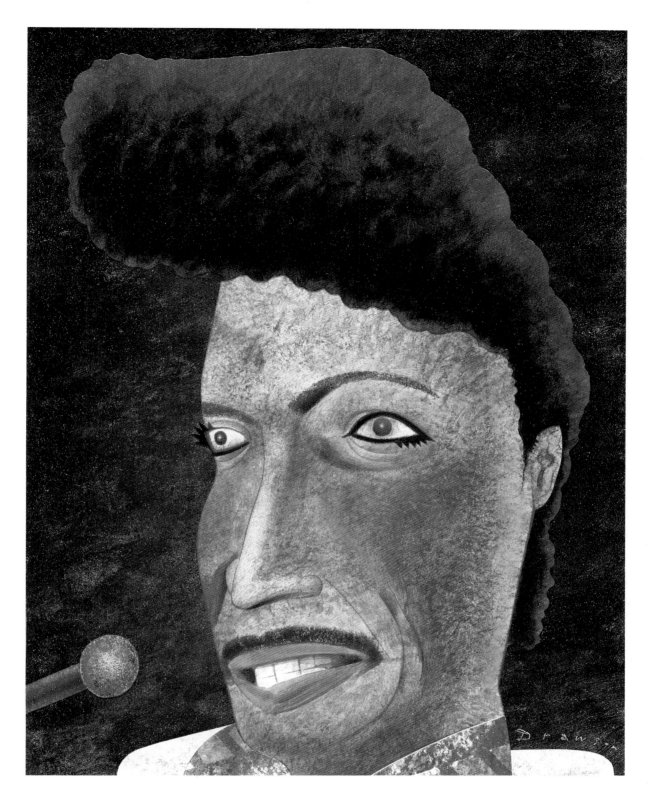

Art Director
Tom Staebler
Designer
Bruce Hansen
Publication
Playboy
July 1987
Publishing Company
Playboy Enterprises, Inc.
Writer
John Waters

Blair Drawson

"Little Richard Happy At Last" featured this portrait
of the star. Medium: Acrylic on paper, mounted on
panel.

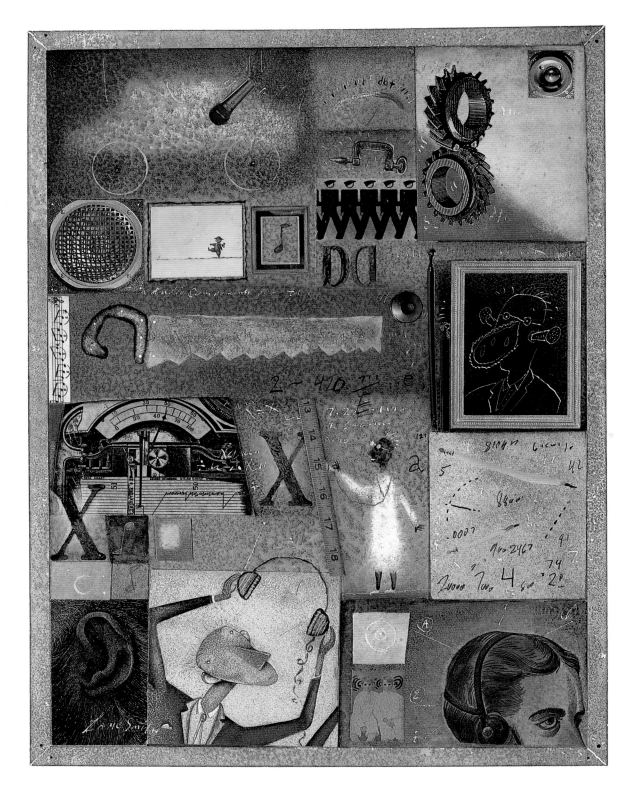

ART DIRECTOR
Sue Llewellyn
DESIGNER
Sue Llewellyn
PUBLICATION
Car Stereo Review
February 1988
PUBLISHING COMPANY
Diamandis Communications, Inc.
WRITER
Ken Pohlmann

Lane Smith

Lane Smith created this image for "Inside the
O.E.M. Labs," an article describing new techniques
behind factory-installed car stereo systems.
Medium: Oil and collage.

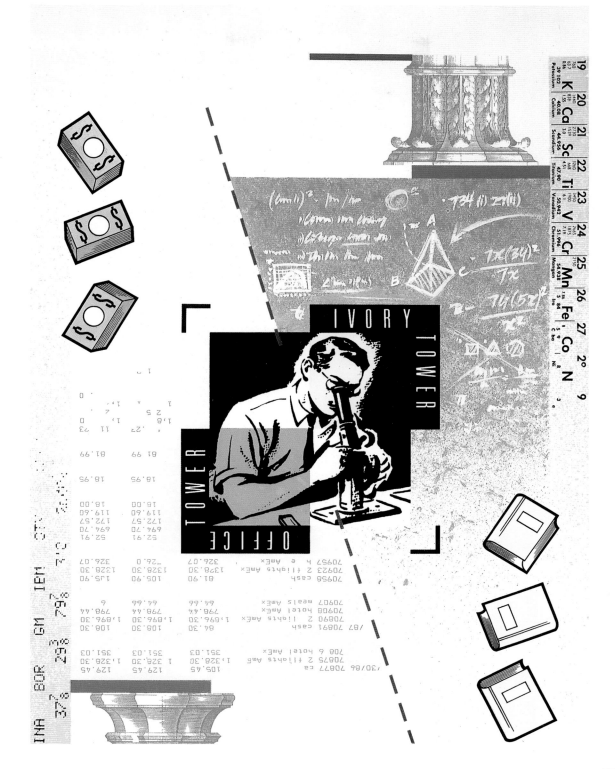

Art Director
Jim Ireland
Designer
Christine Higdon
Publication
Canadian Business Magazine
January 1988
Publishing Company
Canadian Business Media
Writer
David Helwig

Bob Hambly

"Office Tower/Ivory Tower" examined the conflict
between the world of pure academics and the need
to raise university money and provide new ideas for
businesses. Medium: Mixed media.

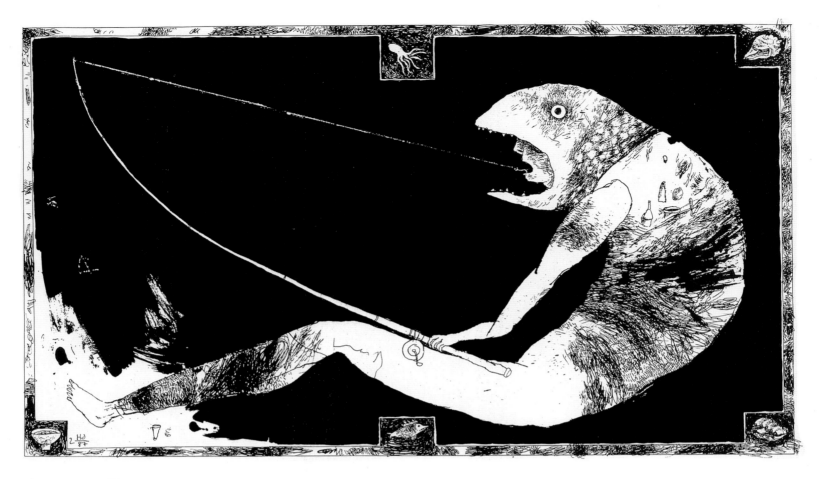

74

ART DIRECTOR
Lucy Bartholomay
DESIGNER
Lucy Bartholomay
PUBLICATION
Boston Globe Magazine
October 18, 1987
PUBLISHING COMPANY
Boston Globe
WRITER
Jerry Ackerman

Henrik Drescher

The article "Deep Trouble" featured this illustration.
Medium: Pen and ink.

ART DIRECTOR
Judy Garlan
DESIGNER
Judy Garlan
PUBLICATION
Atlantic Monthly
February 1988
PUBLISHING COMPANY
Atlantic Monthly
WRITER
T. Coraghessan Boyle

Bill Vuksanovitch

Bill Vuksanovitch captured a moment from
"Sinking House," a short story about a woman who
responds to the death of her husband by calmly
flooding her house. Medium: Pencil.

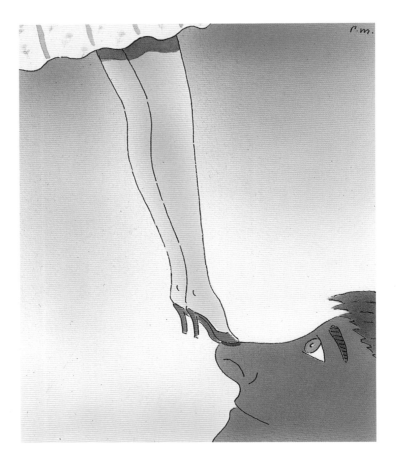

76

ART DIRECTOR
Wendall K. Harrington
DESIGNER
John Bark
PUBLICATION
Esquire
September 1987
PUBLISHING COMPANY
Hearst Corporation
WRITER
Nora Ephron

Paul Meisel

"Ms. Grossberg's Legs" told the tale of a married
man attracted to his divorced neighbor.
Medium: Ink.

DESIGNER
Peter Deutsch
EDITOR
Jerry G. Bowles
PUBLICATION
Quality Review
Spring 1987
PUBLISHING COMPANY
American Society for Quality Control, Inc.
WRITER
Thomas Hine

Guy Billout

The American consumer attitude toward product
reliability is given an ironic twist in Guy Billout's
illustration for the article "Reliability in a
Throwaway Society." Medium: Watercolor and ink.

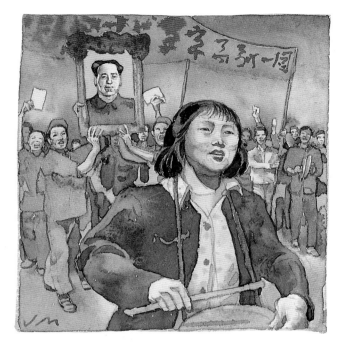

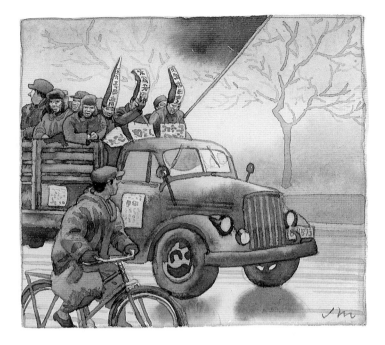

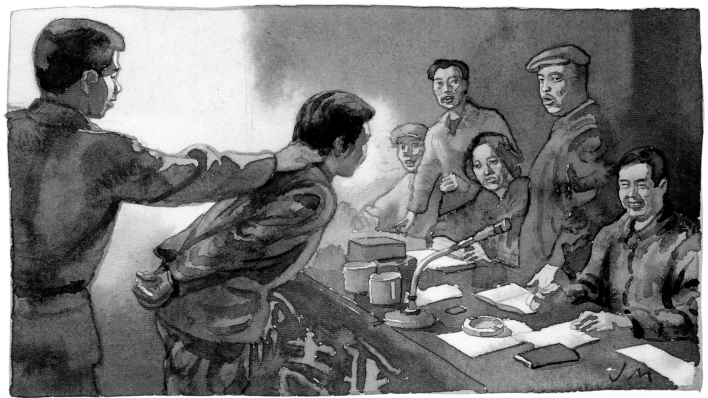

ART DIRECTOR
Rudy Hoglund
DESIGNER
Tom Bentkowski
EDITOR
Ron Kriss
PUBLICATION
Time Magazine
June 8, 1987
PUBLISHING COMPANY
Time, Inc.
WRITER
Nien Cheng

James McMullan

James McMullan's powerful images illustrate "Life
and Death in Shanghai," from a special section of
Time. Medium: Watercolor.

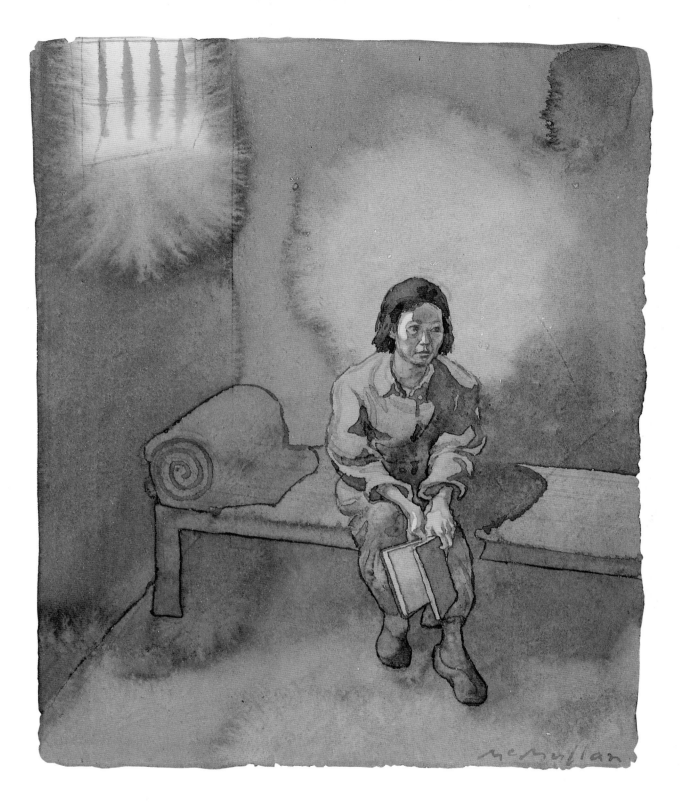

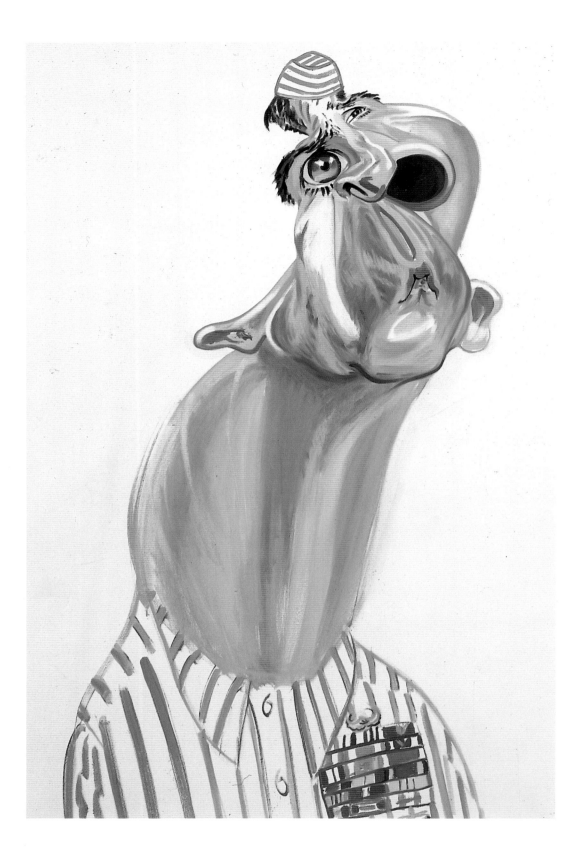

ART DIRECTOR
Fred Woodward
PUBLICATION
Rolling Stone
December 1987
PUBLISHING COMPANY
Straight Arrow Publishers, Inc.

Philip Burke
"Stars and Stripes Forever" in the National Affairs
section featured this view of Oliver North.
Medium: Oil.

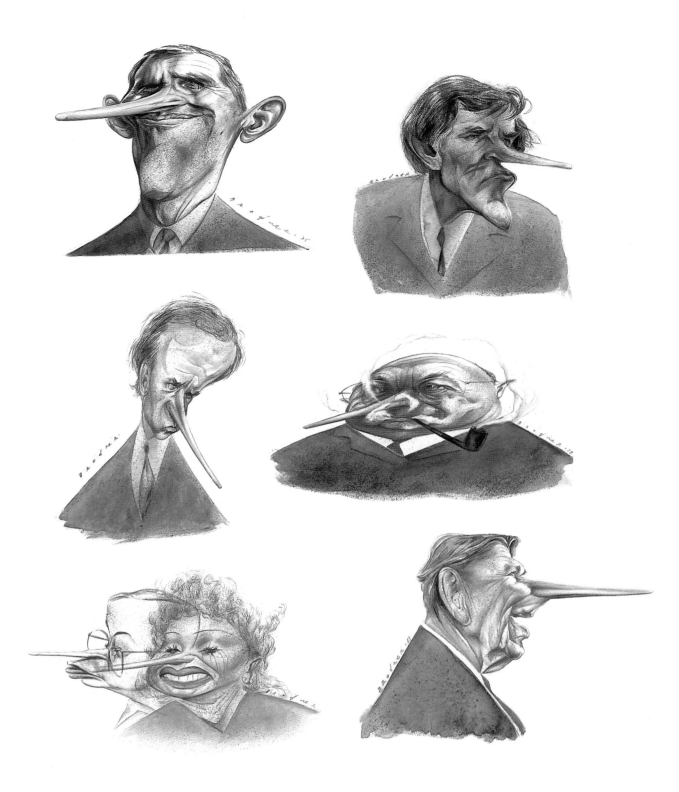

Art Director
Michael Walsh
Publication
**Washington Post Magazine
December 27, 1987**
Publishing Company
Washington Post

Steve Brodner

"The Year of the Big Lie" presented "Academy
Awards of Untruth" to some notorious public
figures. The winners for 1987 included Oliver
North, Gary Hart, Joe Biden, John Poindexter, Jim
and Tammy Bakker, and Ronald Reagan.
Medium: Watercolor.

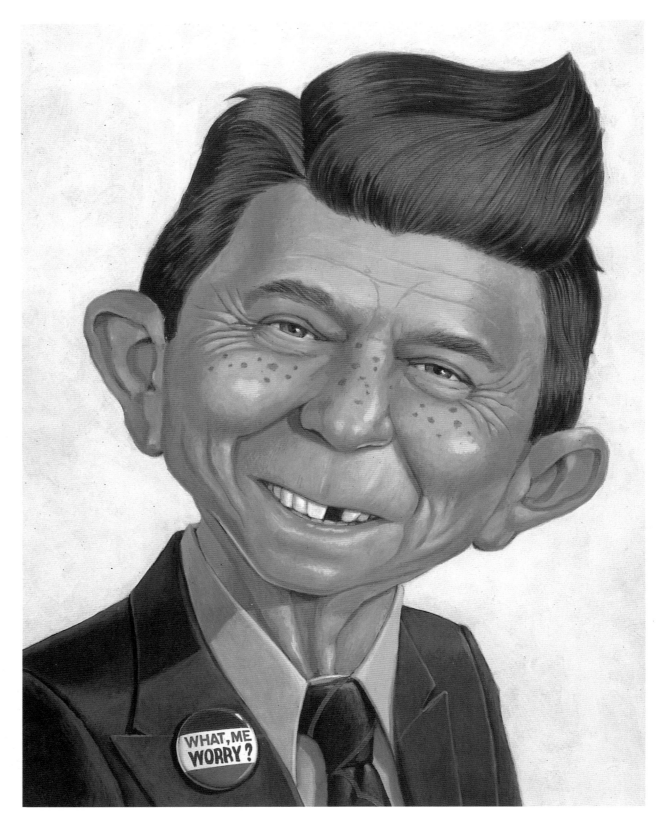

ART DIRECTOR
Fred Woodward

PUBLICATION
Regardie's Magazine

PUBLISHING COMPANY
Regardie's Magazine, Inc.

Steve Pietzsch

"Altered Egos" envisioned Ronald Reagan as Alfred
E. Newman. Medium: Acrylic on paper.

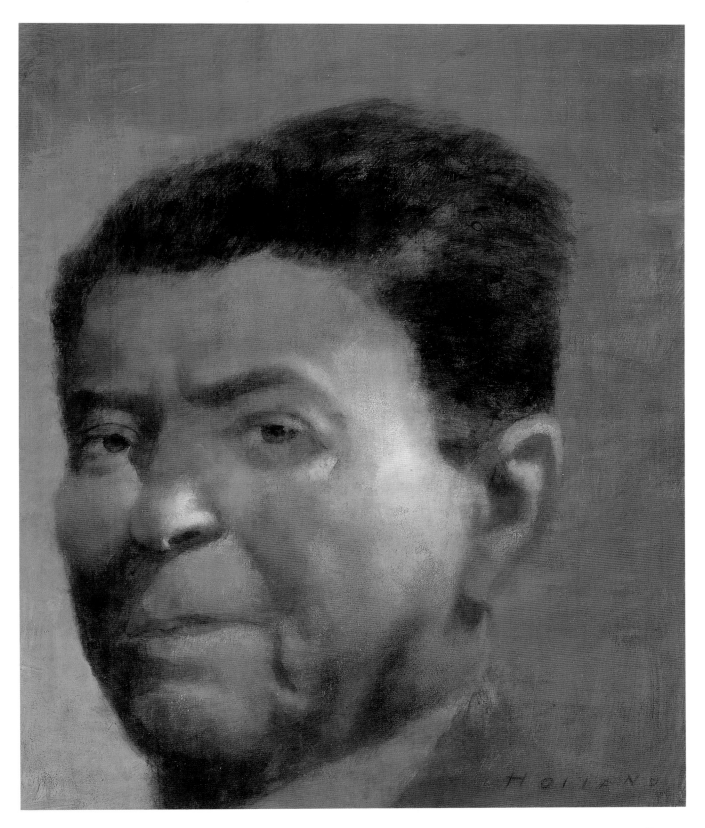

83

ART DIRECTOR
Fred Woodward
PUBLICATION
Rolling Stone
February 25, 1988
PUBLISHING COMPANY
Straight Arrow Publishers, Inc.
WRITER
Frances Fitzgerald

Brad Holland

"Death of a Salesman" examined political failings.
Medium: Acrylic.

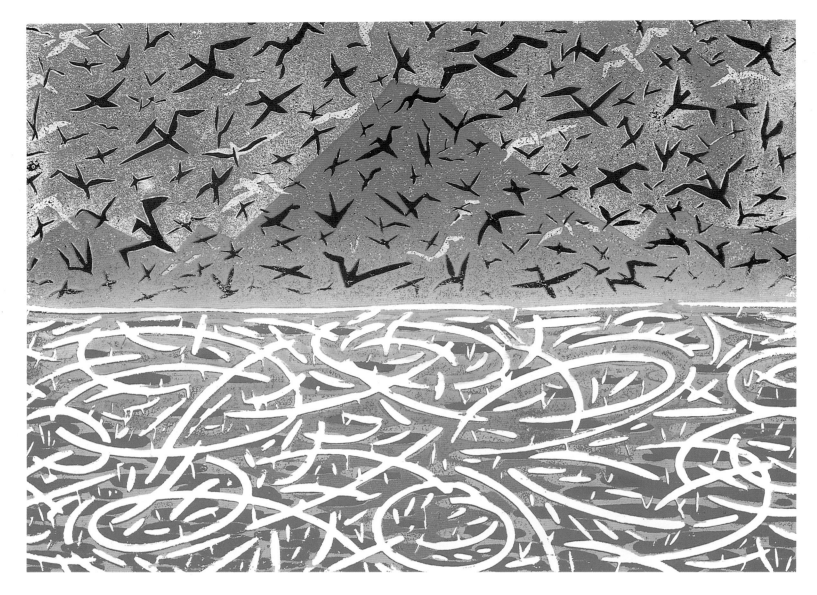

84

ART DIRECTOR
Lloyd Ziff
DESIGNER
Lloyd Ziff
PUBLICATION
Condé Nast Traveler
PUBLISHING COMPANY
Condé Nast Publications, Inc.

Mick Haggerty

Mick Haggerty did this illustration on location as
part of a visual diary of a trip down the Baja
Peninsula for "Off the Road to Baja." Medium:
Block print.

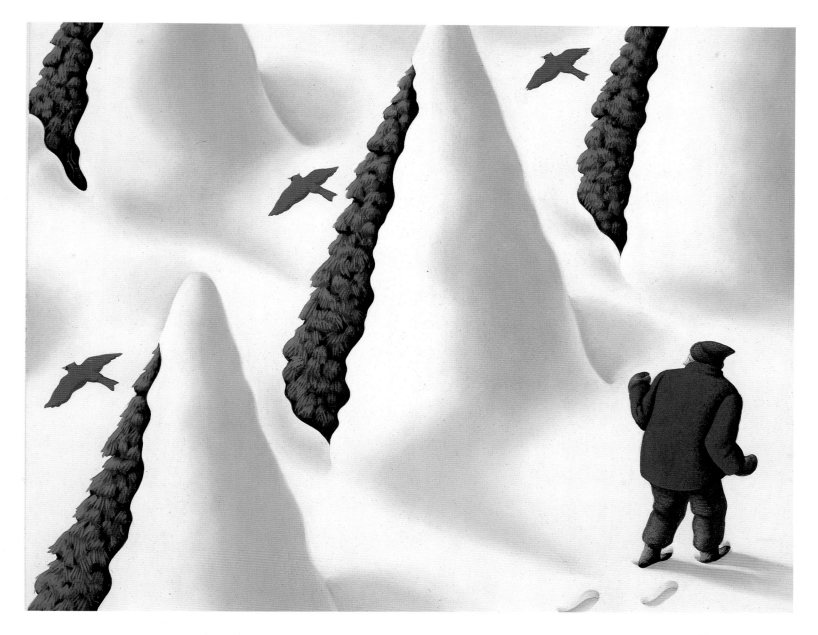

ART DIRECTOR
Kat Dalton
PUBLICATION
Living Bird Quarterly
Autumn 1987
PUBLISHING COMPANY
Laboratory of Ornithology,
Cornell University
WRITER
Michael Harwood

Steve Carver

To emphasize the contrast between the birds and the stark whiteness of the landscape, color was kept limited in illustrations for the story "A Birder's Notebook." Medium: Acrylic and alkyd.

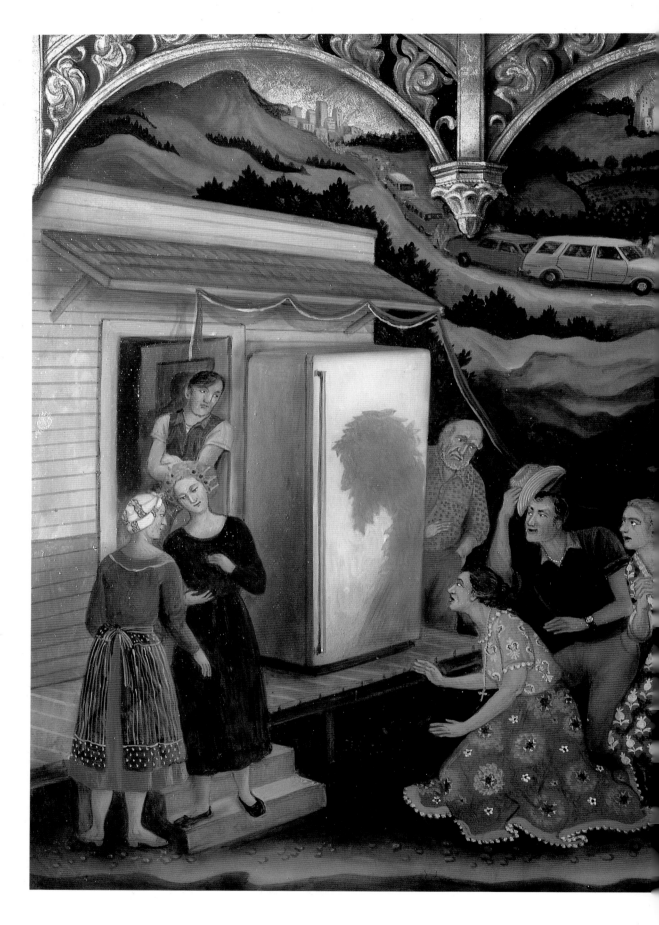

86

ART DIRECTOR
Wendall K. Harrington
DESIGNER
John Bark
PUBLICATION
Esquire
December 1987
PUBLISHING COMPANY
Hearst Corporation

Kinuko Y. Craft

A crowd admires "A Modern Miracle." Medium:
Oil, watercolor, egg tempera, and gold leaf.

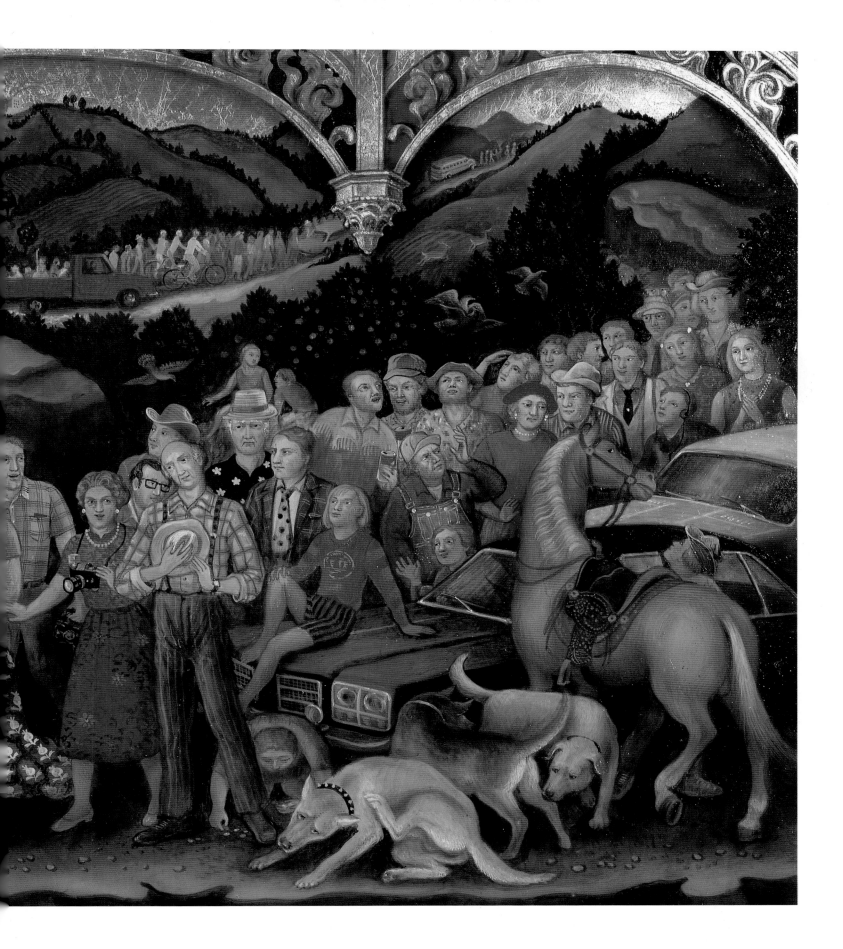

88

ART DIRECTOR
Teresa Fernandes
DESIGNER
Teresa Fernandes
PUBLICATION
Toronto Life Magazine
November 1987
PUBLISHING COMPANY
Toronto Life Publishing Co.

Sandra Dionisi

Sandra Dionisi created visual captions that were used as standing art for "Epicure," the regular feature cuisine section. Medium: Watercolor and gouache.

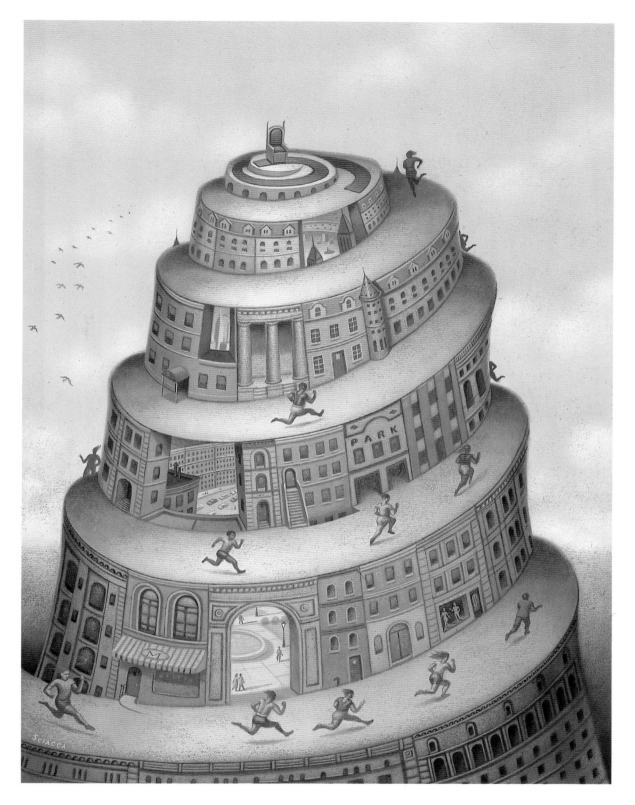

ART DIRECTOR
Richard Mantel
DESIGNER
Richard Mantel
PUBLICATION
New York Magazine
October 26, 1987
PUBLISHING COMPANY
New York Magazine

Tom Sciacca

Tom Sciacca combined the racer theme with sites of
Manhattan for a special advertising section on the
New York City Marathon. Medium:
Acrylic on ragboard.

ART DIRECTOR
Lesley Winson
DESIGNER
Lesley Winson
PUBLICATION
**Details Magazine
March 1988**
PUBLISHING COMPANY
Condé Nast Publications, Inc.

Isabelle Dervaux

The crowd at a spring fashion show admires a Jean-Paul Gaultier design in Isabelle Dervaux's cover illustration. Medium: Brush and ink and pantone color film.

ART DIRECTOR
Teresa Fernandes
DESIGNER
S. Dale Vokey
PUBLICATION
Toronto Life Magazine
January 1988
PUBLISHING COMPANY
Toronto Life Publishing Co.
WRITER
Samuel Ryan

Jeff Jackson

"Where Do Our Restaurant Critics Eat?" asked an
article about dining out in Toronto. Medium:
Pastels and ink.

92

ART DIRECTOR
Paul Hartley
DESIGNER
Hayes Henderson
PUBLICATION
Rebel Arts and Literature Magazine
March 1988
PUBLISHING COMPANY
East Carolina University Press

Hayes Henderson

For an open assignment dealing with different
forms of communication out of context, Hayes
Henderson painted this from photos of black-and-
white movies on T.V. and color negatives. Medium:
Oil glaze on board.

93

Art Director
Doug Turshen
Designer
Doug Turshen
Publication
Child
March–April 1988
Publishing Company
New York Times Magazine Group
Writer
R. Casey

Isabelle Dervaux

Isabelle Dervaux sought the feelings of a child's
pop-up anatomy book for the opening page of a
special report on children's health. Medium: Pen and
ink and collage.

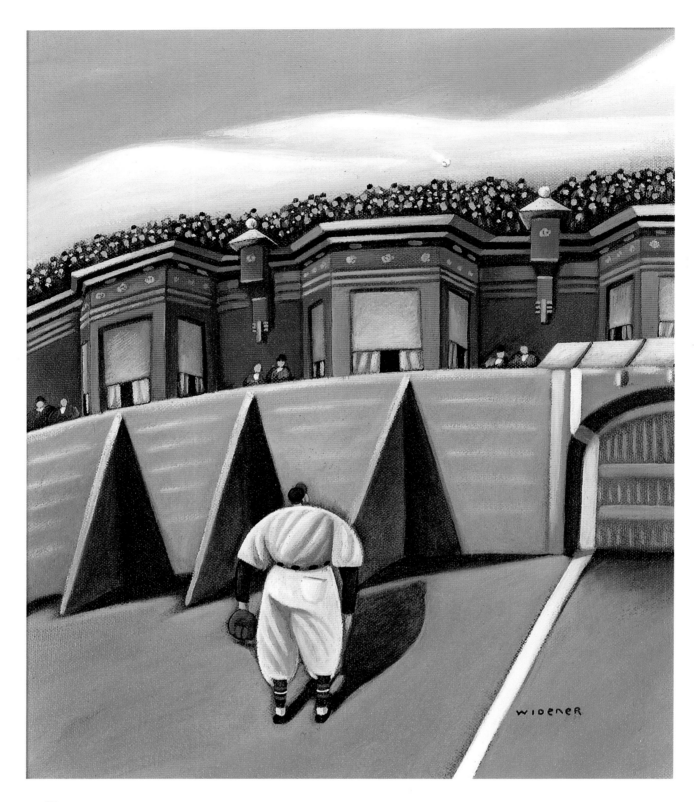

DESIGN DIRECTOR
Steve Hoffman
DESIGNER
Edward Truscio
PUBLICATION
Sports Illustrated
August 17, 1987
PUBLISHING COMPANY
Time, Inc.
WRITER
Noel Hynd

Terry Widener

The right field wall of a baseball stadium in
Philadelphia was the subject of "Shibe Park."
Medium: Acrylic.

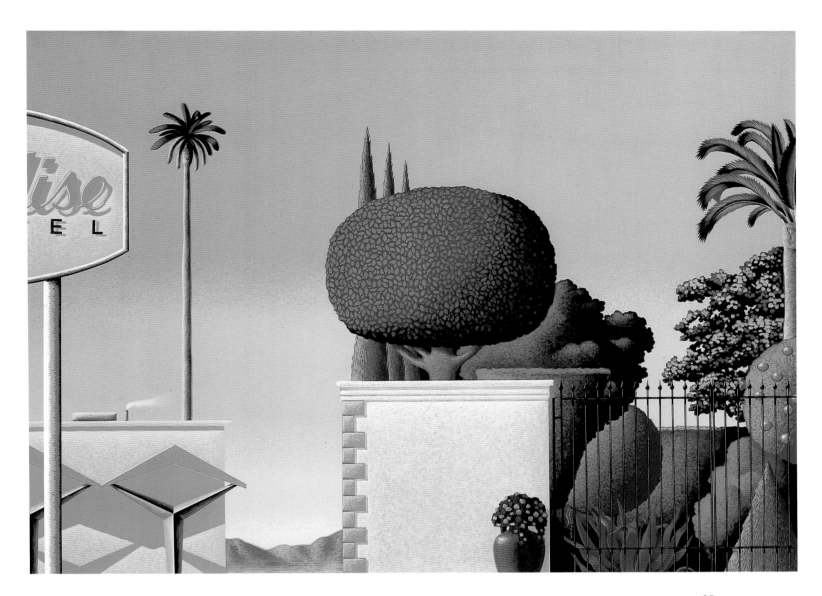

95

Art Director
Lynn Staley
Publication
Boston Globe
March 1988
Publishing Company
Boston Globe

Steve Carver

"Secret Gardens of L.A." explored hidden
attractions in contrast to the more typical tourist
spots of southern California. Medium: Acrylic and
alkyd.

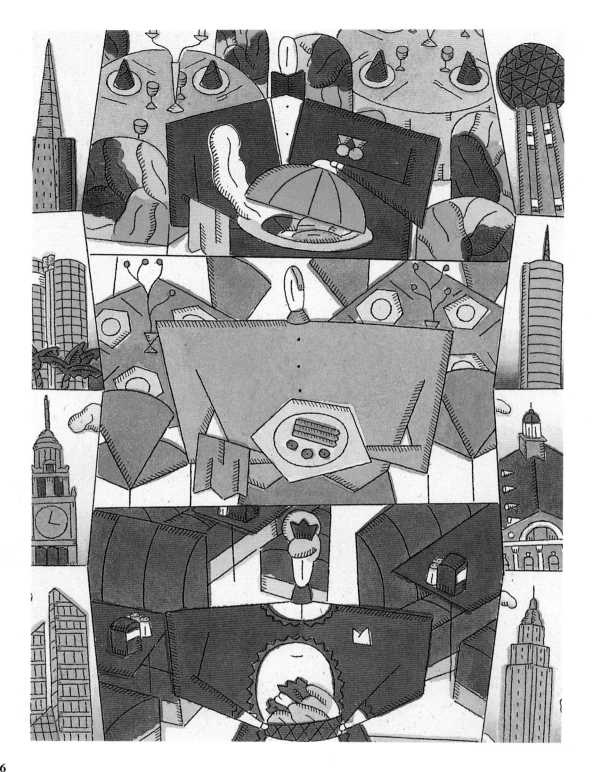

96

ART DIRECTOR
Linda Stillman
DESIGNER
Linda Stillman
PUBLICATION
Tiffany Magazine
Fall-Winter 1987
PUBLISHING COMPANY
Tiffany and Co.
WRITERS
Michael Batterberry and
Ariane Batterberry

Philippe Weisbecker

Three different types of restaurants — the old
guard, the avant-garde, and local flavor — are
shown with key landmarks representing eight
different cities for "The Tiffany Traveler Dines Out."
Medium: Watercolor and pen and ink.

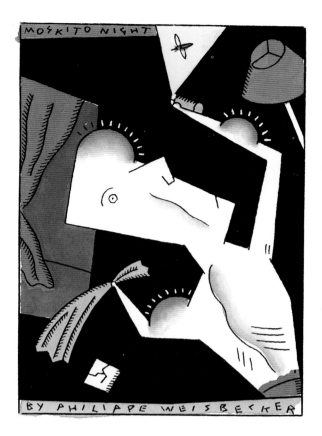

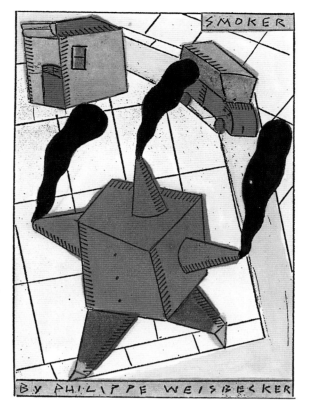

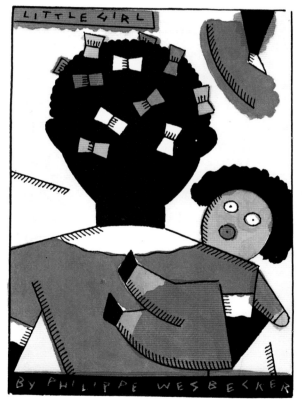

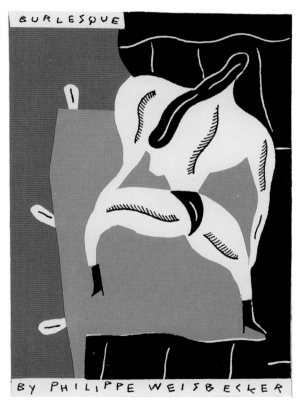

PUBLICATION
Village Voice

PUBLISHING COMPANY
Village Voice Corporation

Philippe Weisbecker

Philippe Weisbecker contributes the well-known
back page illustrations in the *Village Voice*; seen here
are *Moskito Night,* from the August 25, 1987 issue;
Smoker, from April 7, 1987; *Little Girl,* from July
28, 1987; and *Burlesque,* from the June 10, 1987 issue.
Medium: Watercolor and pen and ink.

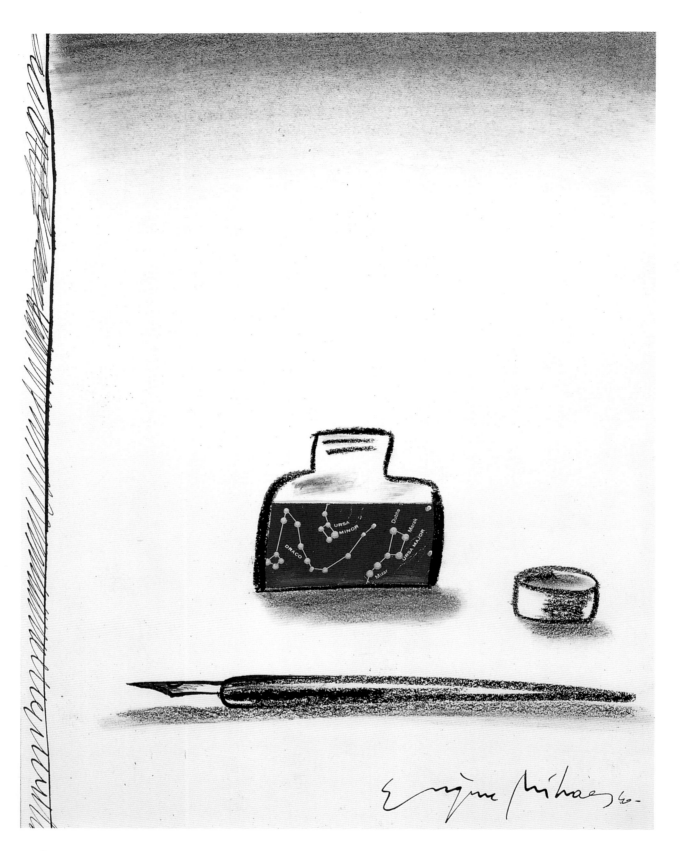

ART DIRECTOR
Lee Lorenz
PUBLICATION
The New Yorker
January 25, 1988
PUBLISHING COMPANY
The New Yorker, Inc.

Eugene Mihaesco

Eugene Mihaesco was given free rein in designing
this *New Yorker* cover. Medium: Pastel and
pen and ink.

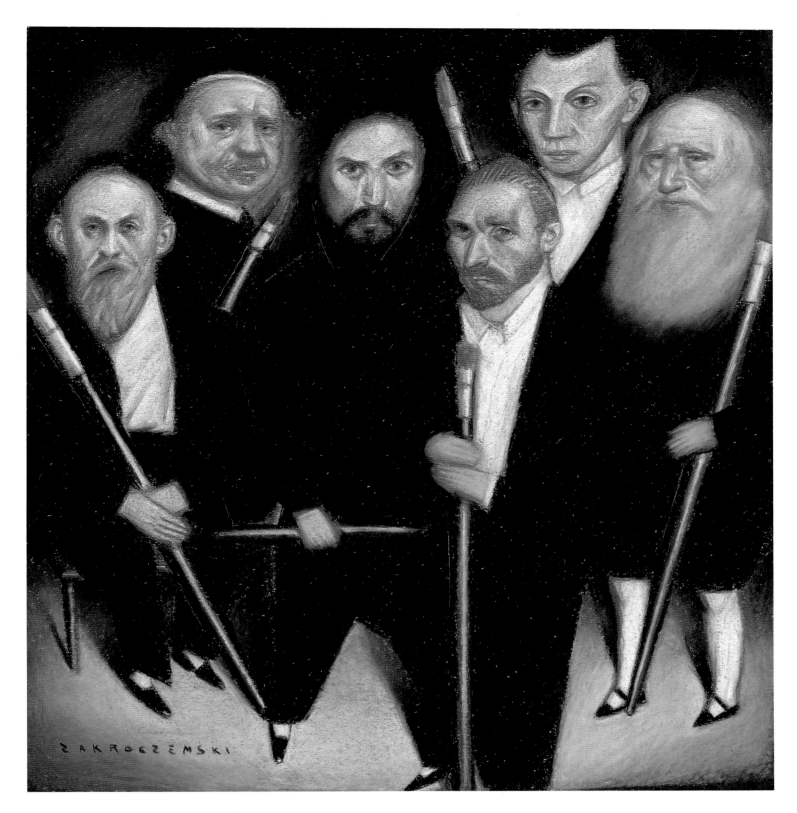

ART DIRECTOR
Tim A. Frame
PUBLICATION
Connections
April 1988
PUBLISHING COMPANY
Whittle Communications
WRITER
Suzanne Harper

Daniel Zakroczemski

Six of the masters — Monet, Mondrian,
Rembrandt, van Gogh, Picasso, da Vinci — meet for
a group portrait for "Who's Who in Art History."
Medium: Prismacolor.

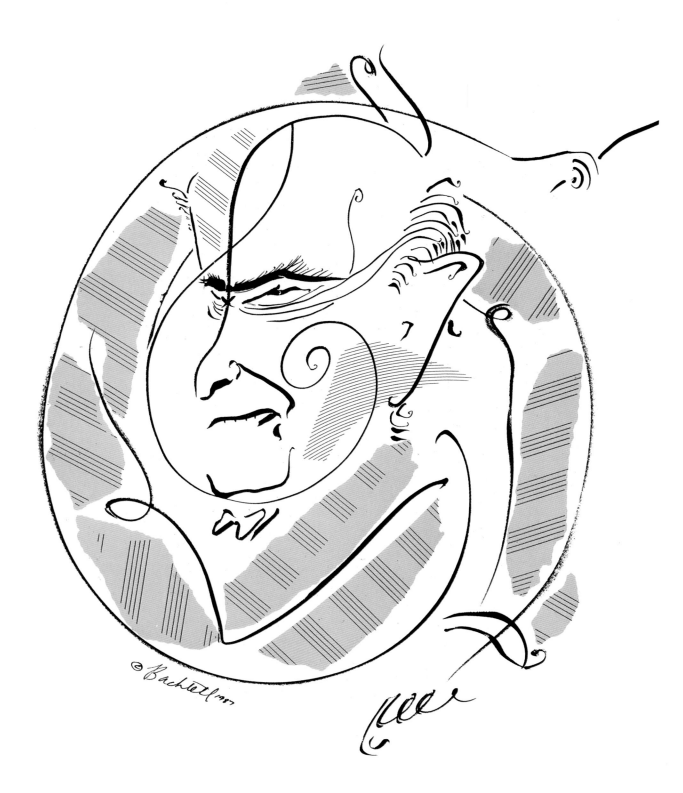

ART DIRECTOR
Cynthia Hoffman
PUBLICATION
Chicago Magazine
October 1987
PUBLISHING COMPANY
Metropolitan Communications, Inc.
WRITER
Phillip Huscher

Tom Bachtell

Working outward from the treble clef, Tom Bachtell
composed a portrait of Sir Georg Solti for
"Marketing the Maestro," an article on the
conductor's seventy-fifth birthday celebrations.
Medium: Ink and cut paper.

Art Director
Scott Mires

Designer
Scott Mires

Publication
**Dance Exercise Today
June–July 1987**

Publishing Company
International Dance Association

Writer
Patricia Loverock

James Staunton

A fit, attractive woman gazes at a grotesquely distorted self-image, in an illustration for "Beauty or Beast," an article about women in good physical shape who see themselves as fat and unattractive. Medium: Watercolor and colored pencil.

ART DIRECTOR
Gina Davis
DESIGNER
John Lee
PUBLICATION
Savvy Magazine
February 19, 1988
PUBLISHING COMPANY
Family Media, Inc.
WRITER
Eric Berg

Juan Botas

The artist's own anxiety over income taxes provided
inspiration for an image to accompany "Getting the
Jump on Uncle Sam." Medium: Gouache.

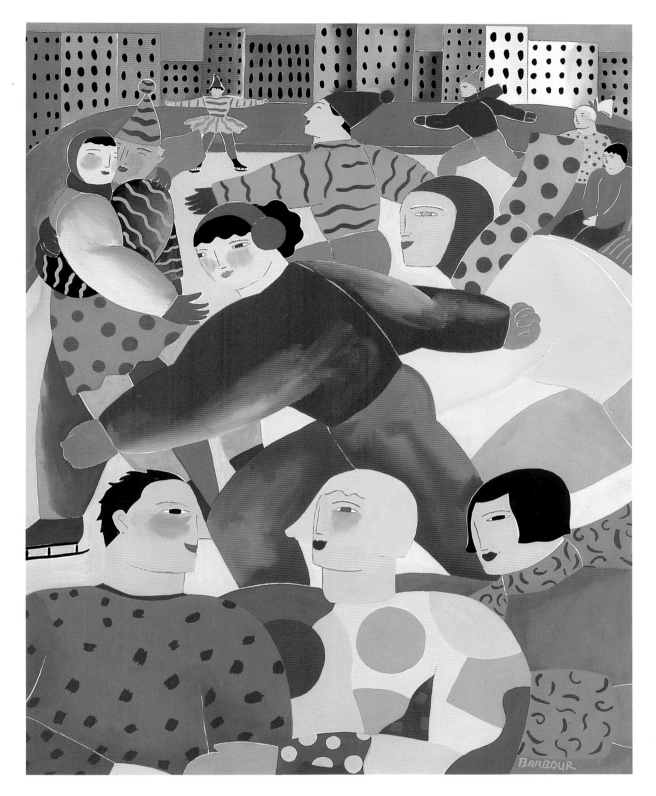

ART DIRECTOR
Richard Mantel
DESIGNER
Richard Mantel
PUBLICATION
New York Magazine
November 30, 1987
PUBLISHING COMPANY
New York Magazine

Karen Barbour

A special advertising section looked at "Winter
Sports and Fitness." Medium: Gouache.

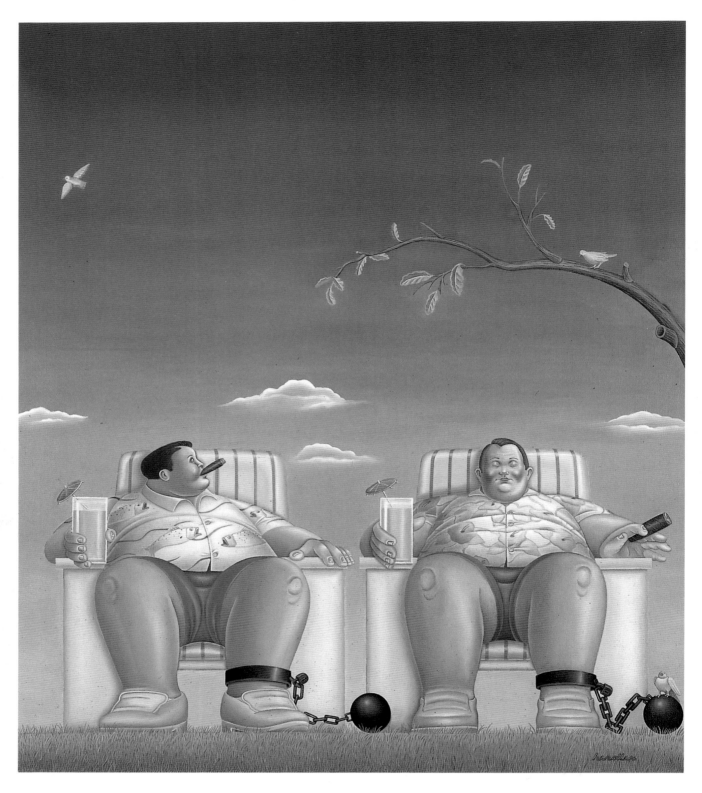

ART DIRECTOR
Philip Brooker
DESIGNER
Sandra Hendler
PUBLICATION
**Tropic Magazine
October 18, 1987**
PUBLISHING COMPANY
Miami Herald
WRITER
David Satterfield

Sandra Hendler

"Club Fed" examined Eglin Prison, where convicted
felons serve time in a country club atmosphere.
Medium: Oil.

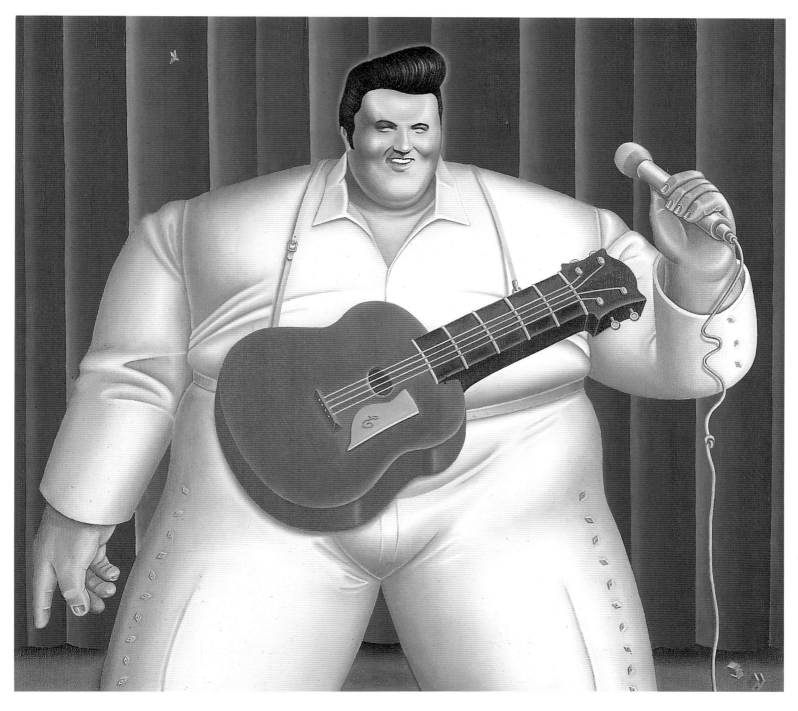

ART DIRECTOR
Philip Brooker
DESIGNER
Sandra Hendler
PUBLICATION
Tropic Magazine
August 16, 1987
PUBLISHING COMPANY
Miami Herald
WRITER
Dave Barry

Sandra Hendler

"Don't Be Cruel," a cover story on Elvis Presley,
looked at Elvis in his later days. Medium: Oil on
canvas.

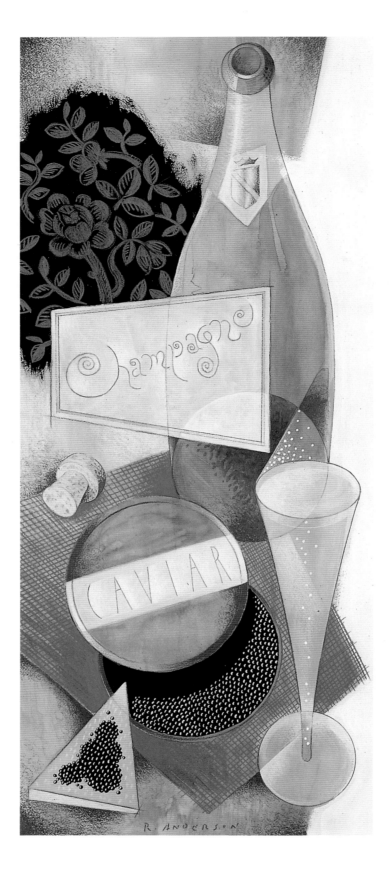

ART DIRECTOR
Julia Nead
PUBLICATION
**Times Picayune
February 4, 1988**
PUBLISHING COMPANY
Times Picayune Publishering Co.
WRITERS
Frank Bailey and Lily Jackson

Robert Anderson

Robert Anderson chose champagne and caviar —
traditionally elegant foods — to illustrate "Festive
Fare," an article in the food section. Medium:
Watercolor, gouache, and colored pencil.

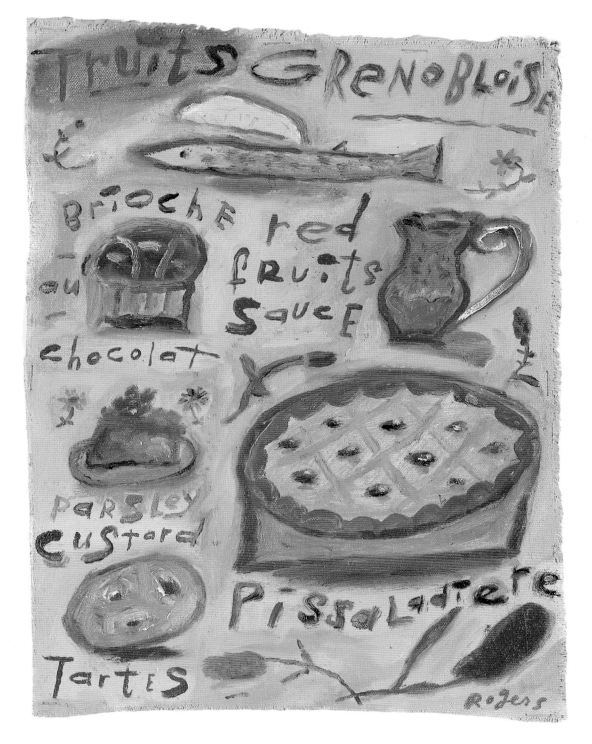

ART DIRECTOR
Matthew Drace
DESIGNER
Beth Gullickson
PUBLICATION
San Francisco Focus Magazine
February 1988
PUBLISHING COMPANY
KQED
WRITER
Jacqueline Killeen

Lilla Rogers

Rather than concern herself with a literal
representation of foods, Lilla Rogers chose to evoke
the luscious, earthy quality associated with them.
The thickness of the paint suggests a foodlike
texture, and the torn canvas edges add a rustic
feeling. The illustration appeared in "Mangez-vous
Français?," an article about French cuisine.

ART DIRECTOR
Ronn Campisi
DESIGNER
Ronn Campisi
PUBLICATION
Enterprise Magazine
Summer 1987
PUBLISHING COMPANY
Digital Equipment Corporation

Anthony Russo

Anthony Russo's illustration accompanied the article
"Decworld '87: The Network at Work." Medium:
Watercolor.

ART DIRECTORS
Robert Best and Josh Gosfield
PUBLICATION
New York Magazine
December 21, 1987
PUBLISHING COMPANY
New York Magazine
EDITOR
Melissa Morgan

Ross McDonald

Famous New Yorkers remembered New York in
"What I Miss." Medium: Linocut.

110

ART DIRECTOR
Michael Walters
DESIGNER
Roy Weimann
PUBLICATION
California Business Magazine
March 1988
PUBLISHING COMPANY
California Business News, Inc.
WRITER
G. Pascal Zachary

Roy Weimann

The difficulty of creating names to accommodate
the rapid proliferation of new companies is
symbolically depicted in Roy Weimann's illustration
for "Jabberwocky, Inc.," an article on the subject.
Medium: Airbrush, color photocopy, and collage.

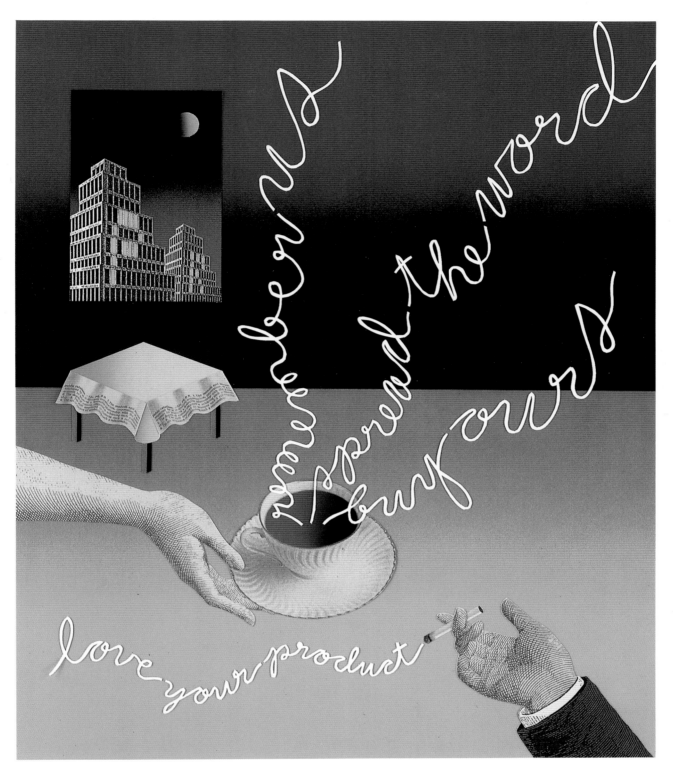

ART DIRECTOR
Fabien Baron
DESIGNER
Margot Frankel
PUBLICATION
New York Woman
October 1987
PUBLISHING COMPANY
American Express Publishing Corporation
WRITER
David Finkle

Gene Greif

The unspoken code of the public relations world is
symbolically represented in this illustration for the
article "An Exclusive Invitation." Medium: Mixed
media collage.

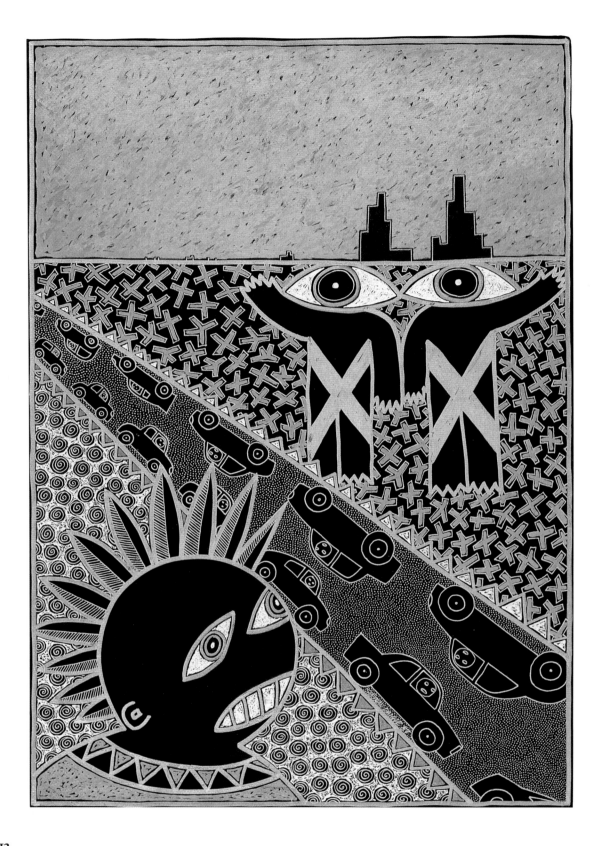

ART DIRECTOR
Gianni Caccia
DESIGNER
Stephan Daigle
PUBLICATION
Vice Versa Magazine
December 1987
PUBLISHING COMPANY
Vice Versa Publications

Stephan Daigle

Stephan Daigle's response to the theme of American
vision appeared on the cover of *Vice Versa*'s year-end
issue. Medium: Felt-tip pen.

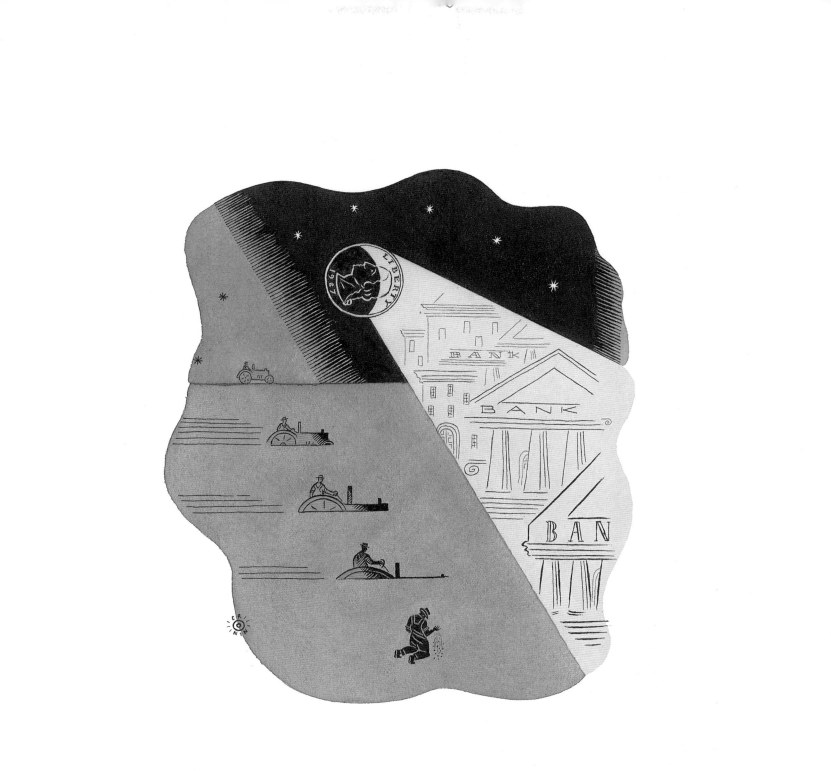

113

ART DIRECTOR
Fred Woodward
PUBLICATION
Rolling Stone
September 24, 1987
PUBLISHING COMPANY
Straight Arrow Publishers, Inc.
WRITER
William Greider

Brian Cronin

"Debt Trap," an article in the National Affairs series,
featured this illustration. Medium: Watercolor and
pen and ink.

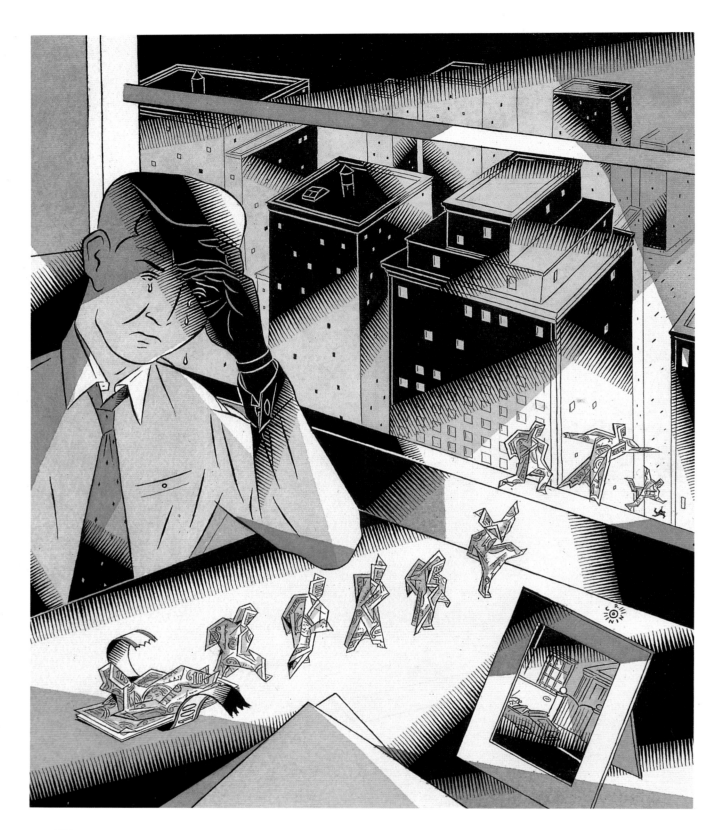

ART DIRECTOR
Fred Woodward
PUBLICATION
Rolling Stone
December 17, 1987
PUBLISHING COMPANY
Straight Arrow Publishers, Inc.
WRITER
William Greider

Brian Cronin

Another article in the National Affairs series, "Crash
Diet," used this image. Medium: Watercolor and
pen and ink.

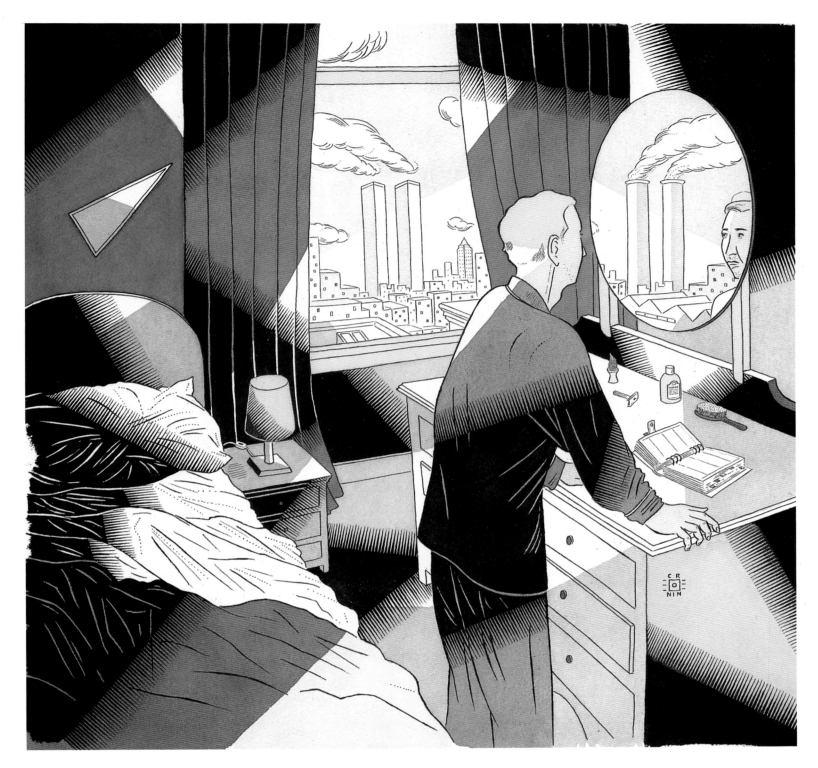

ART DIRECTOR
Fred Woodward
PUBLICATION
**Rolling Stone
March 24, 1988**
PUBLISHING COMPANY
Straight Arrow Publishers, Inc.
WRITER
Pete Wilkinson

Brian Cronin

"Black Monday Blues" looked at the effects of the
stock market on the M.B.A. Medium: Watercolor
and pen and ink.

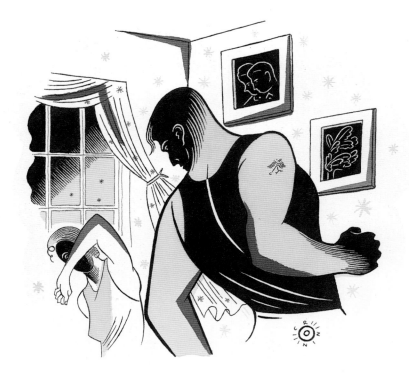

ART DIRECTOR
Gina Davis
DESIGNER
Sue Ng
PUBLICATION
Savvy Magazine
October 1987
PUBLISHING COMPANY
Family Media, Inc.

Brian Cronin

The problem of domestic violence was discussed in
"When Violence Begins at Home." Medium:
Watercolor and pen and ink.

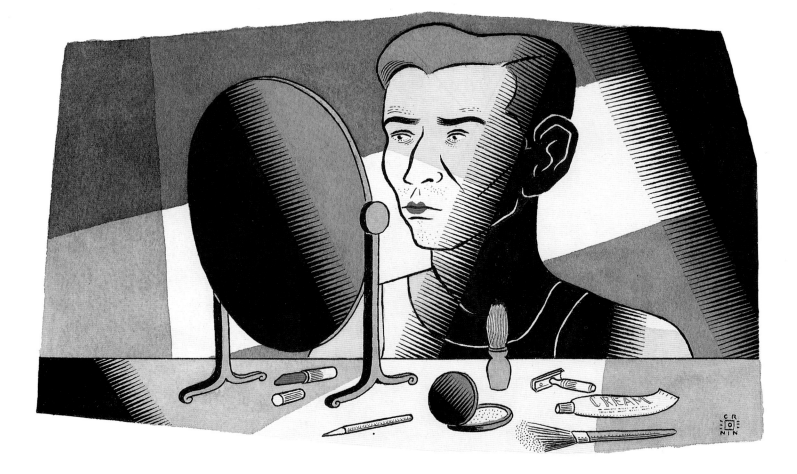

117

ART DIRECTOR
Teresa Fernades
DESIGNER
S. Dale Vokey
PUBLICATION
Toronto Life Magazine
October 1988
PUBLISHING COMPANY
Toronto Life Publishing Co.
WRITER
Helen Bulock

Brian Cronin

The humorous side of men and cosmetics was
examined in "Cosmetics Perjury." Medium:
Watercolor and pen and ink.

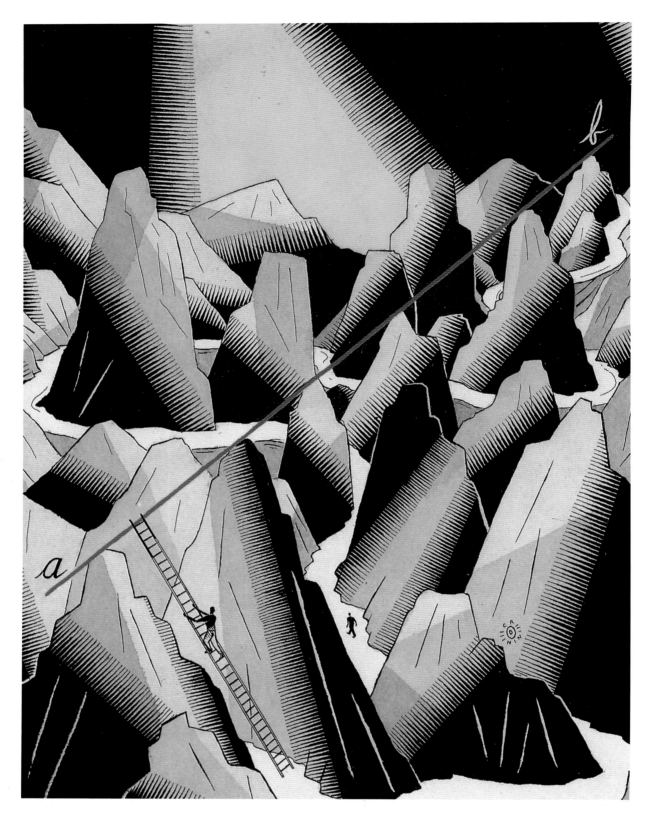

ART DIRECTOR
Skip Johnston
PUBLICATION
P.C. World
January 1988
PUBLISHING COMPANY
PCW Communications, Inc.
WRITER
Tom Swan

Brian Cronin

"Ten Time Savers" explored computer shortcuts.
Medium: Watercolor and pen and ink.

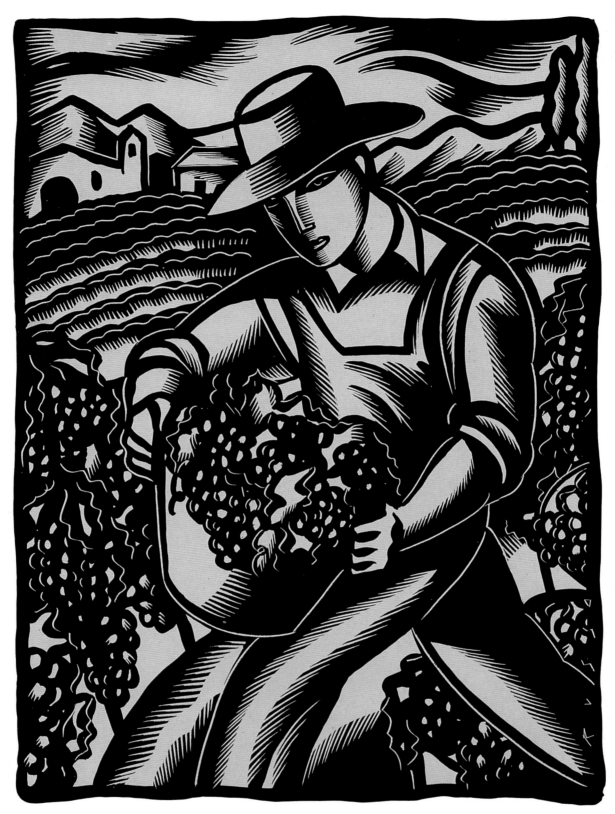

ART DIRECTOR
Rip Georges
PUBLICATION
L.A. Style
May 1987
PUBLISHING COMPANY
L.A. Style, Inc.
WRITER
Gerald Boyd

Anthony Russo

Gerald Boyd's image of a grape harvester
accompanied the article "Grape Expectations."
Medium: Scratchboard.

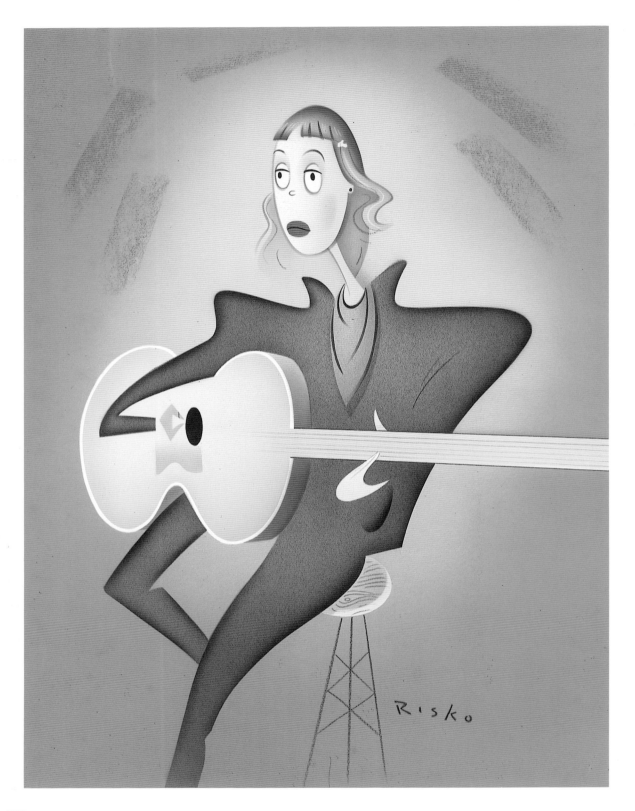

Art Director
Derek Ungless
Publication
Rolling Stone
June 18, 1987
Publishing Company
Straight Arrow Publishers, Inc.
Writer
David Browne

Robert Risko

Robert Risko has captured numerous performers for
Rolling Stone's "Records" feature. Here, "Vega's Good
Standing" profiled singer Suzanne Vega. Medium:
Gouache and airbrush.

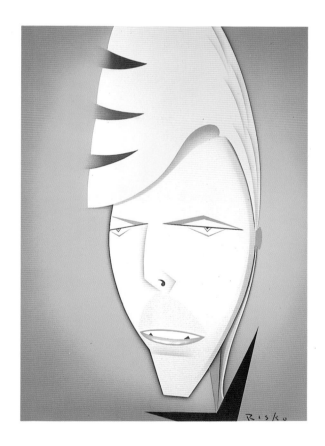

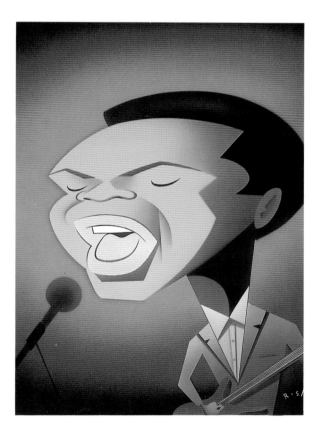

WRITER
Anthony DeCurtis
February 26, 1987

"Los Lobos Shake, Rattle and Worry." Medium:
Gouache and airbrush.

WRITER
Steve Pond
June 4, 1987

Robert Risko's portrait of David Bowie for "Never
Say Never." Medium: Gouache and airbrush.

WRITER
Steve Pond
April 9, 1987

"U2 Rises to the Occasion." Medium:
Gouache and airbrush.

WRITER
Jon Pareles
January 29, 1987

"Robert Cray's New Blues Power." Medium:
Gouache and airbrush.

ART DIRECTOR
Bruce Ramsay
DESIGNER
Bruce Ramsay
PUBLICATION
Saturday Night Magazine
December 1987
PUBLISHING COMPANY
Saturday Night Magazine
WRITER
Andrew Malcom

Rene Zamic and Tomijo Nitto

To emphasize the duality of Canadians for
"Northern Contradictions," the illustration was
assigned to two different artists. Medium: Acrylic
and pen and ink.

123

ART DIRECTOR
Sue Llewellyn
DESIGNER
Sue Llewellyn
PUBLICATION
Stereo Review
August 1987
PUBLISHING COMPANY
Diamandis Communications, Inc.
WRITER
Ian G. Masters

Jeanne Fisher

Jeanne Fisher created an abstract European
landscape for the article "European Audio."
Medium: Pastel.

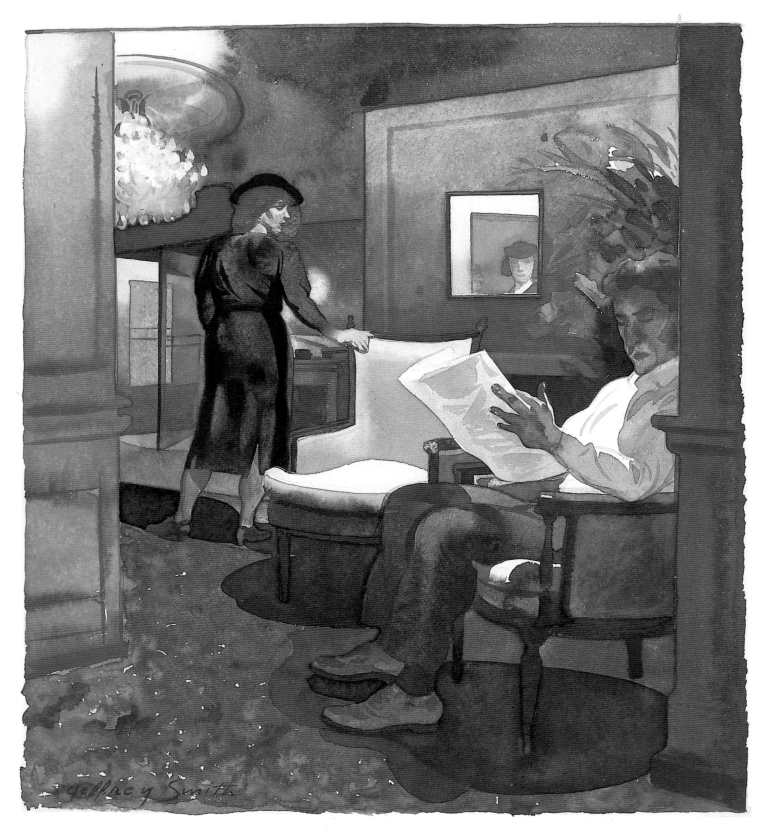

ART DIRECTOR
Lucy Bartholomay
PUBLICATION
**Boston Globe Magazine
December 1987**
PUBLISHING COMPANY
Boston Globe
WRITER
Howard Norman

Jeffrey Smith

This image appeared with the story "Kiss in the
Hotel Joseph Conrad." Medium: Watercolor.

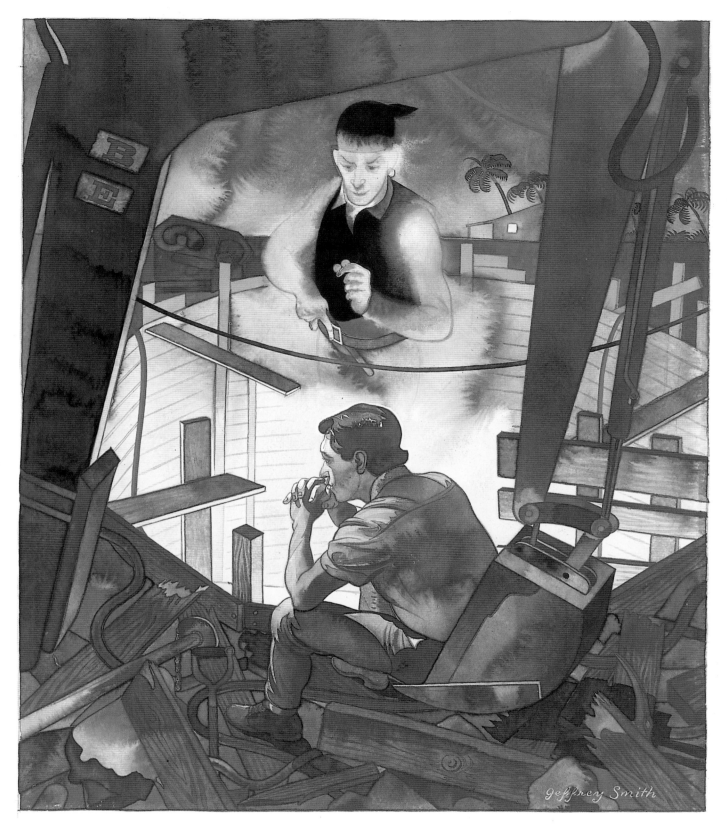

ART DIRECTOR
Wendall K. Harrington
PUBLICATION
Esquire
March 1988
PUBLISHING COMPANY
Hearst Corporation
WRITER
John Sayles

Jeffrey Smith

Jeffrey Smith created this image for the story
" 'Treasure,' the Ghost." Medium: Watercolor.

Art Directors
Cynthia Hoffman and Kerig W. Pope
Publication
Chicago Magazine
February 1988
Publishing Company
Metropolitan Communications, Inc.

Cathie Bleck

Cathie Bleck depicted the different departments of
Chicago magazine in small, irregular shapes. Seen
here are the dining, theater, and movie spots, for
pieces by Carla and Alan Kelson, Anthony Adler,
and Penelope Mesic. Medium: Scratchboard.

ART DIRECTOR
Barbara Solowan
DESIGNER
Barbara Solowan
PUBLICATION
Chicago Magazine
June 1987
PUBLISHING COMPANY
Metropolitan Communications, Inc.
WRITER
Daniel Santow

Valerie Sinclair

Valerie Sinclair produced colorful, free-floating graphic spots to tie together the various stories in the "Summer Pleasures" feature. Shown here are the pieces for Daniel Santow's "Free For All," Dan Kenig's "Sound Unbound," and Brenda Shapiro's "A Place in the Sun." Medium: Acrylic and airbrush.

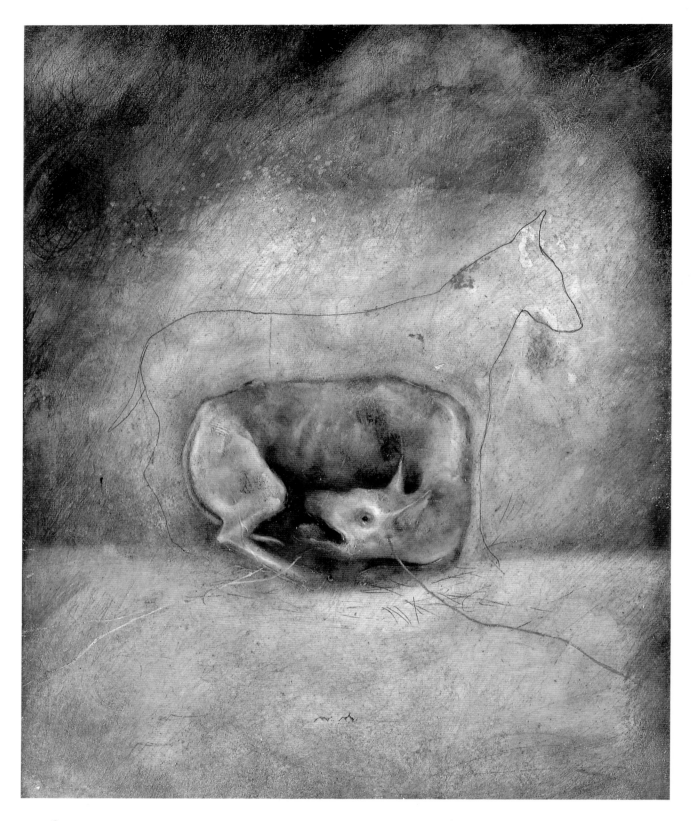

128

ART DIRECTOR
Fred Woodward
PUBLICATION
Rolling Stone
March 24, 1988
PUBLISHING COMPANY
Straight Arrow Publishers, Inc.
WRITER
Mike Sager

Matt Mahurin

Matt Mahurin's illustrations appeared in "Inhuman
Bondage," an article about animal liberation groups.
Medium: Oil on paper.

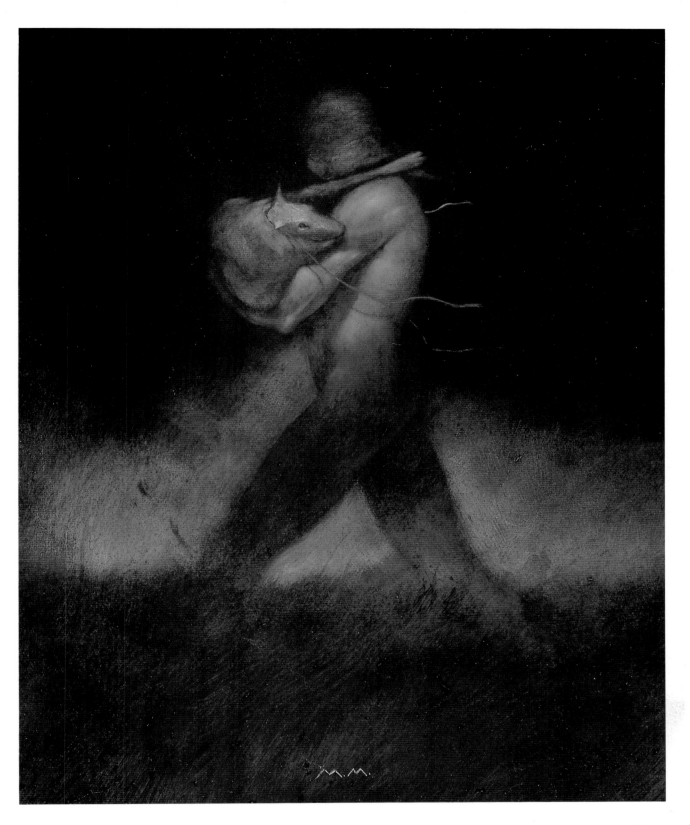

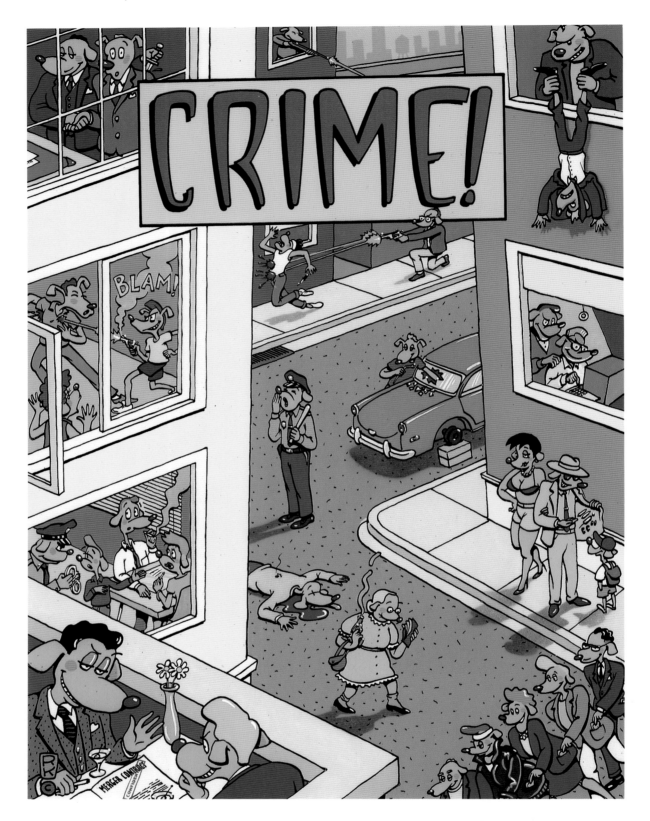

ART DIRECTOR
Peter Kleinman
DESIGNER
Robert Kopecky
PUBLICATION
National Lampoon
January 22, 1988
PUBLISHING COMPANY
National Lampoon, Inc.

Robert Kopecky

Robert Kopecky's canine villains and victims
appeared on a lead page introducing a section on
crime. Medium: Ink and cel vinyl on acetate.

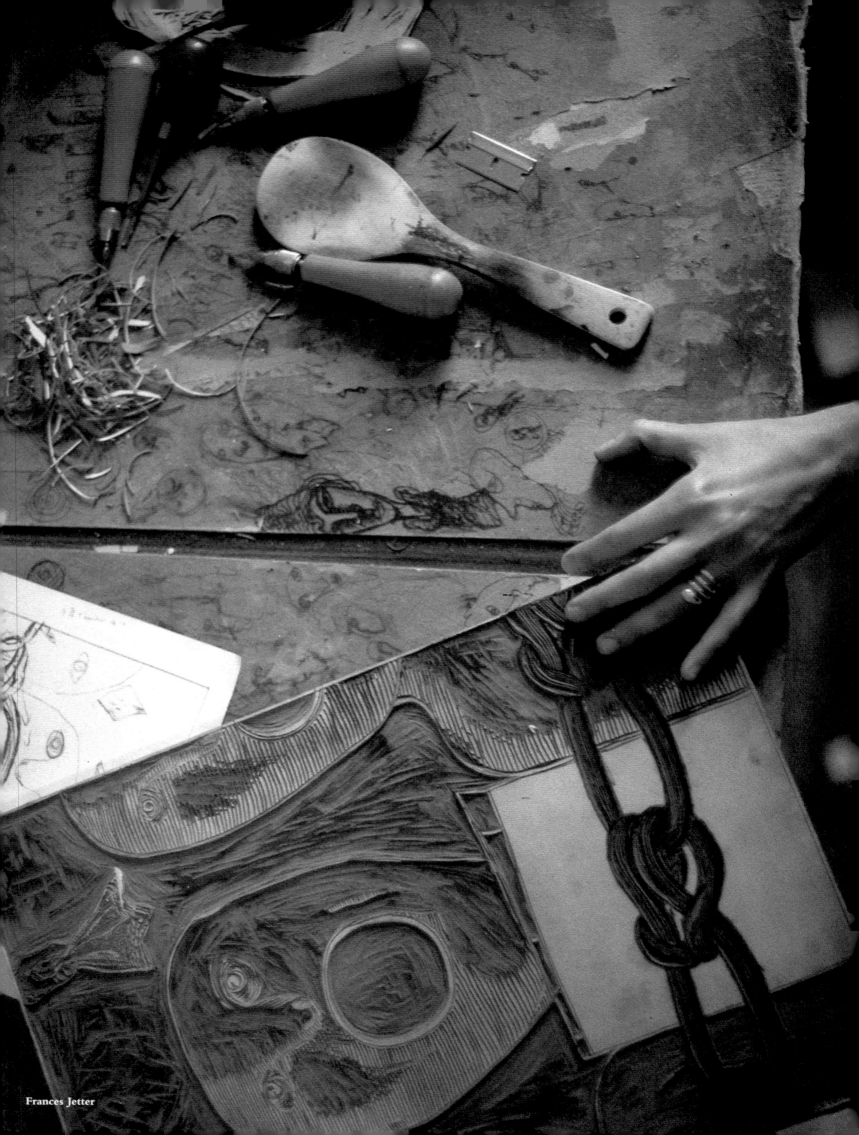

Frances Jetter

2

BOOKS

Cover and interior illustrations for all types of fiction and nonfiction books

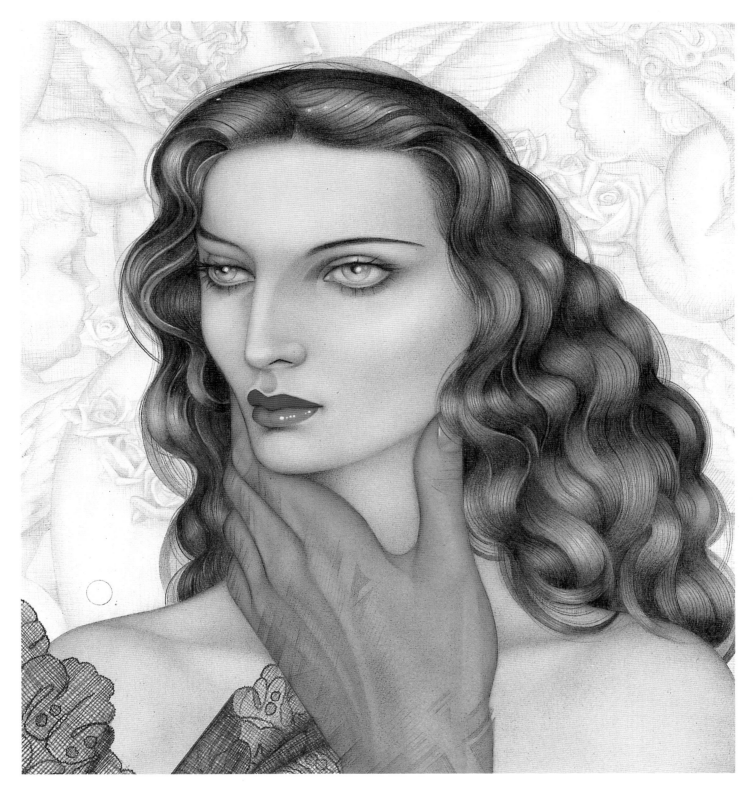

ART DIRECTOR
Louise Fili
DESIGNER
Louise Fili
AUTHOR
Ruth Rendell
PUBLISHER
Pantheon Books
January 1988

Mel Odom

To create an image that was eerie and yet generic
enough to serve as the cover for an anthology (Ruth
Rendell's collected stories), Mel Odom struck this
balance between the bizarre and the beautiful.
Medium: Gouache.

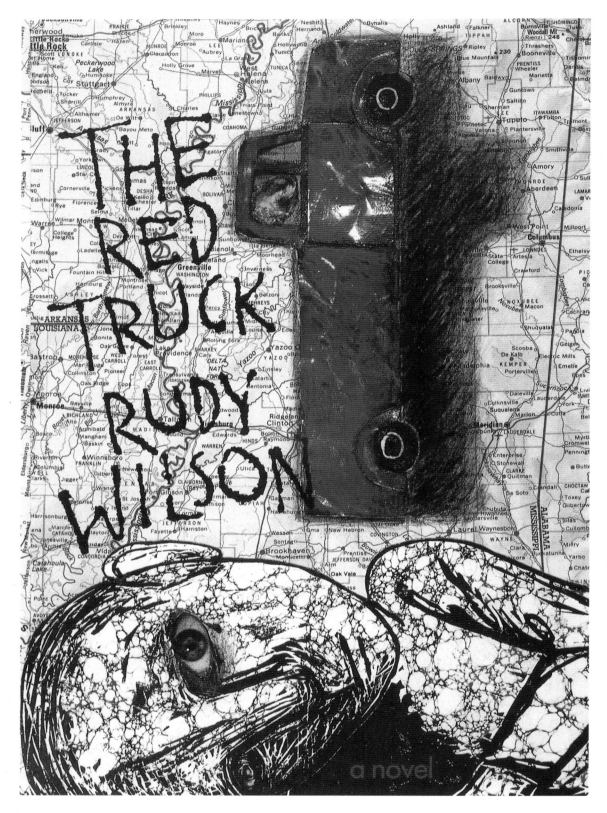

ART DIRECTOR
Sara Eisenman
DESIGNER
Frances Jetter
AUTHOR
Rudy Wilson
PUBLISHER
**Alfred A. Knopf
May 1987**

Frances Jetter

Frances Jetter's cover illustration for *The Red Truck*
evokes the power and violence of the novel.
Medium: Woodblock with collage of metal.

Art Director
Joseph Montebello
Designer
Julie Metz
Author
Renata Adler
Publisher
Harper & Row
February 1988

Steven Guarnaccia

Symbolic and event-related elements appear on the
cover of *Pitch Dark*, a novel that explores the
sensibilities of an exceptional woman. Medium:
Watercolor.

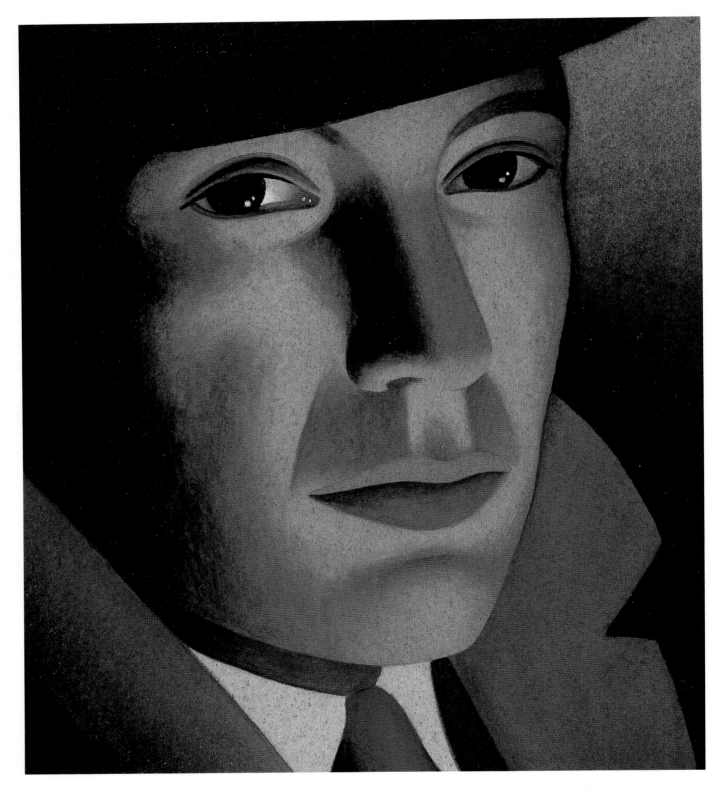

138

ART DIRECTOR
Joseph Montebello
DESIGNER
James Steinberg
AUTHOR
Michael Gilbert
PUBLISHER
Harper & Row
May 1988

James Steinberg

Since James Steinberg has done illustrations for
previous Michael Gilbert mysteries, the author gave
him carte blanche on the cover for *The Young
Petrella,*, a collection of stories on the adventures of
detective Patrick Petrella. Medium: Colored pencil.

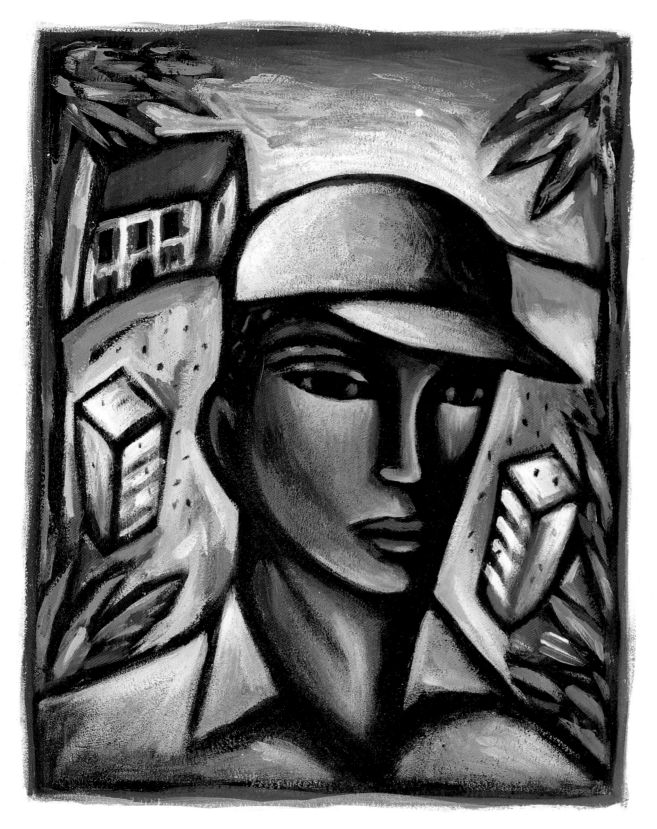

139

ART DIRECTOR
Andy Carpenter
AUTHOR
Seth Rolbein
EDITOR
Andy Carpenter
PUBLISHER
St. Martin's Press
September 1987

Anthony Russo

This image appeared as the cover of *Sting of the Bee*.
Medium: Acrylic.

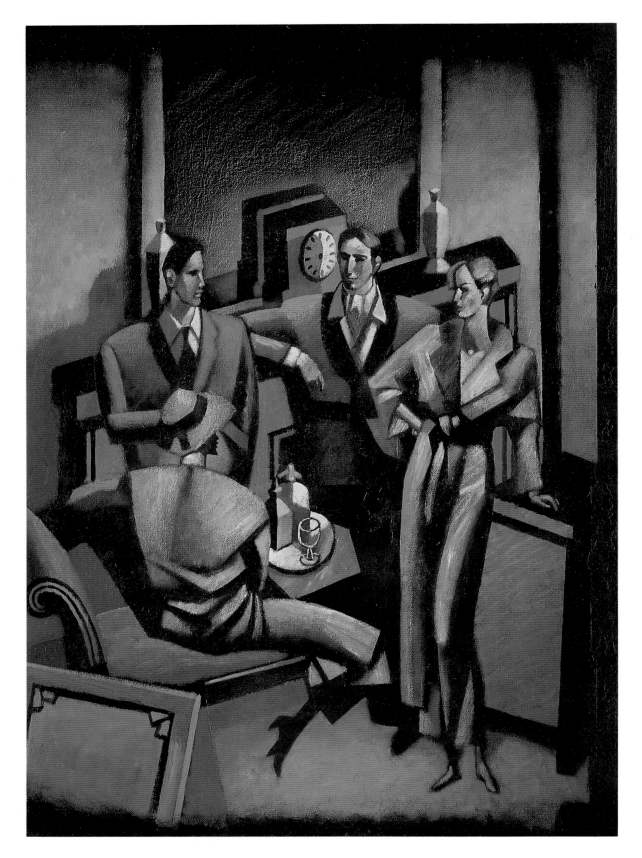

ART DIRECTOR
Andy La Breacht
AUTHOR
Harry Mathews
PUBLISHER
Weidenfeld & Nicolson

John H. Howard

The lives of a group of people over a thirty-year
span were explored in the novel *Cigarettes.* Medium:
Acrylic.

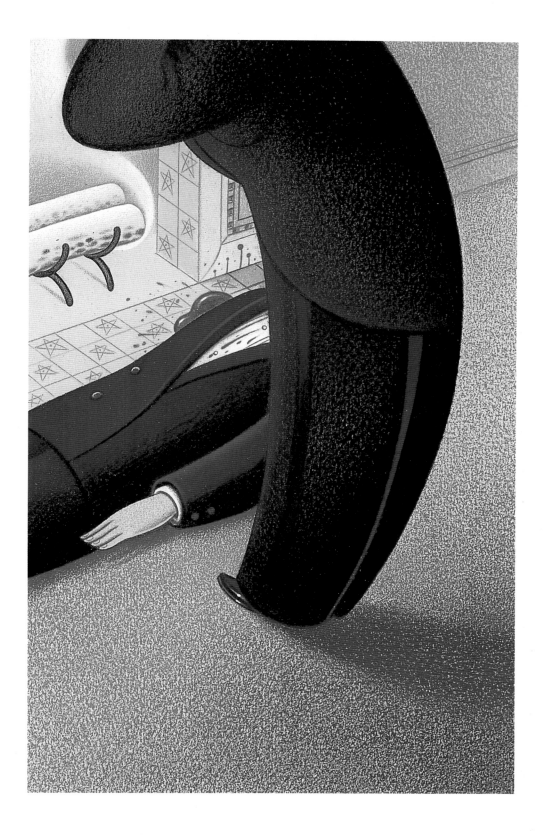

ART DIRECTOR
Tom Egner
DESIGNER
Martha Sedgwick
AUTHOR
Sara Woods
PUBLISHER
Avon Books
April 1988

Dave Calver

For a murder mystery series, Dave Calver has
depicted the various deaths of the victims. This, the
eleventh cover in the series, was for a story
involving devil worship in a staid London mansion.
Medium: Colored pencil.

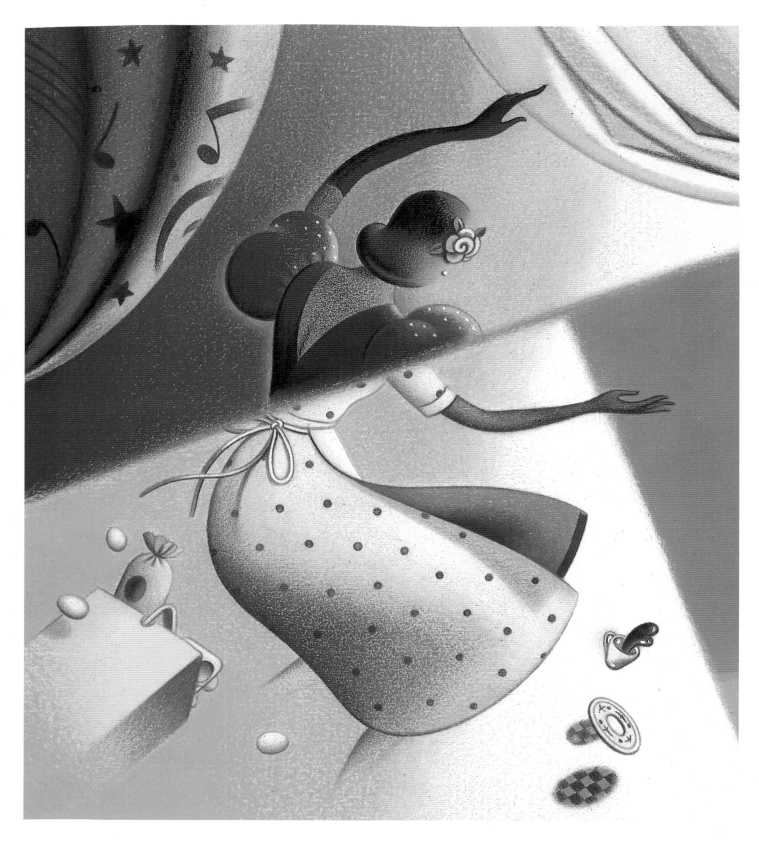

ART DIRECTOR
Victor Weaver
AUTHOR
Al Young
PUBLISHER
Dell Publishing
Summer 1988

Dave Calver

The out-of-body experiences in *Seduction by Light*, a
metaphysical comedy, are captured in the cover
illustration. Medium: Colored pencil.

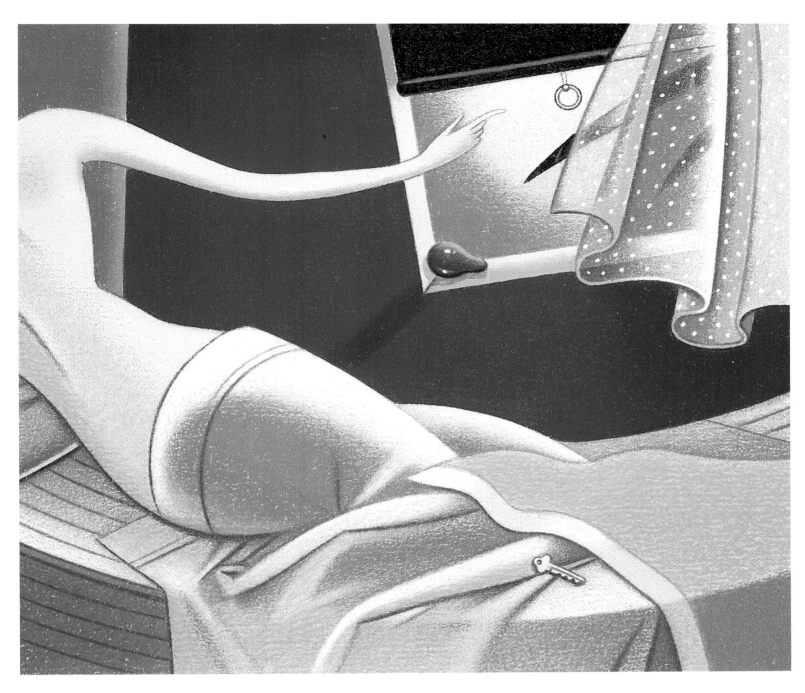

I43

ART DIRECTOR
Greg Wilkin
AUTHOR
Perri Klass
PUBLISHER
Plume Fiction
PUBLISHING COMPANY
New American Library
Spring 1987

Dave Calver

Dave Calver created a cover image for *I Am Having an Adventure* that is representative of the whole: The book is a collection of short stories involving relationships between friends, lovers, parents, and children.

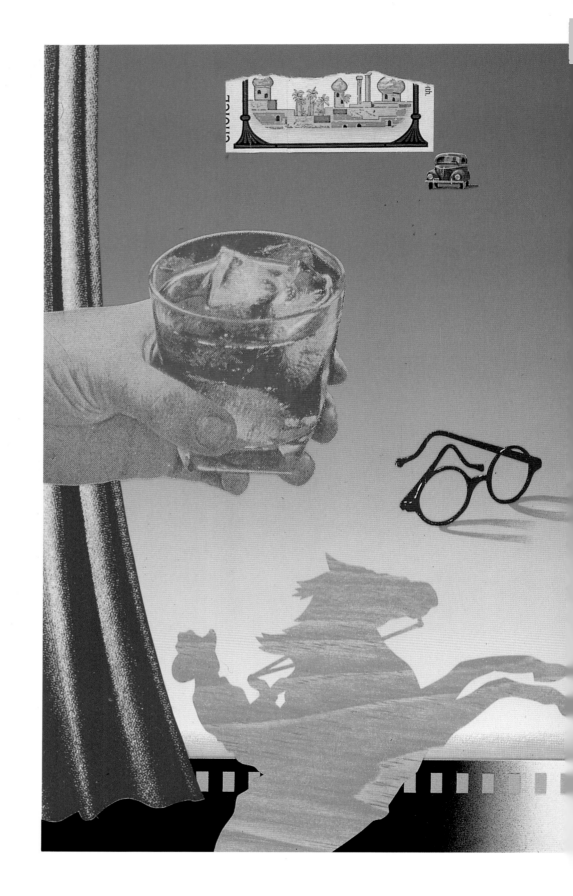

145

Art Directors
Carin Goldberg and Frank Metz
Designer
Carin Goldberg
Author
Robert Coover
Publisher
Linden Press
Publishing Company
Simon & Schuster

Gene Greif

The surreal imagery of Robert Coover's writing
inspired the cover for his story collection *A Night at
the Movies*. Medium: Mixed media collage.

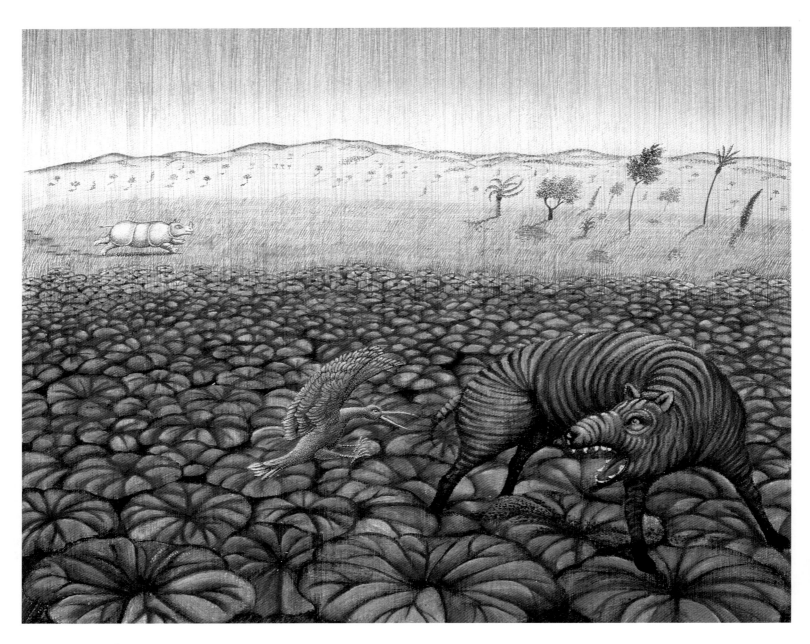

146

ART DIRECTOR
Peter Sis
DESIGNER
Denise Cronin
AUTHOR
Peter Sis
EDITOR
Frances Foster
PUBLISHER
Alfred A. Knopf
October 1987

Peter Sis

Peter Sis created images for *Rainbow Rhino* that
would teach children about friendship and harmony.
Full-color illustrations depict happier scenes, while
loneliness is represented in black and white.
Medium: Oil.

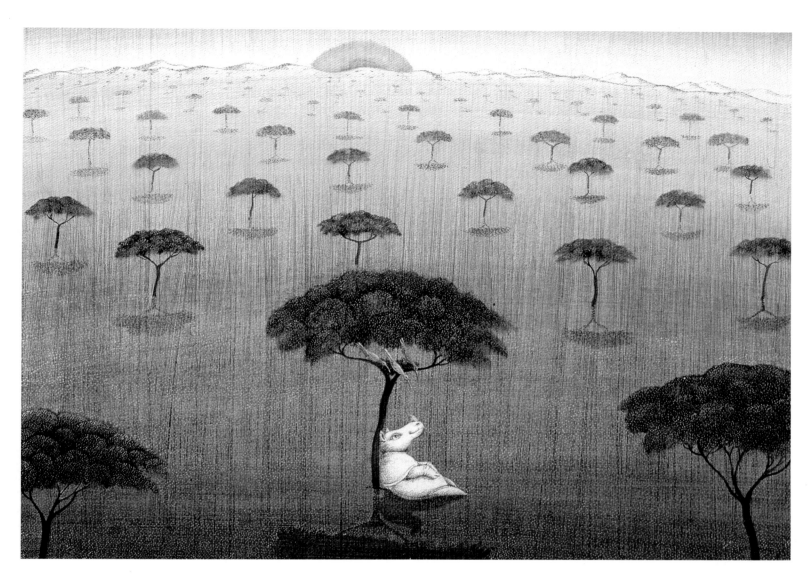

147

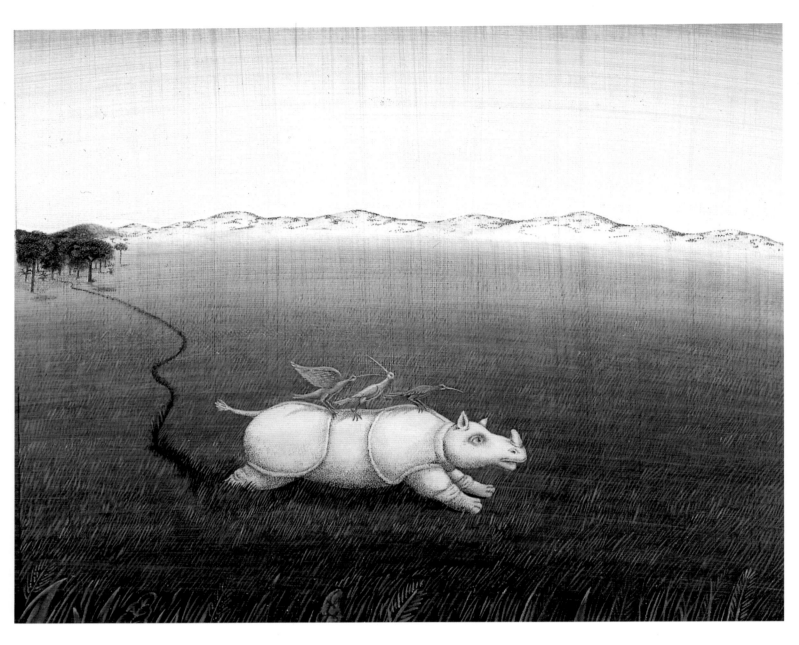

148

Art Director
Cecilia Yung
Author
Lane Smith
Editor
Beverly Reingold
Publisher
Macmillan Publishing Co.
March 1988

Lane Smith

Flying Jake, a wordless picture book, tells the story
of a boy who, while chasing his escaped pet bird,
begins to fly. Medium: Oil, colored pencil, and
charcoal on tissue paper.

ART DIRECTOR
Cecilia Yung
DESIGNER
Cecilia Yung
AUTHOR
Eve Merriam
EDITOR
Beverly Reingold
PUBLISHER
Macmillan Publishing Co.
November 1987

Lane Smith

The delightfully macabre alphabet book *Halloween
ABC* included these four images. Medium: Oil.

154

ART DIRECTORS
**Tibor Kalman, Maria Kalman,
and Tim Horn**
DESIGNER
M&Co.
AUTHOR
David Byrne
EDITOR
Nancy Paulsen
PUBLISHER
**Viking Kestral
October 1987**

Maira Kalman

Stay Up Late combines the words of a Talking Heads
song with illustrations to create a whimsical look at
family life from a child's point of view. Medium:
Gouache, pastel, and colored pencil.

155

156

ART DIRECTOR
Frank Olinsky
DESIGNER
Frank Olinsky
AUTHORS
Frank Olinsky and Talking Heads
PUBLISER
Perennial Library
PUBLISHING COMPANY
Harper & Row
November 1987

Rodney Alan Greenblat

This and the following ten illustrations appear in the book *What the Songs Look Like*, a compilation of various artists' interpretations of Talking Heads songs. Song title: "This Must Be the Place (Naive Melody)." Medium: Mixed media installation.

Lynda Barry

Song title: "Social Studies." Medium: Acrylic on
paper with pounded aluminum border.

Frank Olinsky

Song title: "Moon Rocks." Medium: Gouache, ink,
and collage.

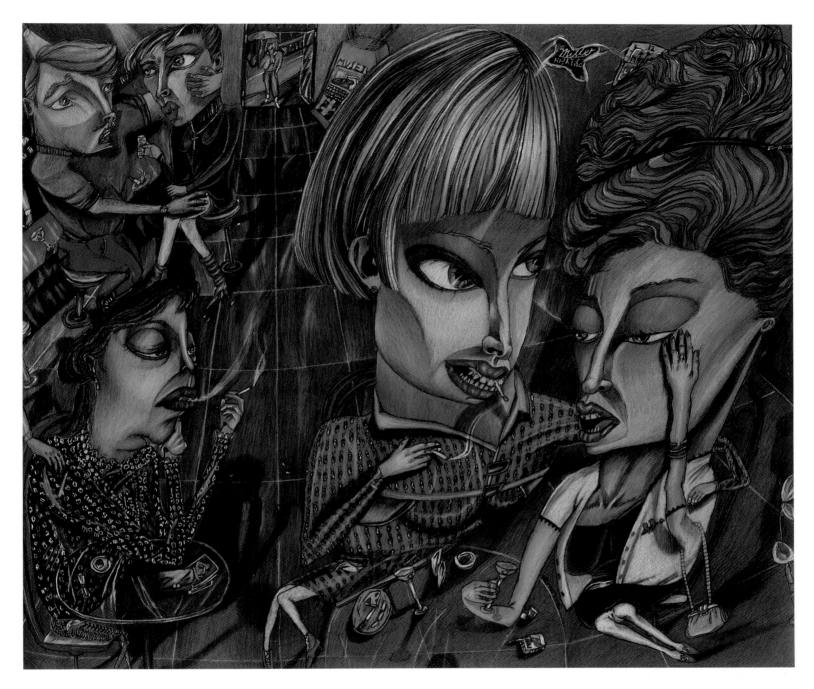

159

Sara Schwartz

Song title: "The Girls Want to Be with the Girls."
Medium: Colored pencil.

160

Stephen Kroninger
Song title: "Psycho Killer." Medium: Collage.

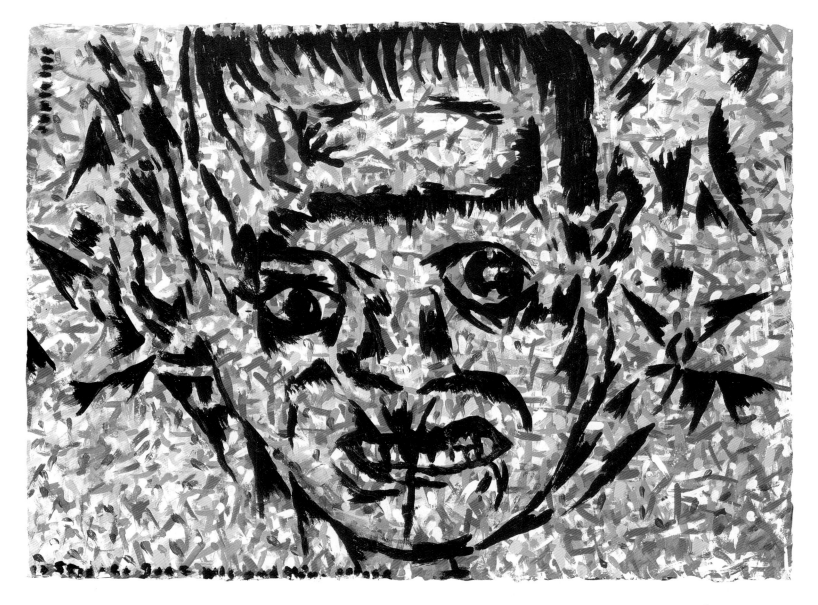

161

Gary Panter
Song title: "Drugs." Medium: Acrylic on paper.

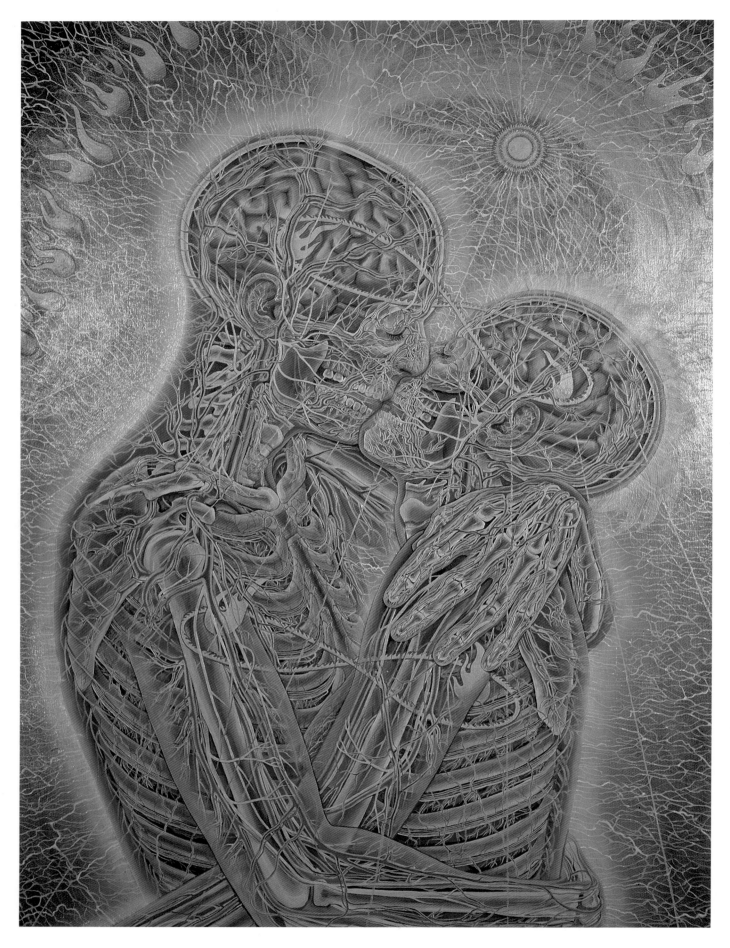

Alex Grey

Song title: "Stay Hungry." Medium:
Oil on linen.

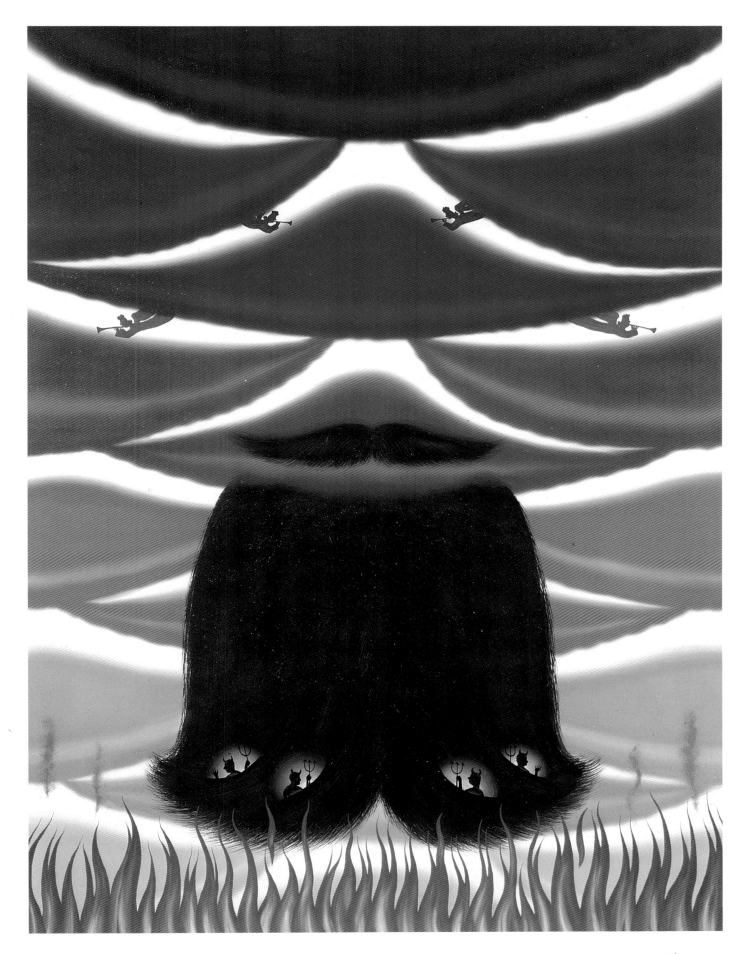

Roger Brown

Song title: "Born Under Punches (The Heat Goes
On)." Medium: Oil on canvas.

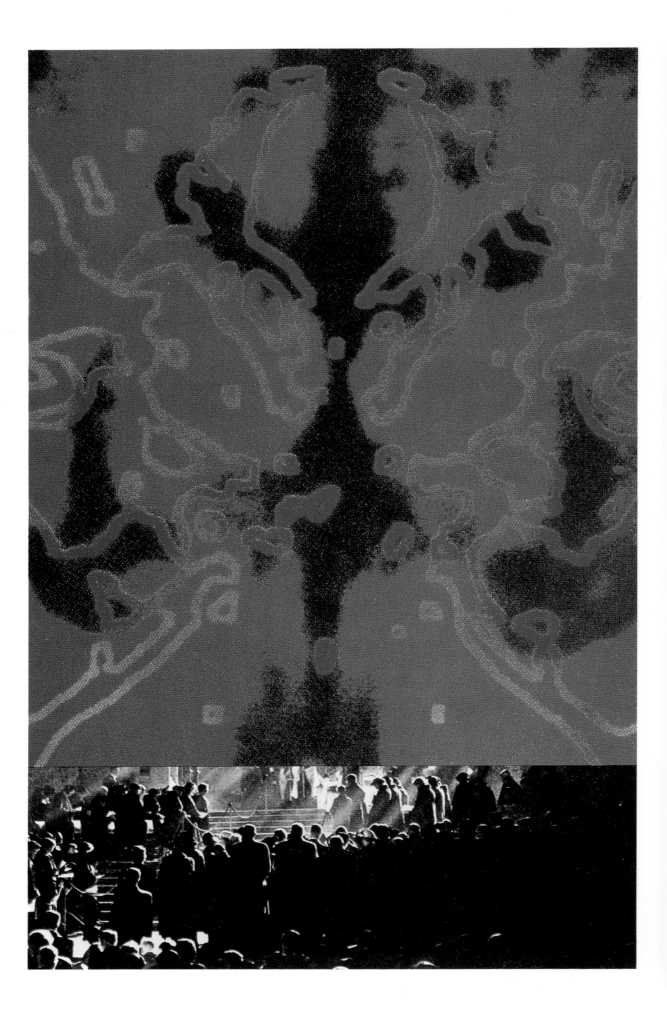

Robert Longo
Song title: "Walk It Down." Medium: Mixed media.

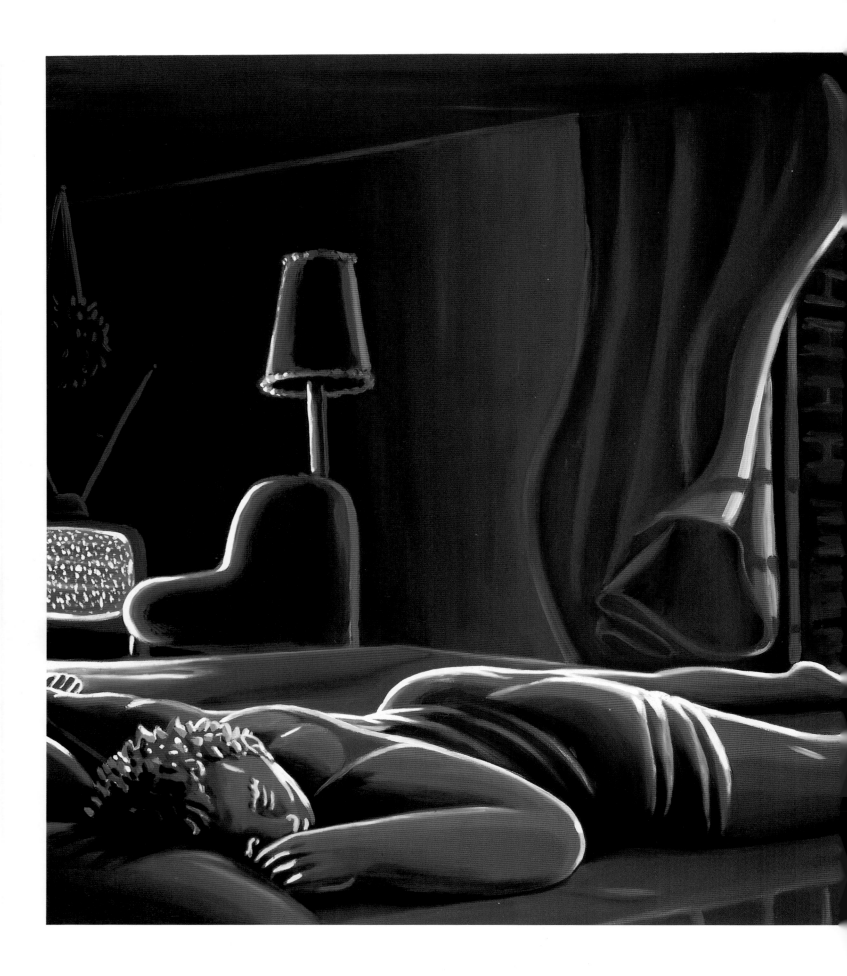

Robert Yarber

Song title: "With Our Love." Medium: Oil and
acrylic on canvas.

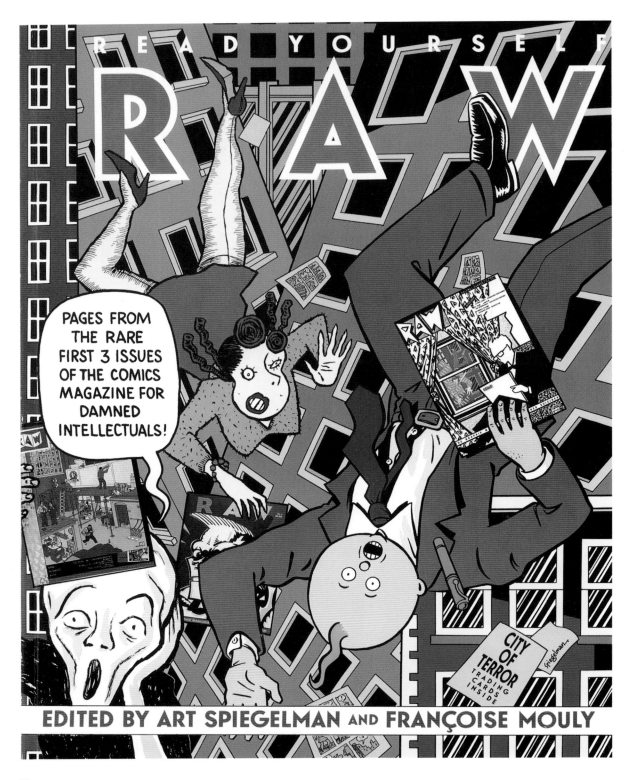

168

ART DIRECTOR
Louise Fili
DESIGNER
Art Spiegelman
AUTHORS
Art Spiegelman and Françoise Mouly
EDITORS
Art Spiegelman and Françoise Mouly
PUBLISHER
Random House
October 1987

Art Spiegelman

The first three issues of *Raw*, the internationally acclaimed magazine of avant-garde comics and graphics, were issued in book form as *Read Yourself Raw* and featured this cover. Medium: Ink.

3

ADVERTISING

*Illustrations for advertising
in consumer, trade, and
professional magazines*

172

Art Director
John Nagy
Advertising Agency
Sive & Associates
Client
Blue Cross/Blue Shield
September 1987

Rob Day

A physician insurance brochure on preventative care
explored "Recources that Improve the Quality of
Health Care and Reduce Further Risk." Medium:
Oil on paper.

173

ART DIRECTORS
Connie Soteropulos and Kent Hensley
CLIENT
**Dayton Hudson Department Store
Company
August 1987**

Jack Molloy

The warmth and welcome of the country house
emanate from this department store poster.
Medium: Watercolor and woodcut.

174

ART DIRECTOR
Warren Johnson

COPYWRITER
Dave Swanson

ADVERTISING AGENCY
Carmichael Lynch

CLIENT
Network Systems Corporation
May 1987

Andrzej Dudzinski

"Networking nightmares" are illustrated in Andrzej
Dudzinski's series for a computer network brochure.
Medium: Oil crayon on paper.

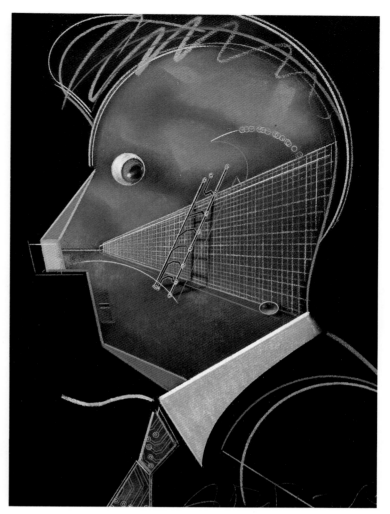

175

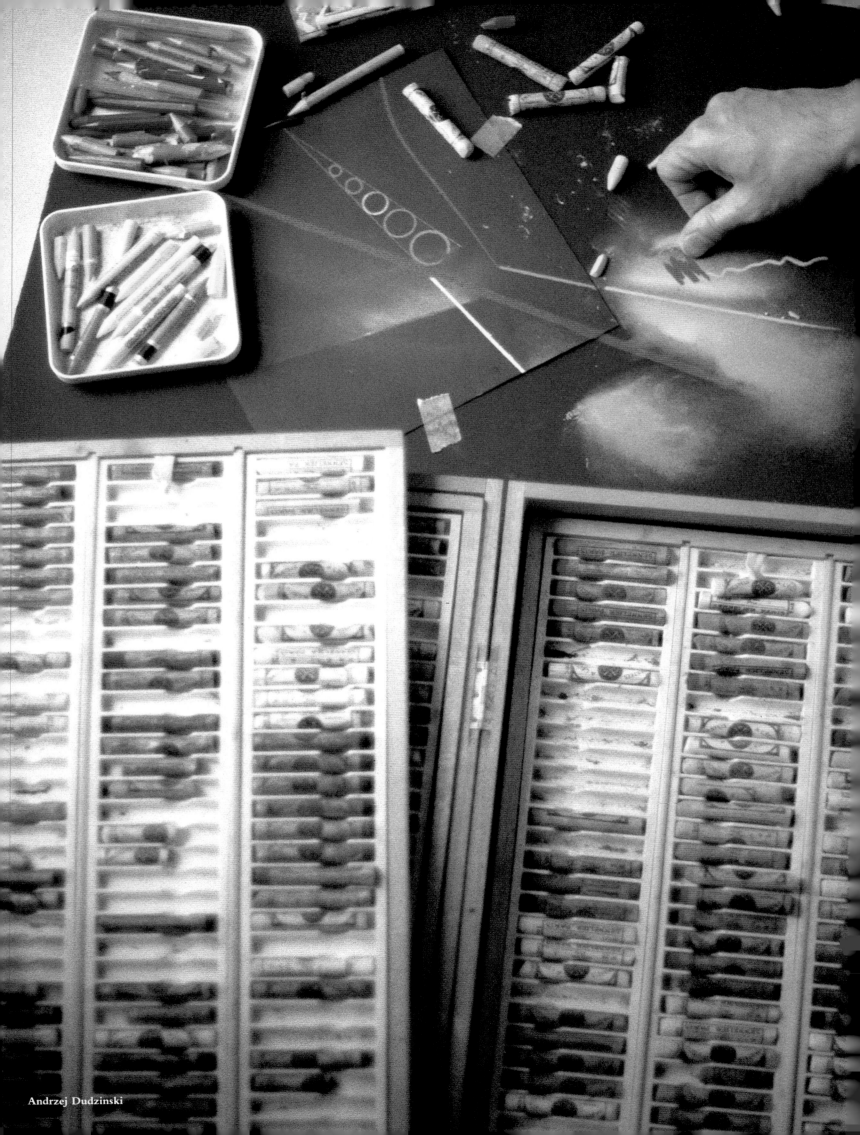

Andrzej Dudzinski

4

POSTERS

*Poster illustrations for
consumer products, institutions,
and special events*

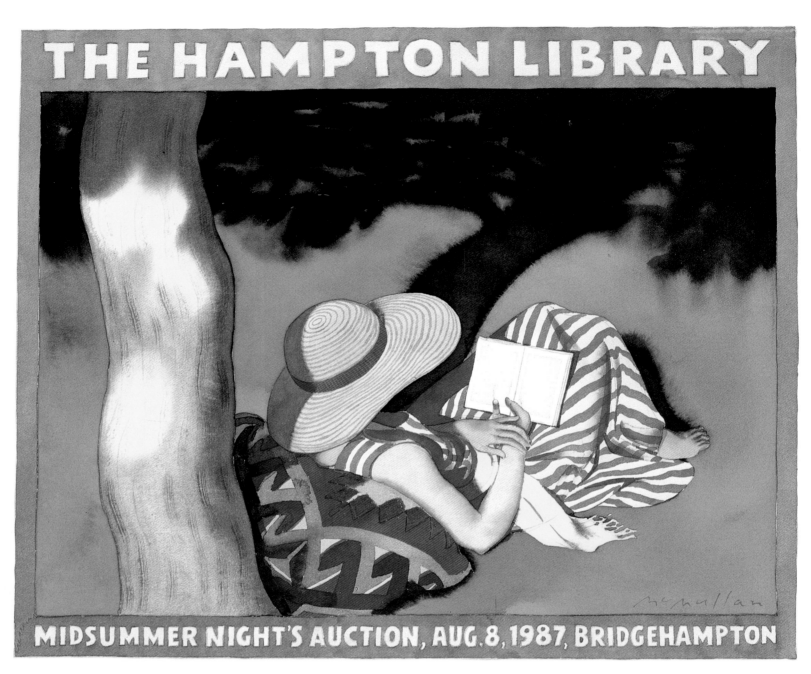

178

ART DIRECTOR
James McMullan
CLIENT
Friends of the Hampton Library

James McMullan

The poster for an auction to benefit the library
conveys the pleasure of summer reading.
Medium: Watercolor.

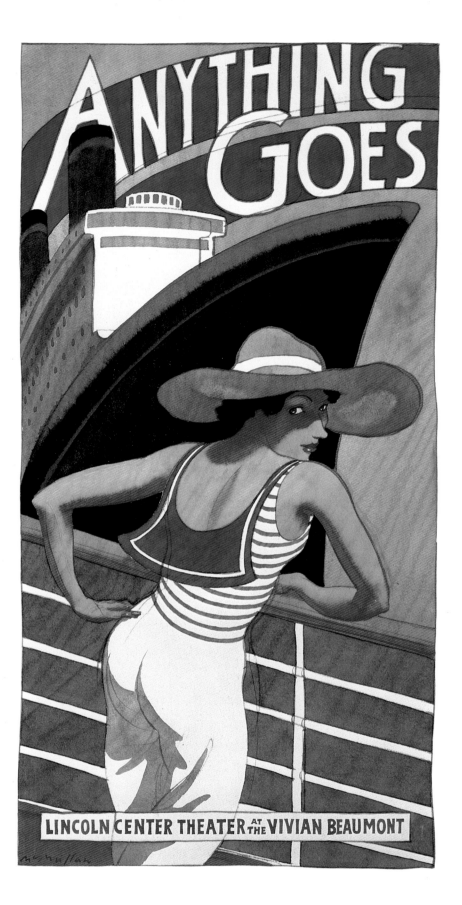

ART DIRECTOR
Jim Russek
ADVERTISING AGENCY
Russek Advertising
CLIENT
**Vivian Beaumont Theater
at Lincoln Center
Fall 1987**

James McMullan

The period setting of *Anything Goes* is captured in
James McMullan's poster. Medium: Watercolor.

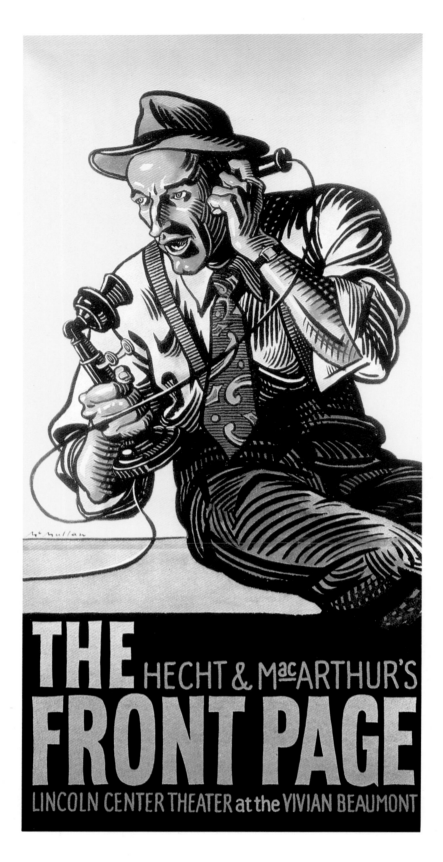

ART DIRECTOR
James Russek
ADVERTISING AGENCY
Russek Advertising
CLIENT
Lincoln Center Theater
January 1987

James McMullan

The roaring '20s arrogance of the tabloid newspaper
reporter is powerfully evoked in a poster for *The
Front Page*. Medium: Watercolor and ink.

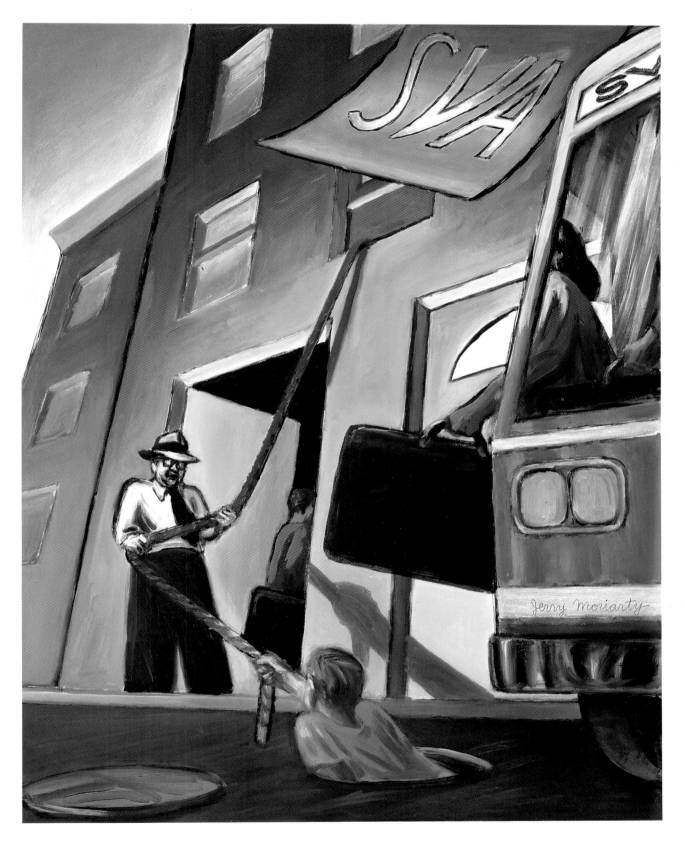

181

CREATIVE DIRECTOR
Silas H. Rhodes
ADVERTISING AGENCY
School of Visual Arts Press, Ltd.
CLIENT
School of Visual Arts
September 1987

Jerry Moriarity

To spread the word about scholarship offerings,
Jerry Moriarity's poster advised students "You Can't
Do It Alone." Medium: Oil.

182

ART DIRECTOR
Clement Mok
DESIGNER
Jill Savini
ADVERTISING AGENCY
Apple Creative Services
CLIENT
Apple Computer, Inc.

Philippe Weisbecker

The joys of summer concerts are celebrated in a
poster for a fourth of July concert. Medium:
Watercolor.

ART DIRECTOR
Louise Fili
CLIENT
American Institute of Graphic Arts

Philippe Weisbecker

Philippe Weisbecker's poster was created for the
AIGA book show. Medium: Watercolor and brush
and ink.

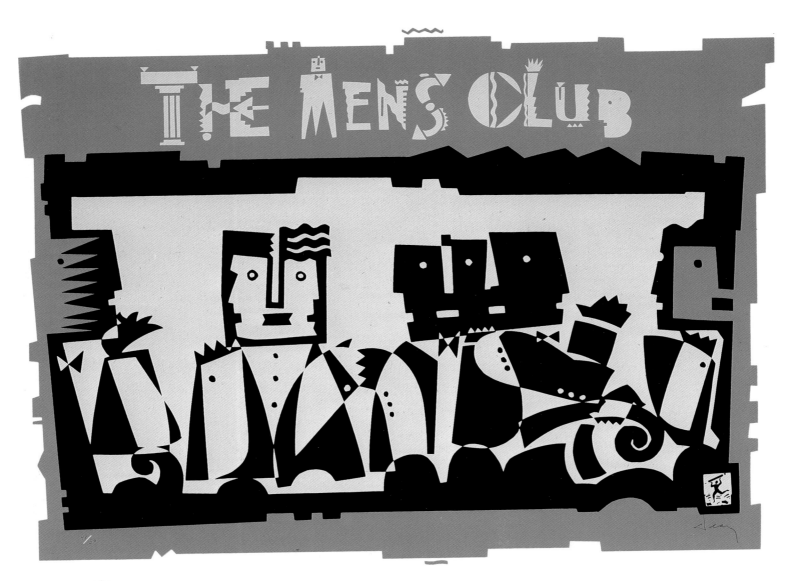

184

ART DIRECTOR
David Diaz
COPYWRITER
David Diaz
ADVERTISING AGENCY
David Diaz Illustration
CLIENT
The Men's Club

David Diaz

A private men's club commissioned this limited
edition poster. Medium: Silkscreen.

185

ART DIRECTOR
Louis Fishauf
ADVERTISING AGENCY
Reactor Art & Design
CLIENT
Athletes World, division of Bata Retail
August 1987

Jean Tuttle

The angularity of Jean Tuttle's athlete emphasizes his
strength in a poster for Reebok footwear. Medium:
Scratchboard and amberlith overlays.

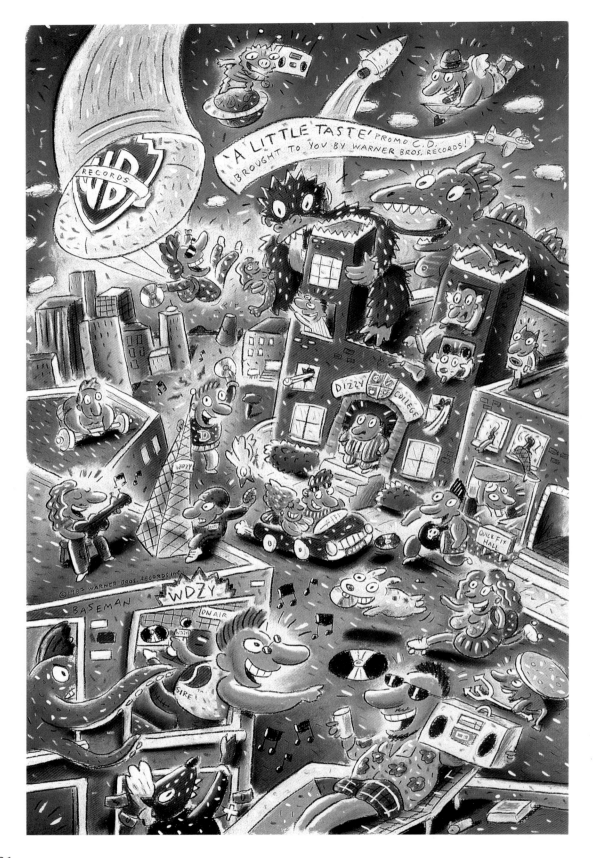

ART DIRECTOR
Jeri McManus Heiden
CLIENT
Warner Brothers Records, Inc.

Gary Baseman

The "virtues" of college life — sex, anarchy, and
rock 'n' roll — are given free rein in *A Little Taste*, a
poster promoting compact disks to college students.
Medium: Pastel.

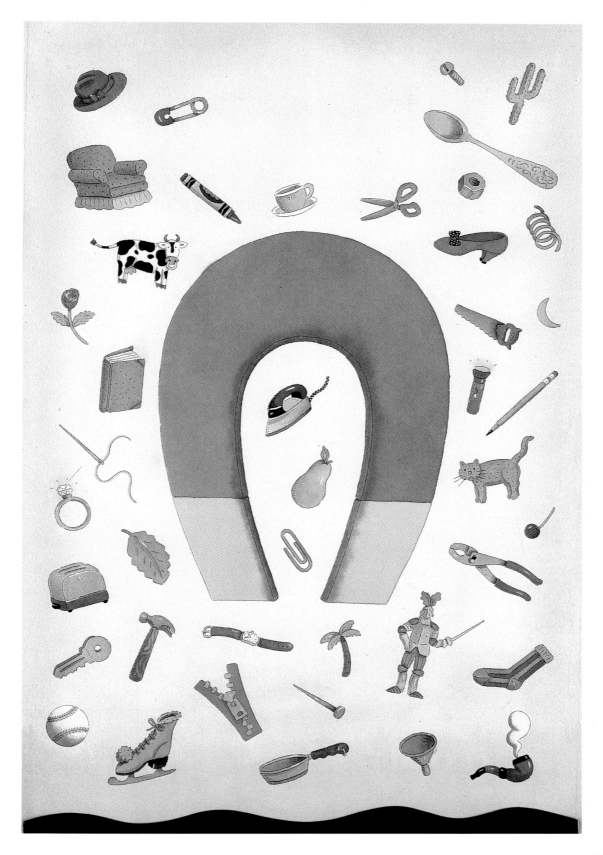

ART DIRECTOR
Carol Carson
COPYWRITER
Jean Marsalla
CLIENT
Scholastic Let's Find Out

Mary Lynn Blasutta

Mary Lynn Blasutta's illustration asked children,
"What Does a Magnet Attract?" Medium:
Watercolor.

188

ART DIRECTOR
R. O. Blechman
ADVERTISING AGENCY
R. O. Blechman, Inc.
CLIENT
Clarion Music Society
Fall 1987

R. O. Blechman

The Leaf Peeper classical concert series in upstate
New York featured this poster. Medium: Ink.

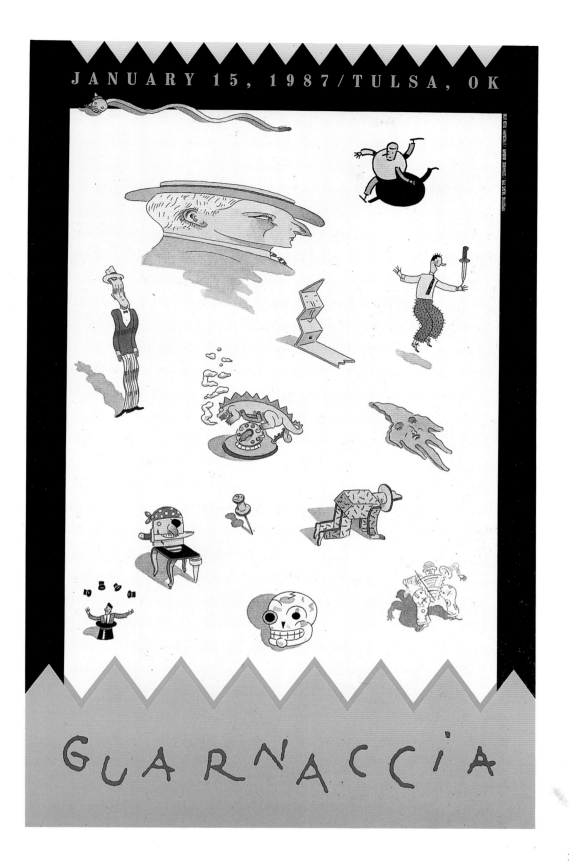

Art Director
Cameron Clement
Advertising Agency
Ackerman Hood & McQueen
Client
Tulsa Art Directors Club
January 15, 1987

Steven Guarnaccia

For a talk he gave to the Tulsa Art Directors Club,
Steven Guarnaccia was asked to produce an image
representative of his work. Medium: Watercolor and
pen and ink.

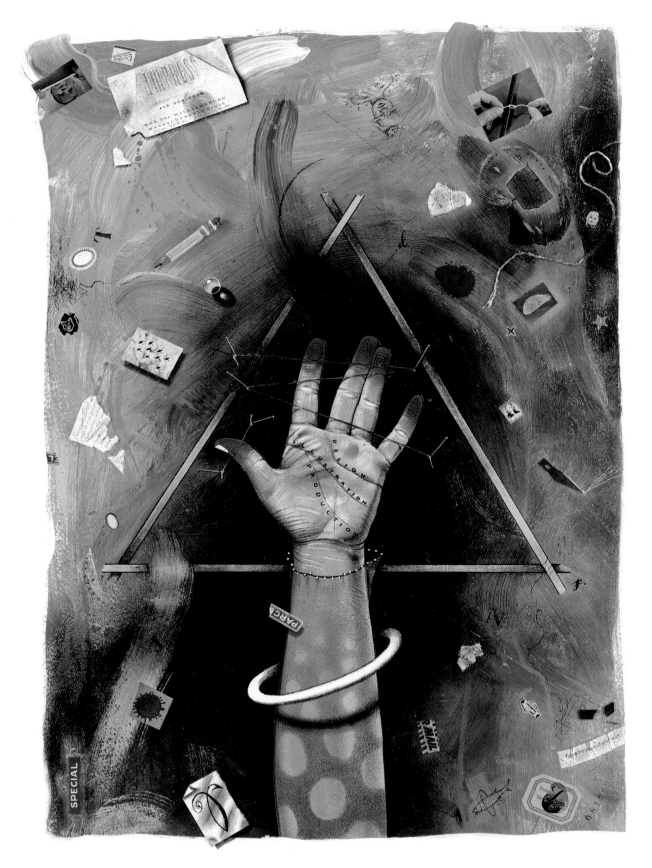

190

ART DIRECTOR
Hans Teensma
COPYWRITER
Lisa Newman
CLIENT
Impress

Kandy Jean Littrell

To promote an art studio, a poster was created to
represent the studio's spirit as well as its services.
Medium: Watercolor, pastel, ink, and collage.

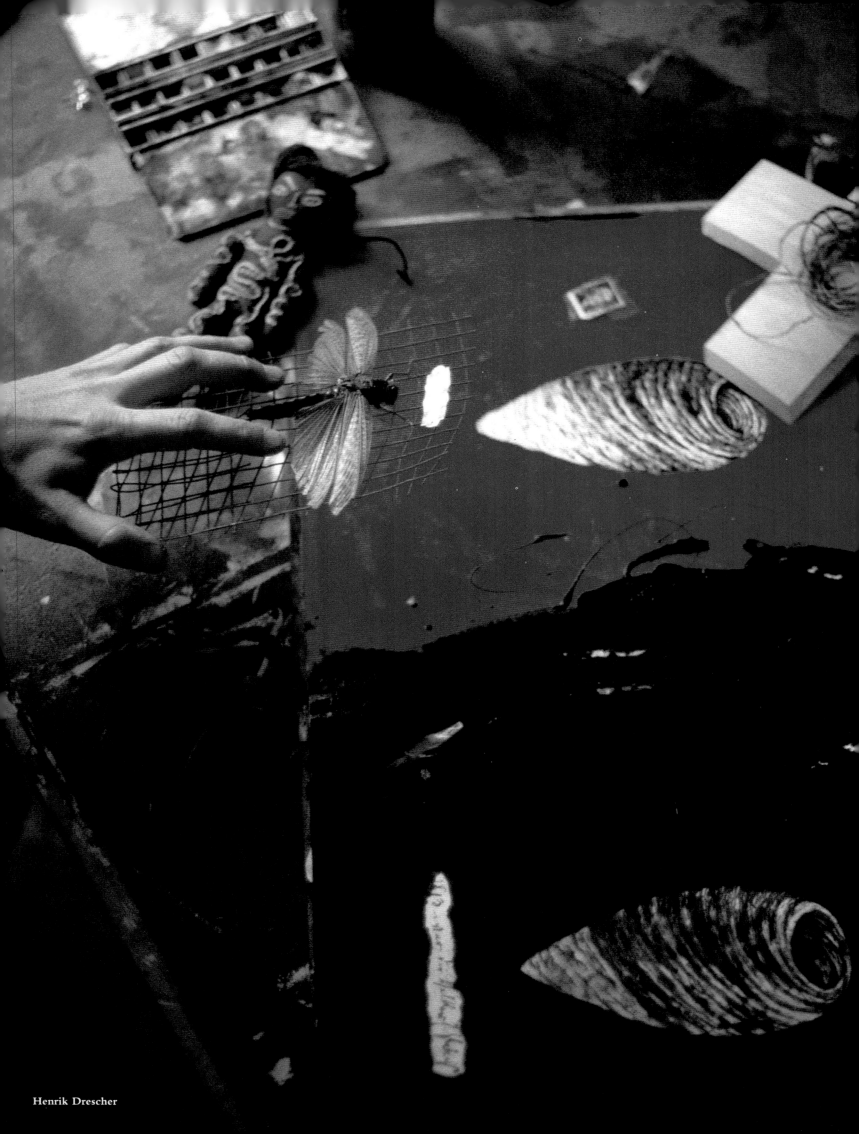

Henrik Drescher

5

PROMOTION

Illustrations for brochures,
record album covers, and
self-promotion

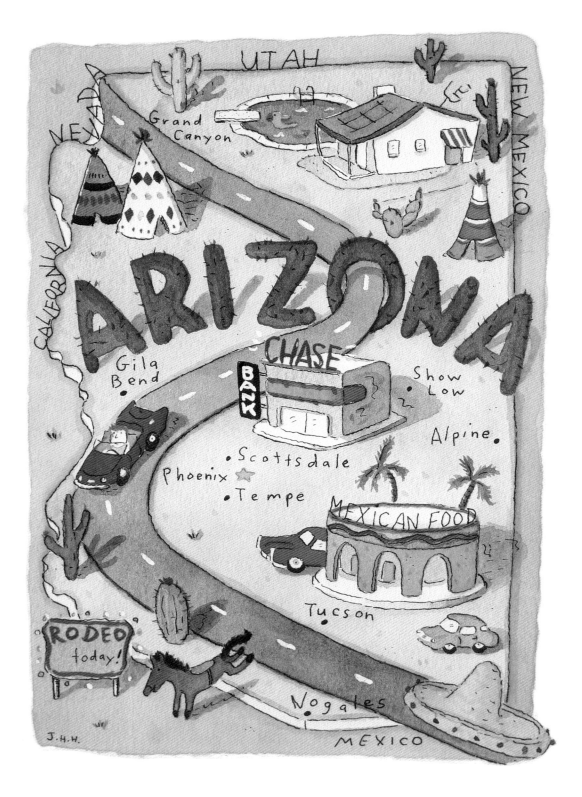

ART DIRECTOR
Keith McDavid
DESIGNER
Tana Klugherz
WRITER
Ed Baum
DESIGN GROUP
Tana & Co.
PUBLISHER
Chase Manhattan Bank
September 1987

Jessie Hartland

This Arizona map appeared in "Dateline," a feature
in Chase Manhattan Bank's bimonthly newsletter
that profiles the international banking business.
Medium: Watercolor, pen and ink.

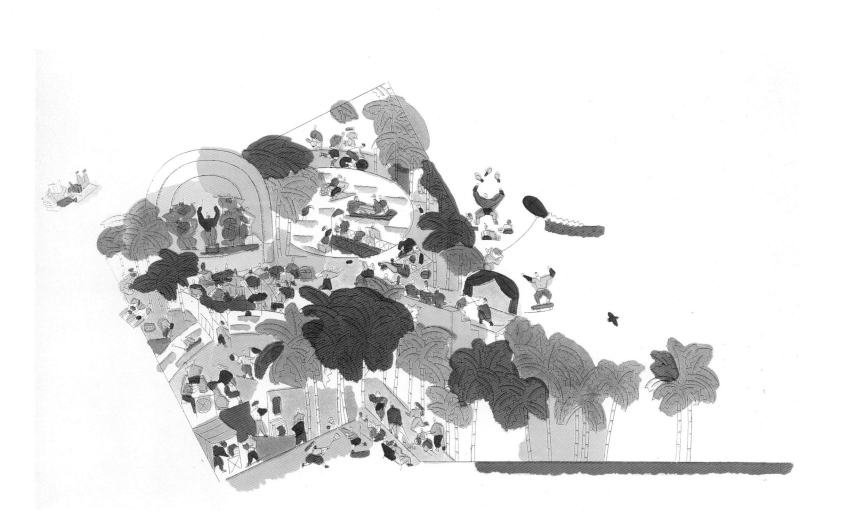

I95

Art Director
Susan Slover
Design Group
Susan Slover Design
Publisher
The Cultural Foundation Founder's Grove
June 1987

Philippe Weisbecker

To raise funds for a new park in Los Angeles,
Philippe Weisbecker illustrated the brochure with
park activities. Medium: Watercolor and pen and ink.

196

ART DIRECTOR
Rebecca Bernstein
DESIGNER
Rebecca Bernstein
WRITERS
Steven Sample and Lawrence Kojaku
PUBLISHER
**University Publications,
State University of New York
at Buffalo
April 1988**

Joel Peter Johnson

Joel Peter Johnson embodied the concept of "sphere of influence" in his illustration for SUNY Buffalo's international program brochure. Medium: Acrylic and oil with collage.

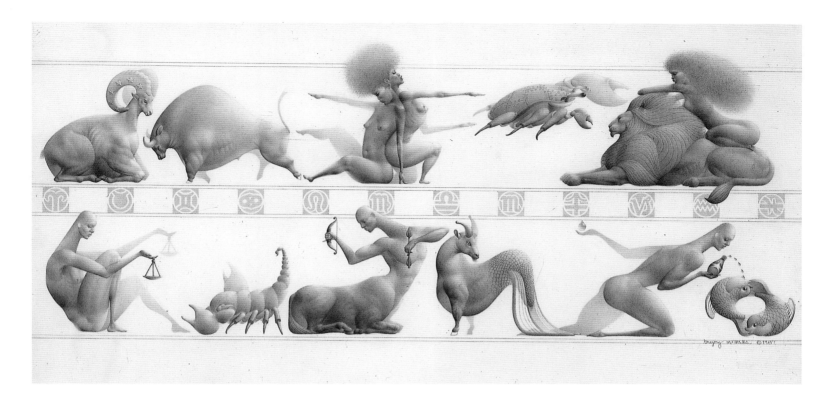

197

Gregory McMickin

For a self-promotional flyer in June 1987, Gregory
McMickin chose to illustrate a common theme (the
signs of the Zodiac) in an uncommon way.
Medium: Graphite.

198

ART DIRECTOR
Christopher Austopchuk
DESIGNER
Christopher Austopchuk
PUBLISHER
CBS Records

Vivienne Flesher

These images were featured on the front and back covers
of *Classic Encounter*, an album by Ramsey Lewis.
Medium: Pastel.

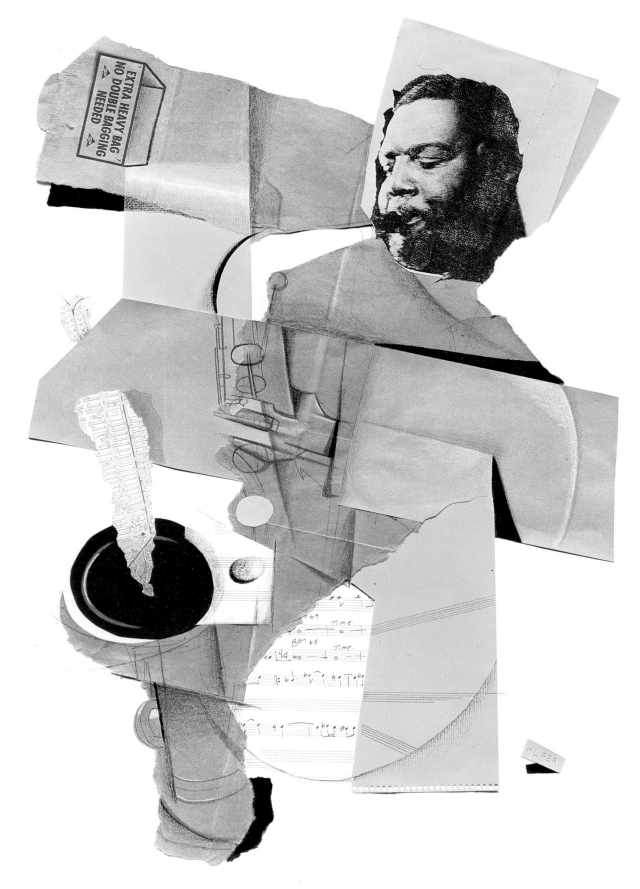

Art Director
Stacy Drummond
Publisher
CBS Records

Peter Kuper

Peter Kuper's personal piece on a saxophone player
evolved into Arthur Blythe's album cover. Medium:
Pencil and collage.

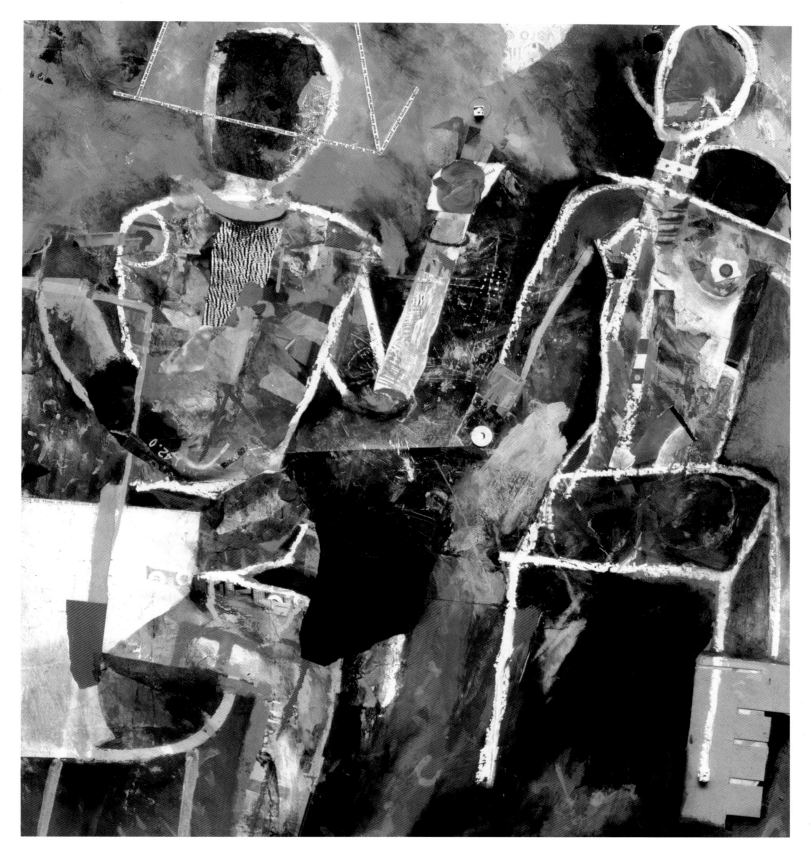

ART DIRECTOR
Stephen Byram
DESIGNER
Stephen Byram
PUBLISHER
CBS Records

Stephen Byram

Stephen Byram produced this cover for Tim Berne's
album. Medium: Mixed media.

202

ART DIRECTOR
Monique Dupras
DESIGNER
Monique Dupras
WRITER
Clarence étrault
DESIGN GROUP
**Burson-Marsteller and
Saidye Bronfman Centre
November 1987**

Normand Cousineau

To invite people to a Brazilian carnival fundraiser,
Normand Cousineau created this colorful postcard.
Medium: Film and colored paper.

DESIGNER
Jean Tuttle

Jean Tuttle

Jean Tuttle wanted to create something that would
not only promote her work but would also provide
a fun product, so she printed her drawing of the
Mexican celebration of the Day of the Dead onto
red cloth bandanas. Medium: Scratchboard and silkscreen.

204

ART DIRECTORS
Esther K. Smith and Dikko Faust
DESIGNER
Michael Bartalos
DESIGN GROUP
Purgatory Pie Press
PUBLISHER
Purgatory Pie Press
January 1988

Michael Bartalos

Michael Bartalos's *Concerto de Toros* and *Capoeira do Brazil* were printed by letterpress as limited edition postcards. Medium: Linoleum block print.

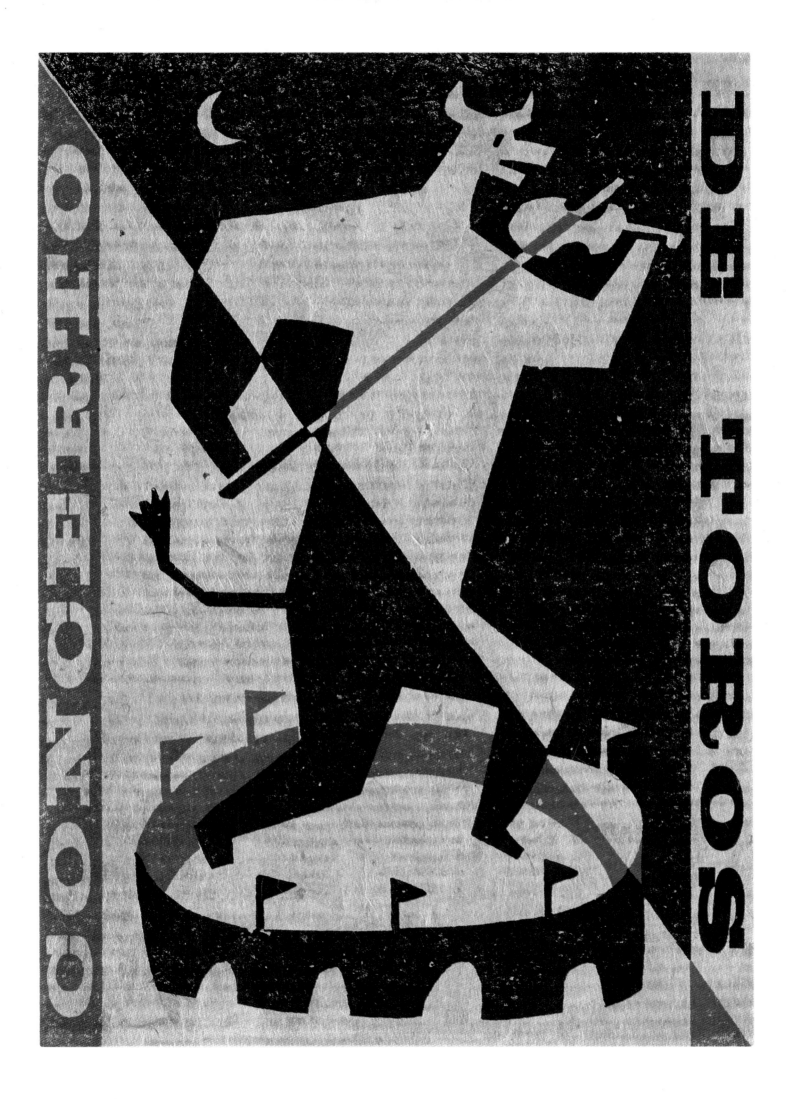

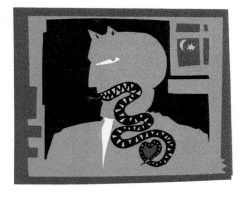
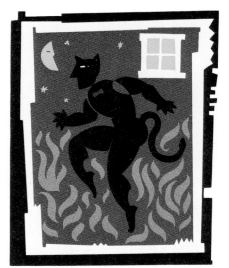
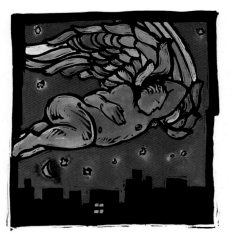

206

ART DIRECTOR
Cecilia A. Conover
DESIGNER
Cecilia A. Conover
WRITER
Marge Piercy
DESIGN GROUP
Evans & Conover
PUBLISHER
David Diaz
September 1987

David Diaz

David Diaz created a book as a self-promotion
piece. Medium: Watercolor, dyes and silkscreen.

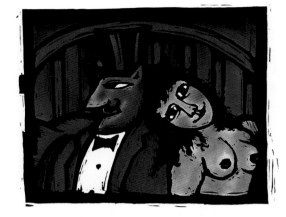

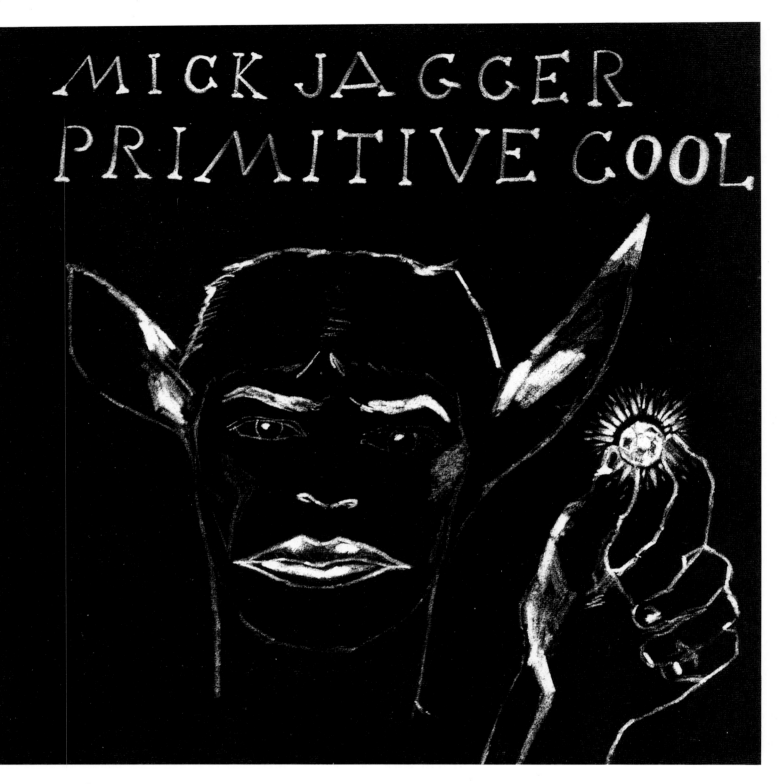

ART DIRECTOR
Christopher Austopchuk
DESIGNER
Christopher Austopchuk
PUBLISHER
CBS Records

Francesco Clemente

To break away from the usually photographic, slick
Rolling Stones look, Francesco Clemente created a
naive, stark look for Mick Jagger's album cover.
Medium: White chalk on black paper.

6

COMPUTER GRAPHICS

*Illustrations produced
by computer for editorial, promotional,
or advertising use*

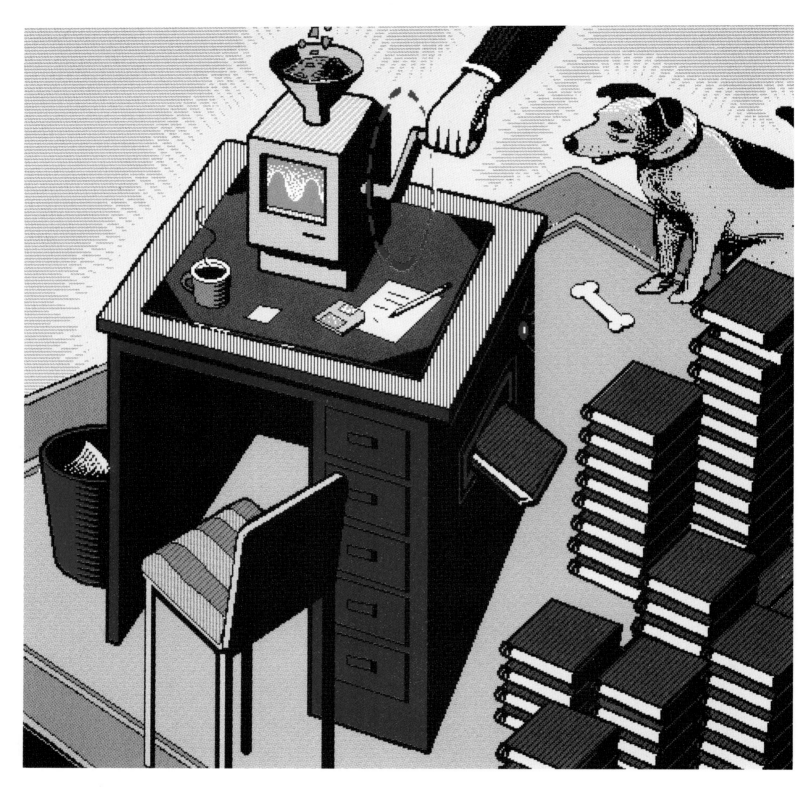

ART DIRECTOR
Gary Ludwig
DESIGNER
Barbara Woolley
PUBLICATION
Apple Desktop Publishing Series
PUBLISHING COMPANY
Spencer Francey Group

Mick Wiggins

The cover of the leader's guide for a desktop
publishing seminar featured this image.

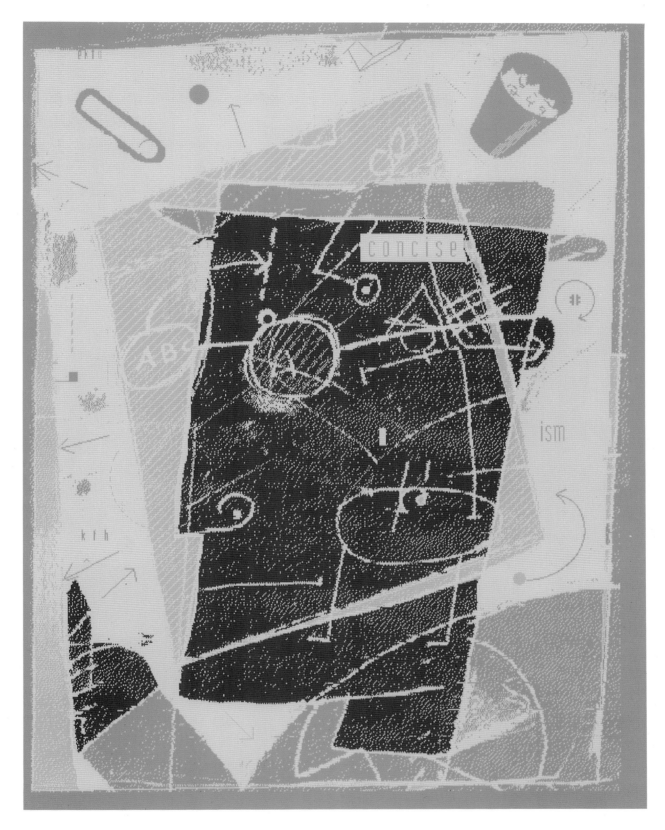

ART DIRECTOR
Christopher Burg
PUBLICATION
Macworld
December 1987
PUBLISHING COMPANY
PCW Communications, Inc.

John Hersey

The feature "Inside Outliner" described software
designed to help writers outline ideas more easily.
John Hersey's accompanying illustration was
produced by digitizing a pencil drawing.

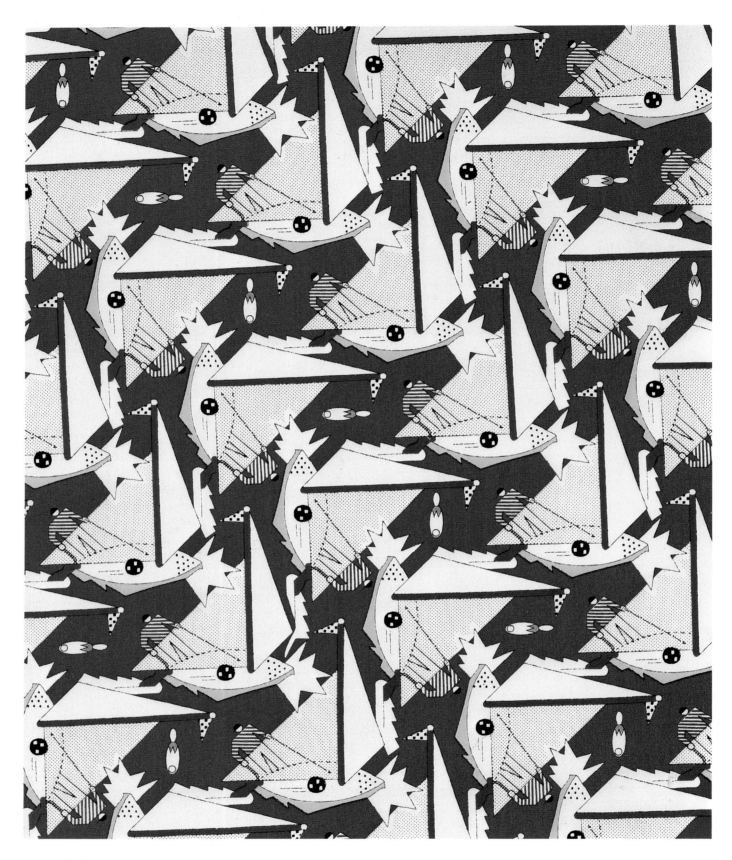

214

ART DIRECTOR
Michael Mabry
CLIENT
Esprit
Spring 1987

John Hersey

John Hersey created a series of continuous
integrated patterns based on unusual combinations
of sports themes: sailing/bowling,
mountaineering/golf, and tennis/sumo wrestling.

215

216

7

UNPUBLISHED WORK

Commissioned but
unpublished illustrations, and
personal work produced by
professionals and students

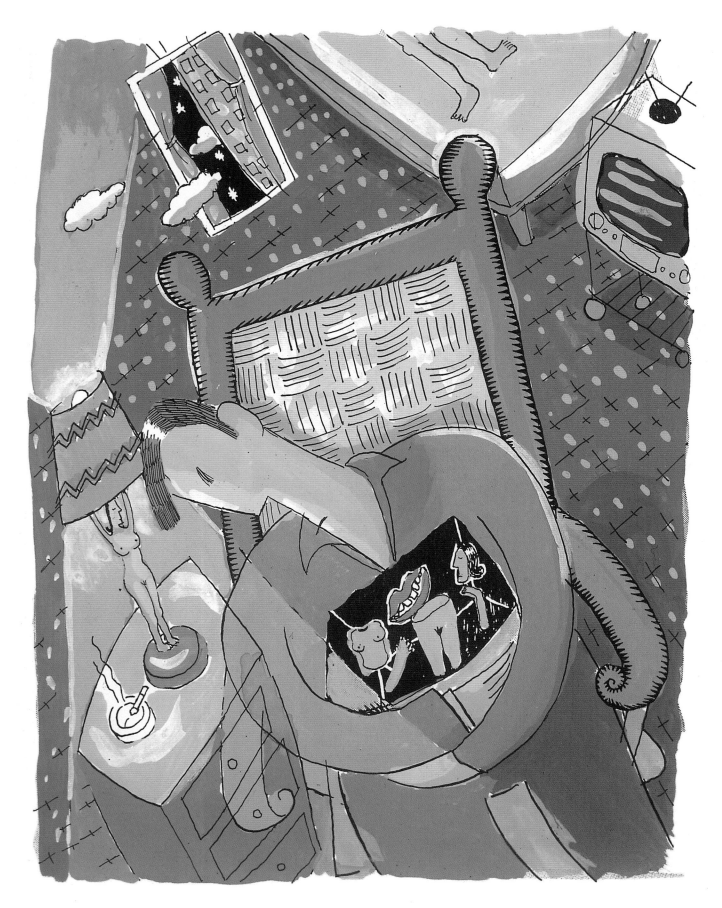

I Live Filing My Dreams, January 1988

Santiago Cohen

Santiago Cohen distorted perspective to create a
dreamlike atmosphere for an illustration inspired by
Eduardo Cesarman's book *Cuarto Menguante*.
Medium: Acrylic and india ink.

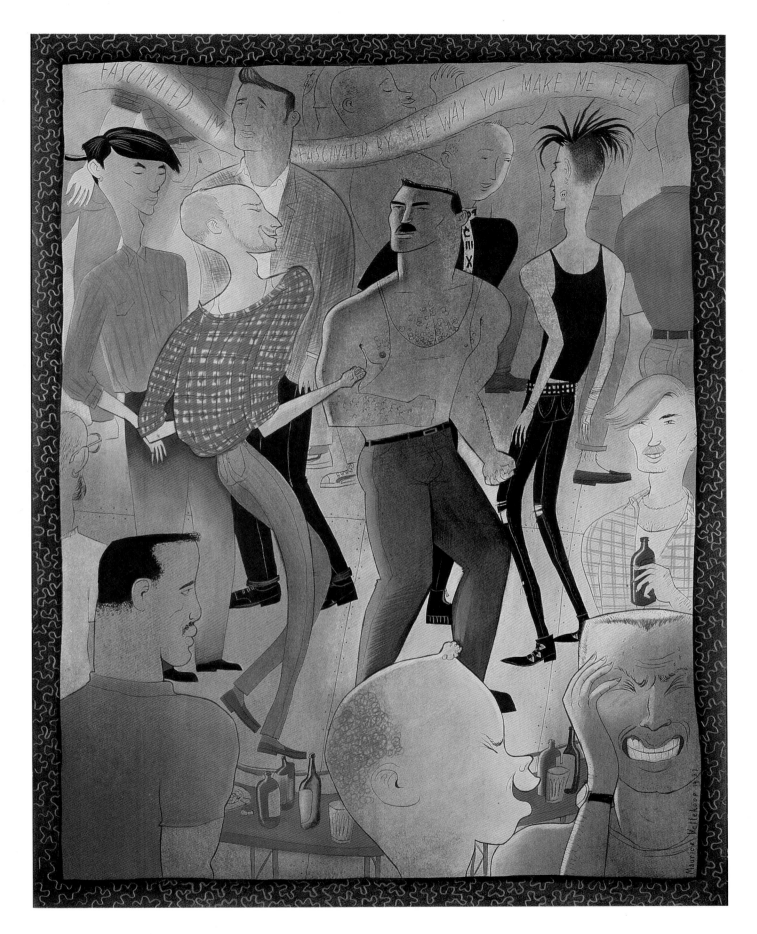

221

Untitled, September 1987

Maurice Vellekoop

This club scene was part of a series for a show of
the artist's work. Medium: Mixed media.

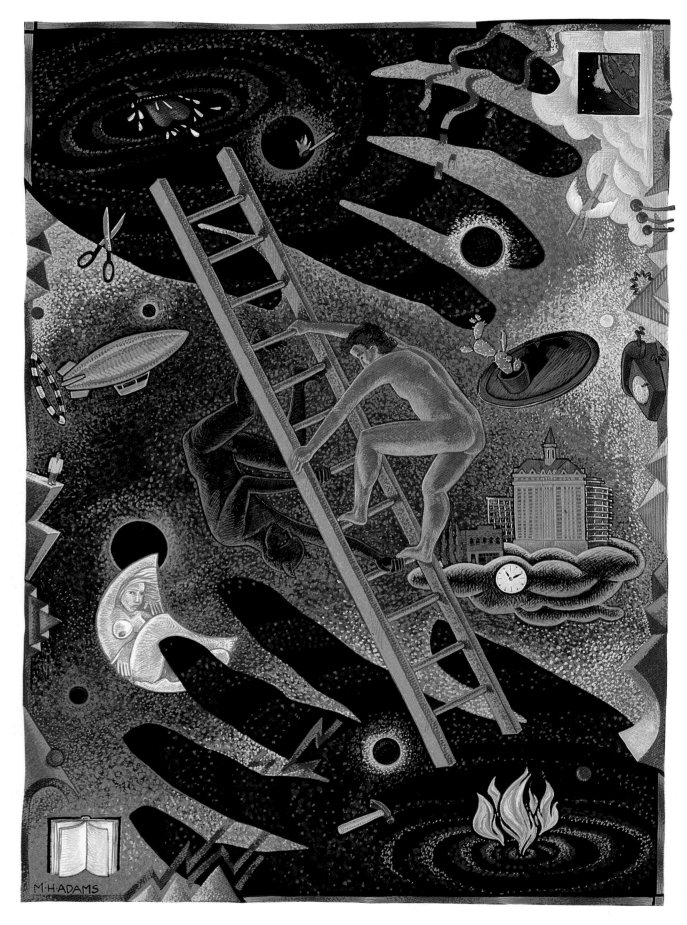

222

Anxious and Ascending, February 1988

Mark H. Adams

The demons of anxiety and disorder are given free
rein in this piece. Medium: Gouache.

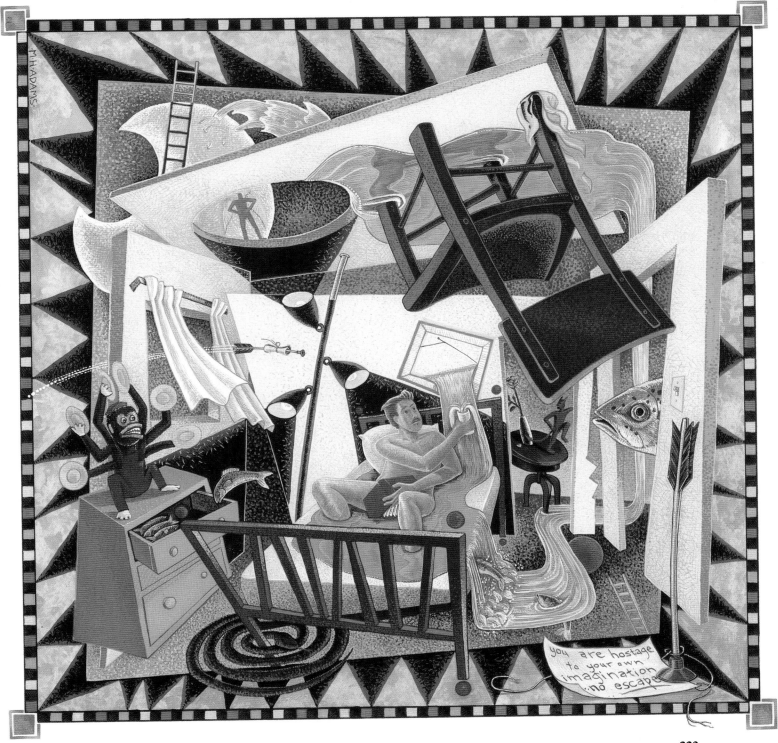

223

Limbo Suite, **February 1988**

Mark H. Adams

The chaos of this room reflects the artist's state of
mind at the time — the illustration helped him find
calmness and confidence amid the confusion.
Medium: Gouache.

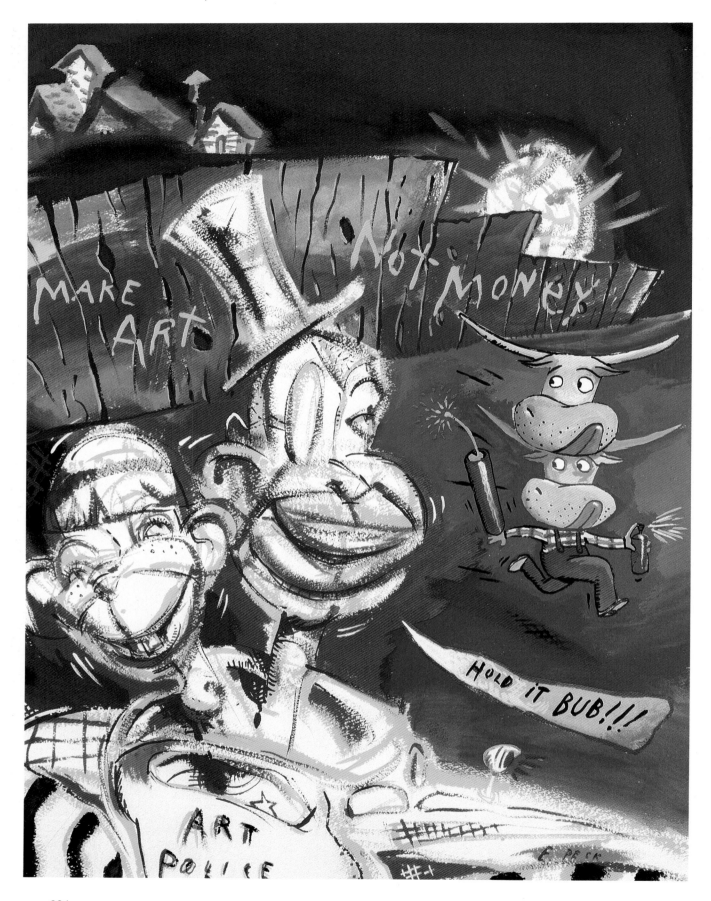

Art Police, **September 1987**

Everett Peck

The proposed cover for Japan's *Idea* magazine (for an
issue featuring Everett Peck's work) plays on the
idea of art for money versus art for art's sake.
Medium: Acrylic on paper.

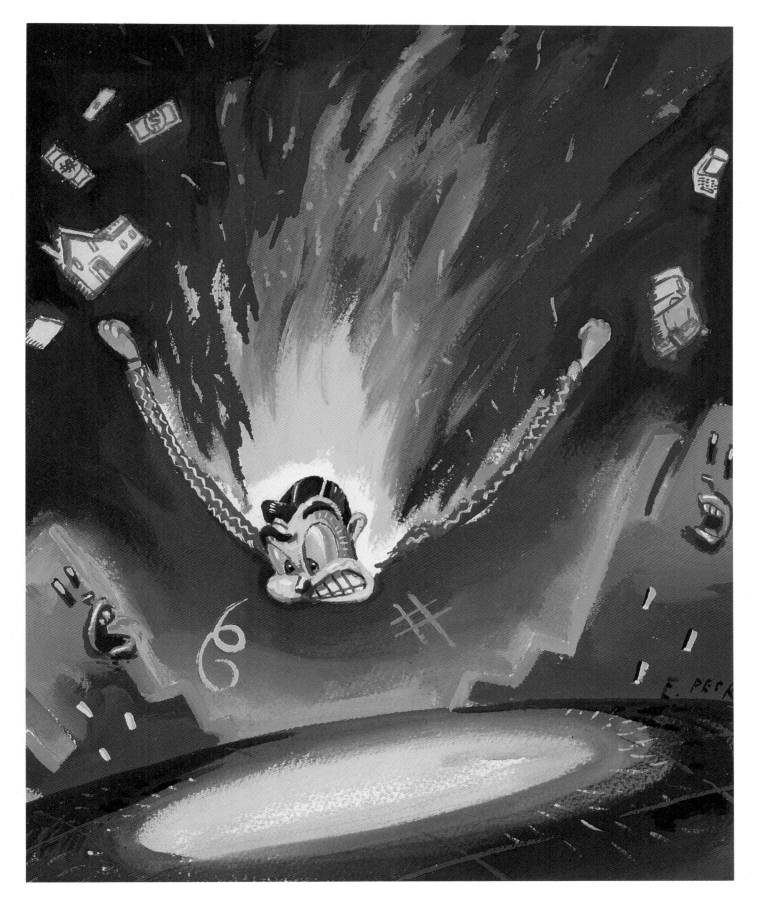

Crash and Burn, June 1987

Everett Peck

Crash and Burn, originally meant to accompany a
publication depicting the rapid rise and potentially
swift burn–out of the Yuppie set, was eventually
rejected as "too dark." Medium: Acrylic on paper.

226

Childhood Memories, November 1987

Philip Brooker

This is one of ten pieces from an ongoing portfolio
project of childhood memories of England.
Medium: Acrylic on fake brick wallpaper.

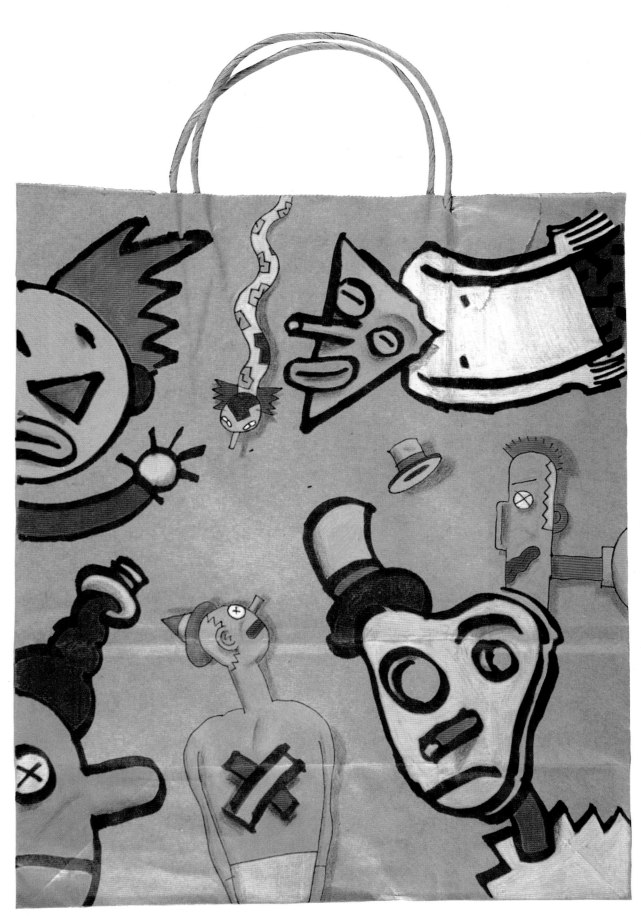

New York Shoppers, **August 1987**

Steven Guarnaccia

Steven Guarnaccia produced shopping bag art as a
personal project. Medium: Colored pencil and
marker.

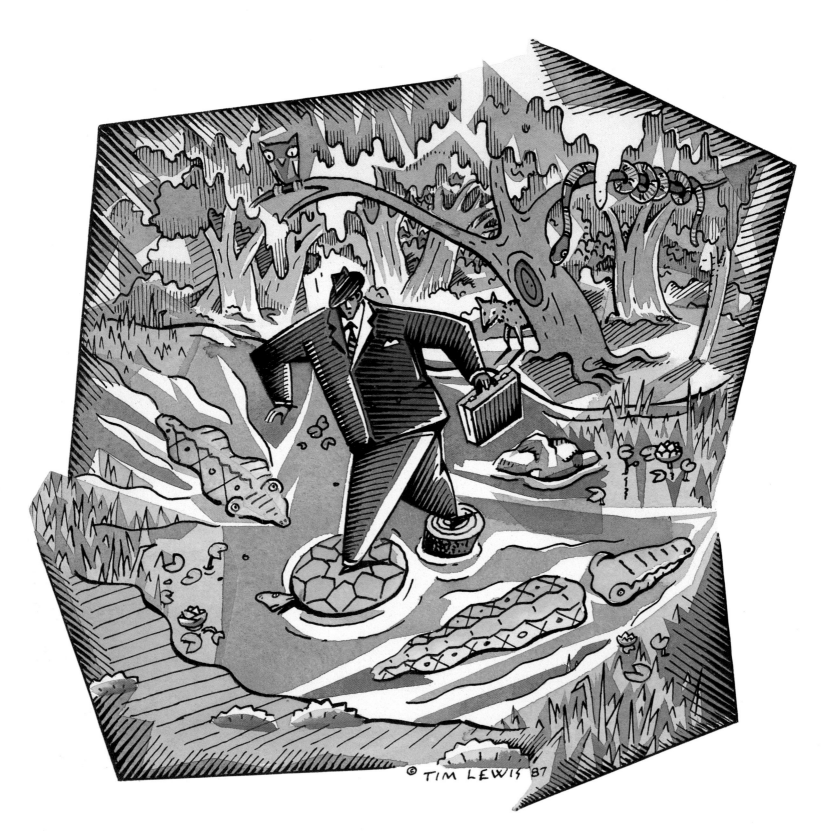

*Three Team Leaders Master a Framework
for Managing Change*, **Spring 1987**

Tim Lewis

Originally intended for a computer magazine, this
illustration was designed as a visual metaphor about
coping with the uncertainty prevalent in a world of
technological changes. Medium: Watercolor and
photocopy.

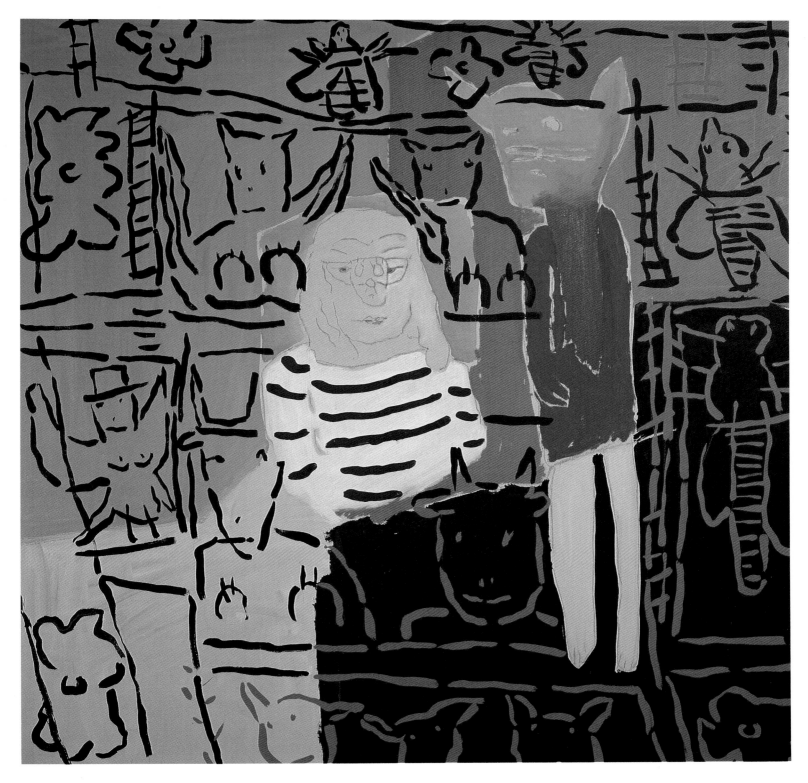

229

Autoportrait, **January 1988**

Nancy Klobucar

To solve the problem of integrating the central figures with the flat, bold background, Nancy Klobucar added playful hieroglyphs. Medium: Acrylic and crayon on canvas.

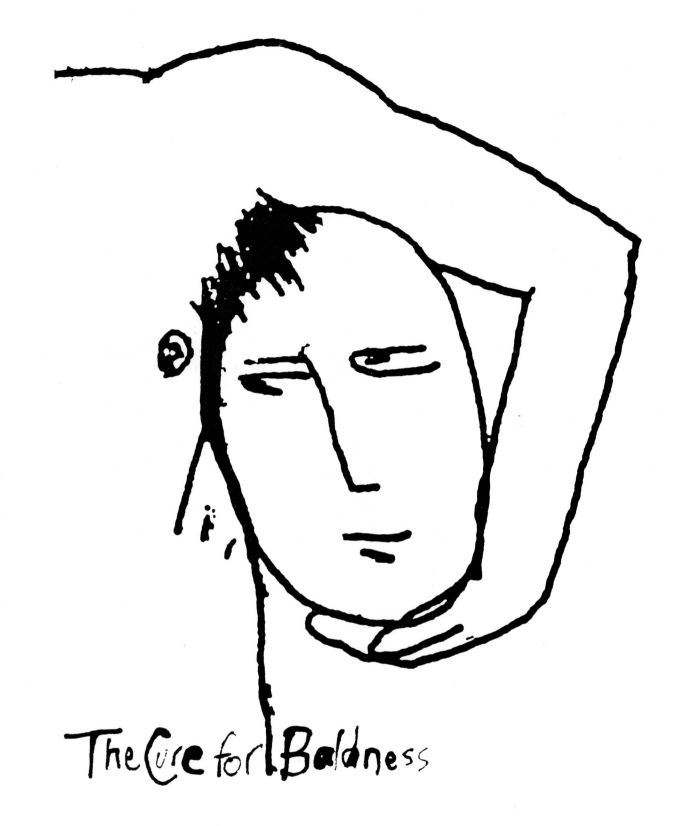

The Cure for Baldness

The Cure for Baldness, **November 1987**

Scott Menchin

Scott Menchin's illustration was inspired by an
article about a barber who specializes in taking care
of bald men. Medium: Pen and ink.

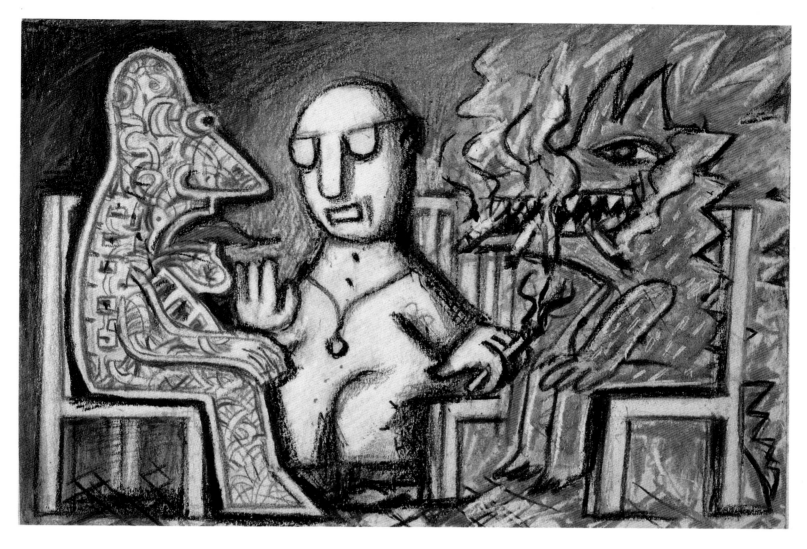

231

*Man's Weakness Facing Addiction
in Therapy Session*

Maciek Albrecht

Two creatures confront a man in an illustration from
Maciek Albrecht's unpublished, self-made book
Triangles. Medium: Colored pencil.

Jonathon Rosen

Jonathon Rosen had created this for *Desert Island Collection*, an album of Stevie Wonder songs interpreted by other artists; the project is still in limbo. Medium: Acrylic and photocopy.

Henrik Drescher

Henrik Drescher salvaged this piece from a cover
painting originally commissioned by Knopf.
Medium: Watercolor, dyes, ink, and collage.

234

Transbay Transit Terminal No. 4,
March 1988

David B. Ryan

Journal drawings made while waiting for the bus
inspired a series of paintings. Medium: Mixed media.

Cat Woman: Portrait of Sue Coe

Sara Schwartz

The feline grace of artist Sue Coe is captured in this
personal piece. Medium: Colored pencil.

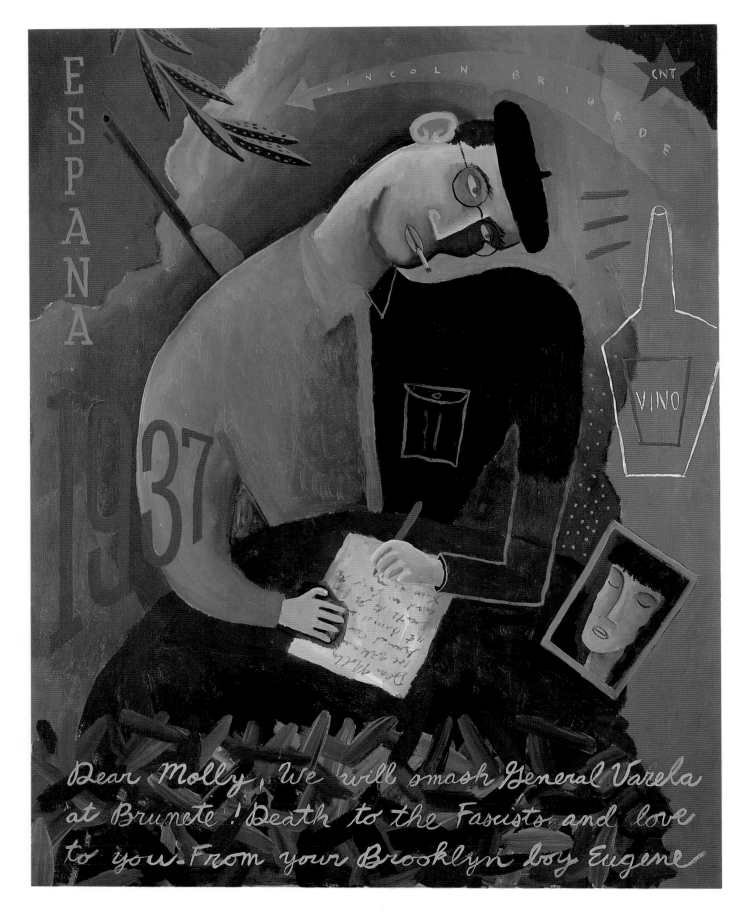

Eugene's Letter, 1987

Josh Gosfield

This paintings were done for three different personal
series: the Mexican Revolution, musicians, and the
Spanish Civil War. Medium: Acrylic.

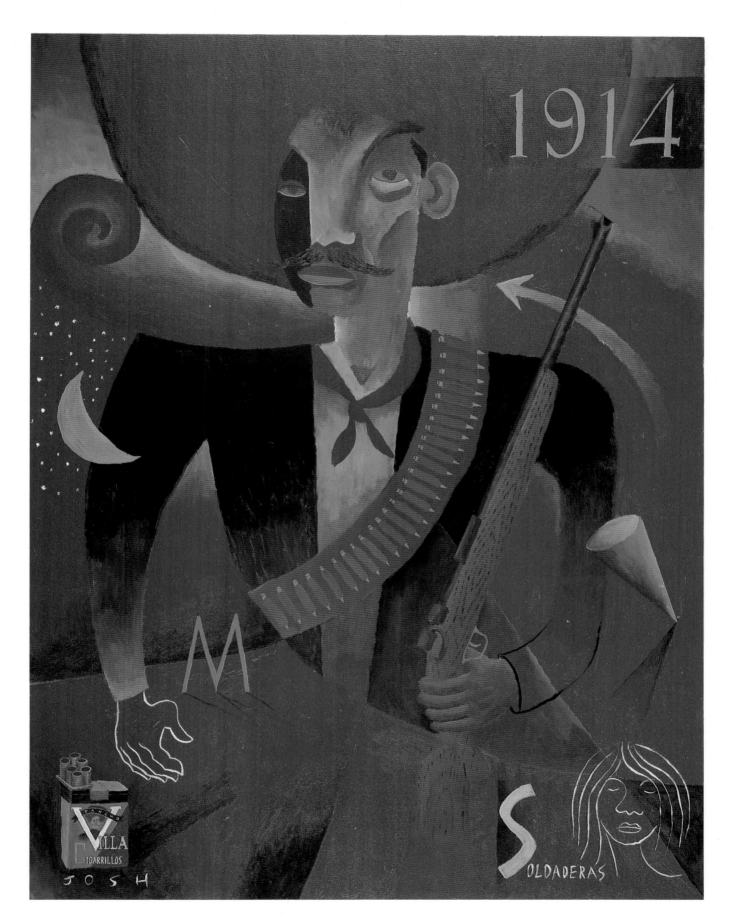

237

Soldaderas, 1987

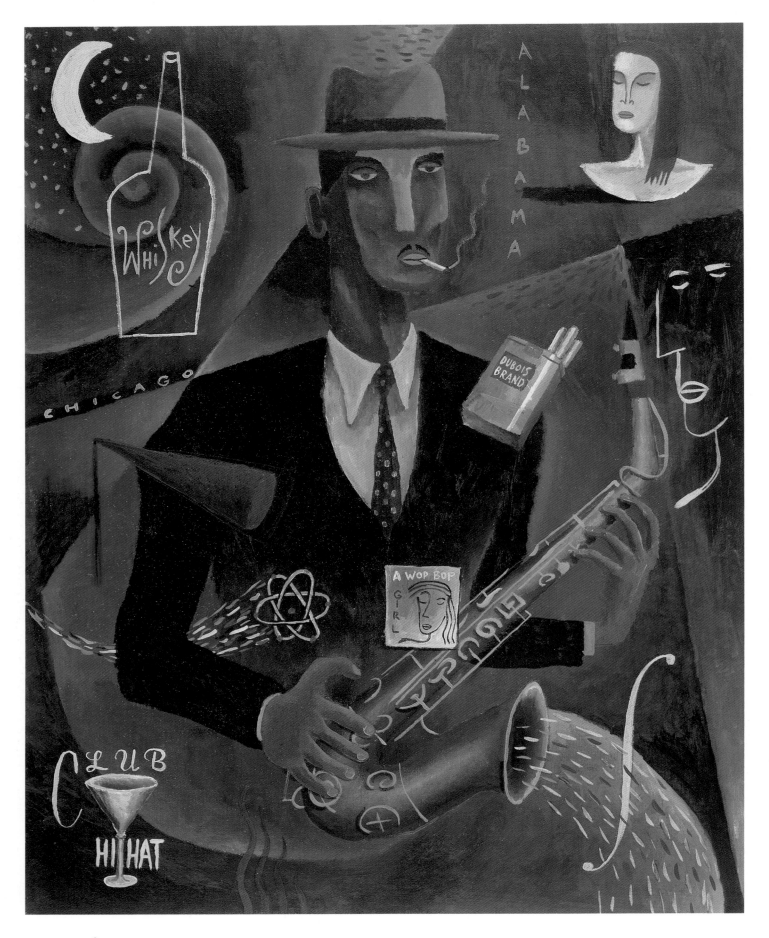

238

Saxophone Man, 1987

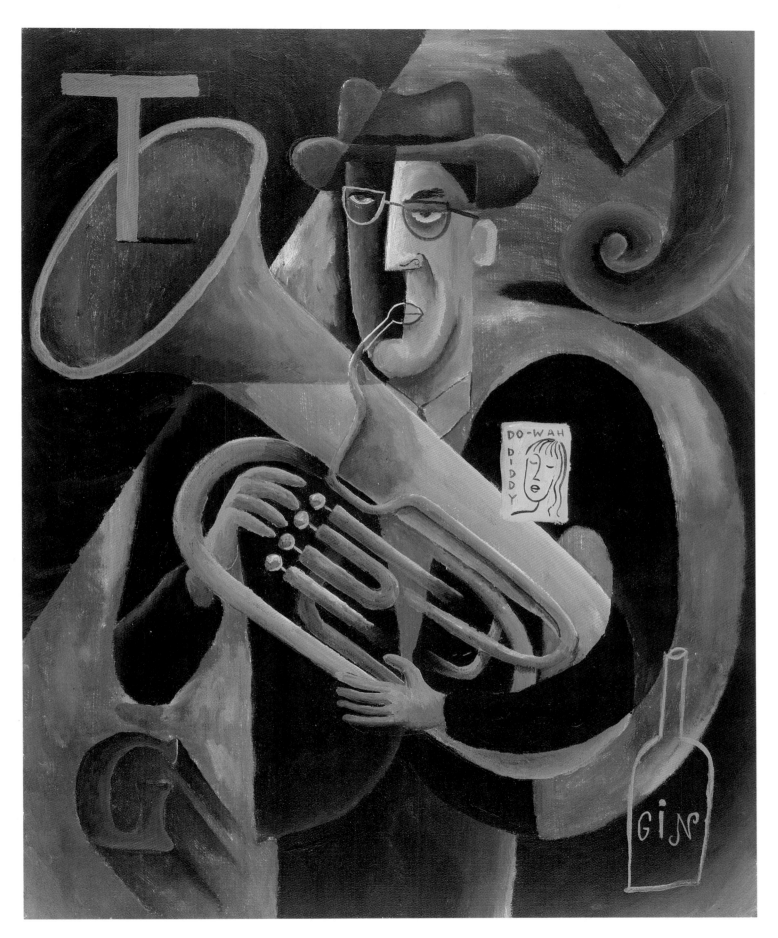

239

Tuba Player, 1987

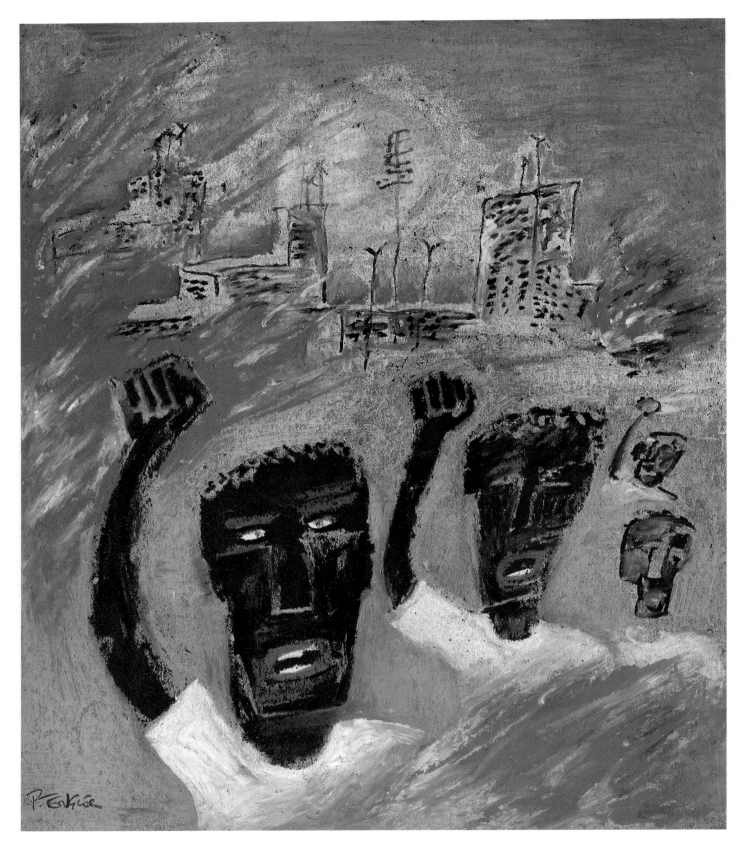

240

Johannesburg, **January 1988**

Peter Tengler

As part of a personal portfolio, Peter Tengler
produced two pieces on the subject of apartheid.
Medium: Oil pastel on paper.

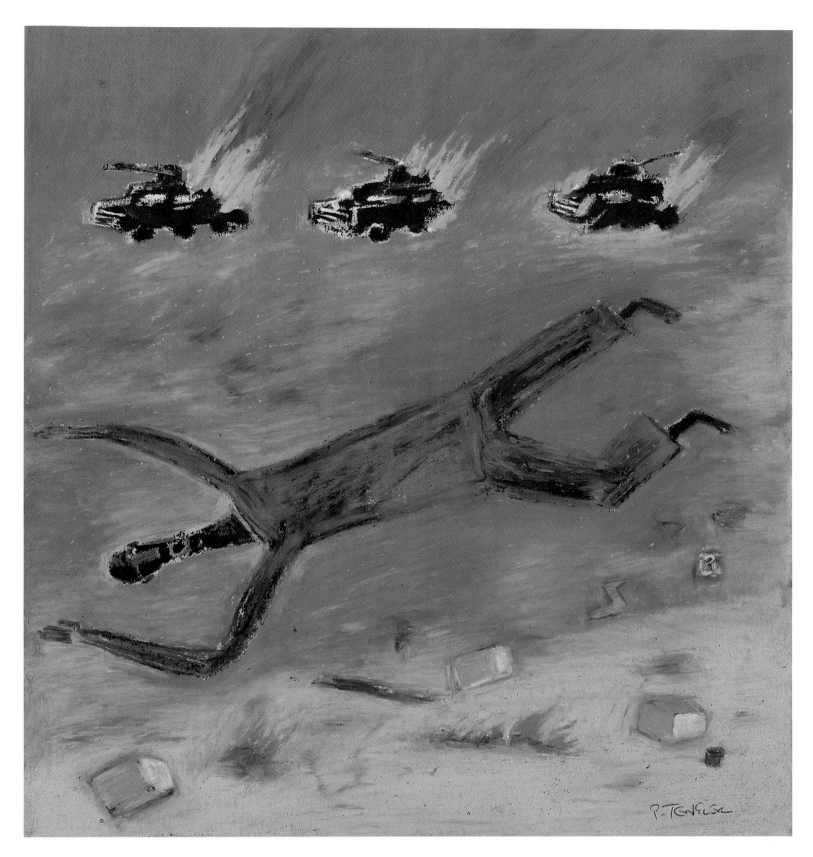

241

Crossroads, **January 1988**

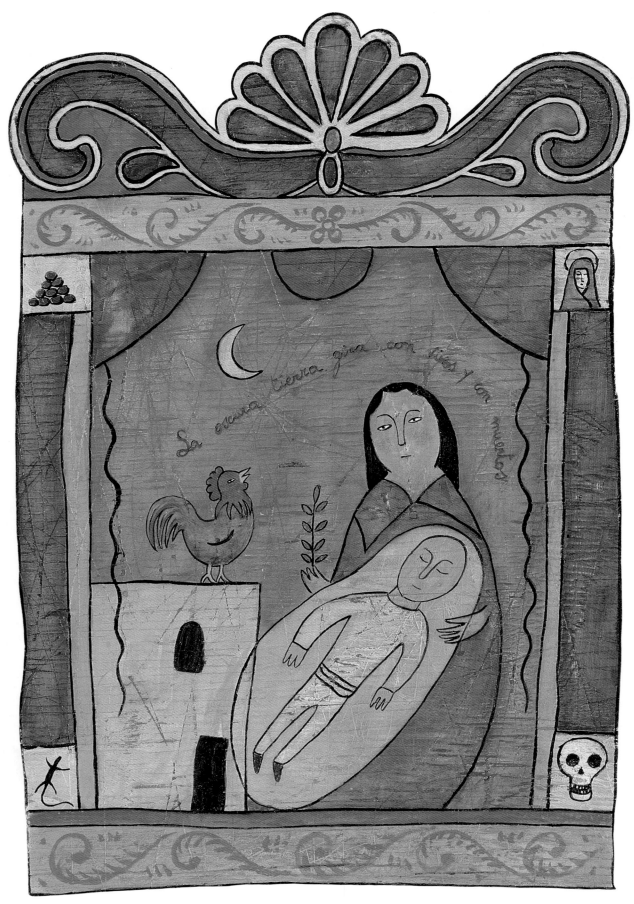

February 1987

Stefano Vitale

For an art school assignment, Stefano Vitale created
two cover images for a book, *Stones for Ibarra*.
Medium: Acrylic, gouache, and watercolor.

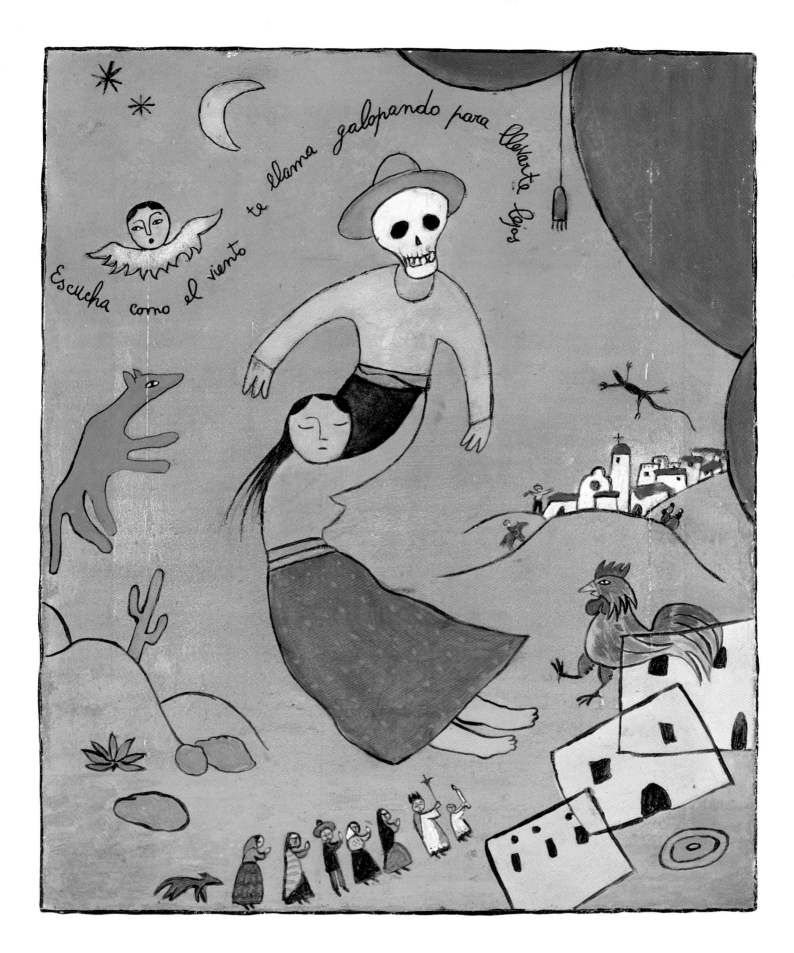

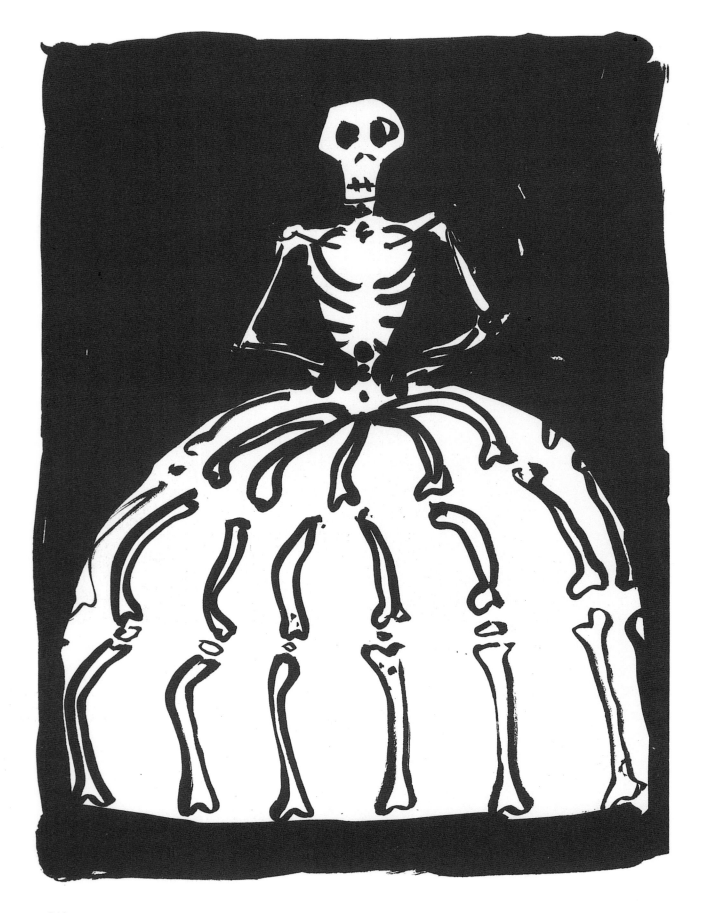

244

Skeleton Dress, **June 1987**

Isabelle Dervaux

Based on a sketchbook drawing, this image was
used as a self-promotion piece and was included in
an exhibition of the artist's work. Medium:
Silkscreen.

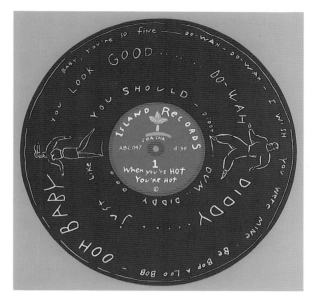

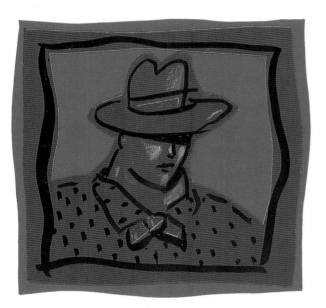

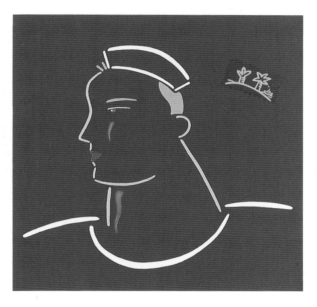

245

Sailor, **February 1988**
Record, **February 1988**
Man in Hat, **February 1988**
Woman, **January 1988**

Catharine Bennett

Catharine Bennett produced these four pieces for
her portfolio. Medium: Mixed media.

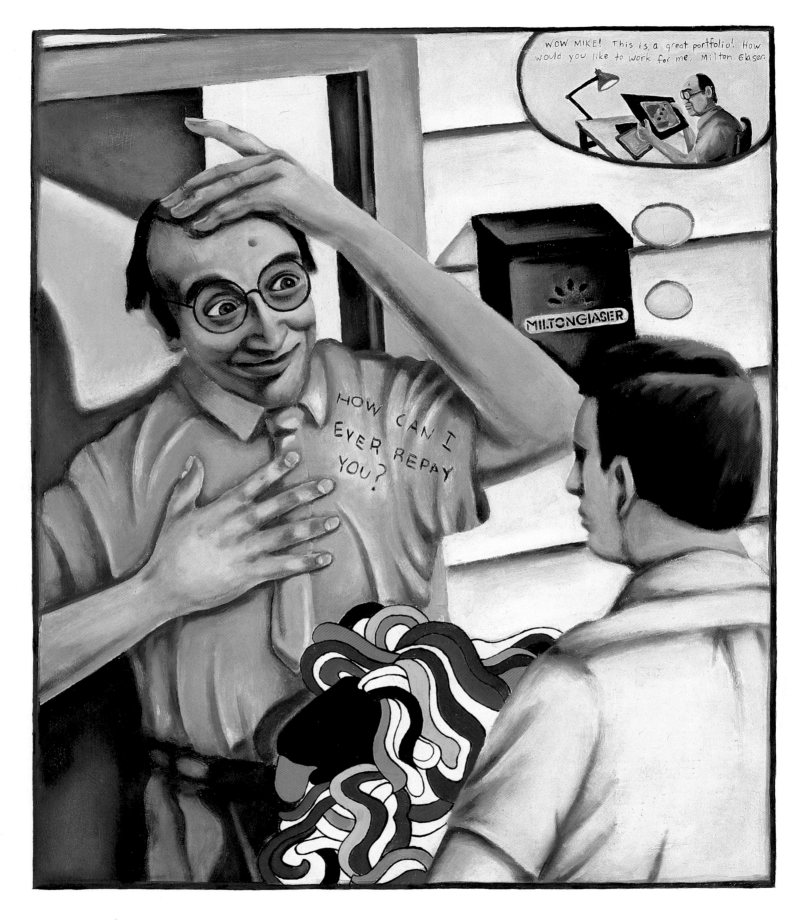

246

The Day I Found Milton Glaser's Dog,
June 1987

Mike Benny

Mike Benny dreams of discovery in his design for a
student poster competition on the theme of luck.
Medium: Oil on paper.

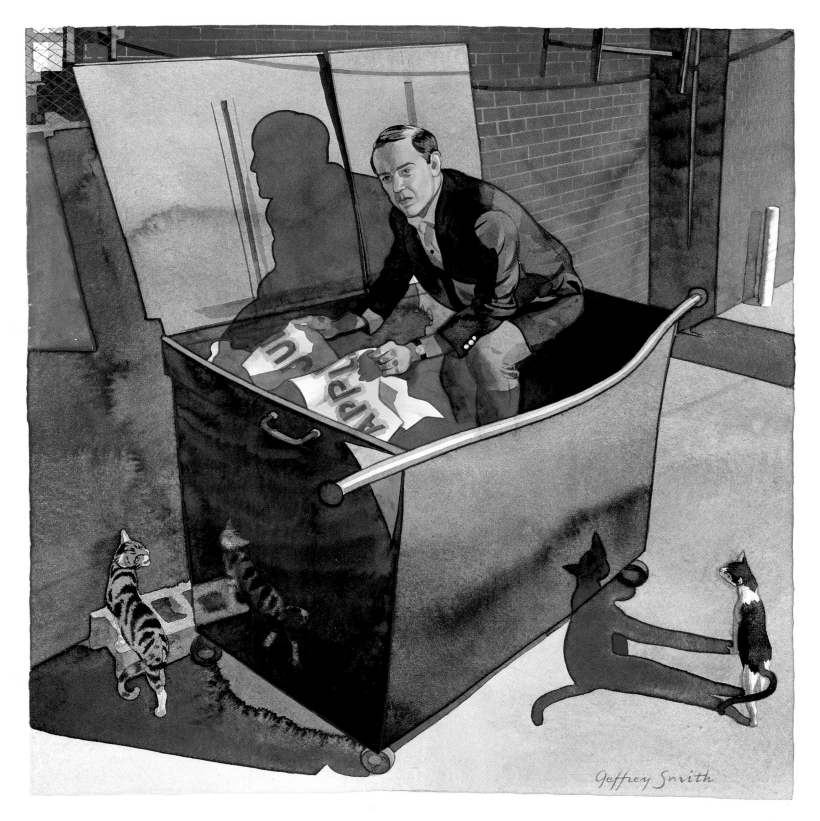

Rosenweicz in the Dumpster,
February 1988

Jeffrey Smith

The events surrounding the Beechnut fake juice
scandal were depicted in a series initially intended
for a *Fortune* magazine article about the
investigation. Medium: Watercolor.

248

Monica Smith

Poet Richard Meltzer inspired this work after
reading his poetry to an art class.
Medium: Silkscreen.

Brothers, **June 1987**

Blair Drawson

Blair Drawson painted *Brothers* as a self–
commissioned piece. Medium: Acrylic on paper,
mounted on board.

INDEX

Illustrators

Publications

Publishers and Publishing Companies

About American Illustration

Each year American Illustration, Inc., has a Graphic Arts Weekend symposium on creativity that attracts people from all over the world. It is held in New York and features "Studio Visits," whereby students and professionals in the graphic arts field visit with illustrators, film animators, art directors, and designers in their studios.

If you would like to learn more about this and other American Illustration activities, or if you are a practising illustrator, artist, or student and want to submit work to the annual competition, write to:

AMERICAN ILLUSTRATION, INC.
67 Irving Place
New York, NY 10003
(212) 460-5558

Edward Booth–Clibborn
President

Stephanie Van Dine
Project Director

COMMITTEE MEMBERS

Julian Allen
31 Walker Street
New York, NY 10013

Carol Carson
138 West 88th Street
New York, NY 10024

Steven Heller
Senior Art Director
New York Times
229 West 43rd Street
New York, NY 10036

Doug Johnson
45 East 19th Street
New York, NY 10003

James McMullan
James McMullan, Inc.
222 Park Avenue South
New York, NY 10003

Gary Panter
505 Court Street
Brooklyn, NY 11231

ADVISORY BOARD

Marshall Arisman
School of Visual Arts
209 East 23rd Street
New York, NY 10010

Ronn Campisi
Ronn Campisi Design
118 Newbury Street
Boston, MA 02116

Seymour Chwast
Pushpin Group
215 Park Avenue South
13th Floor
New York, NY 10003

Rudy Hoglund
Time Magazine
Time & Life Building
Rockefeller Center
1271 Avenue of Americas
New York, NY 10003